In Praise of Aldus Manutius

In Praise of Aldus Manutius

A QUINCENTENARY EXHIBITION

H. George Fletcher

THE PIERPONT MORGAN LIBRARY, NEW YORK

UNIVERSITY RESEARCH LIBRARY
DEPARTMENT OF SPECIAL COLLECTIONS
UNIVERSITY OF CALIFORNIA, LOS ANGELES

1995

EXHIBITION DATES

The Pierpont Morgan Library, New York
10 January–9 April 1995

University Research Library, Department of Special Collections, University of
California, Los Angeles
24 April–28 July 1995

The exhibition and catalogue are funded by a grant from the Lila Wallace-Reader's
Digest Fund. Additional support for the catalogue has been provided by the Samuel
H. Kress Foundation.

Distributed by University of Washington Press
P.O. Box 50096
Seattle, Washington 98145

Library of Congress Cataloging-in-Publication Data

Fletcher, H. George.
 In praise of Aldus Manutius : a quincentenary exhibition : catalogue of the
exhibition / prepared and with an introduction by H. George Fletcher.
 p. cm.
 "An American Homage to mark the five-hundredth anniversary of the first
publication of the Aldine Press." Includes bibliographical references.
 ISBN 0-87598-109-7
 ISBN 0-295-97465-6
 1. Manuzio, Aldo, 1449 or 50–1515—Exhibitions. 2. Manuzio family—His-
tory—Exhibitions. 3. Printing—Italy—Venice—History—Exhibitions. I.
Manuzio, Aldo, 1449 or 50–1515. II. Title.

Z232.M3F55 1995 94-48697
686.2'0945'31—dc20 CIP

The map and the Aldine Family Tree, which has been revised, are reprinted by
permission of the author, H. G. Fletcher, *New Aldine Studies* (San Francisco,
1988), copyright © 1988 by H. G. Fletcher III.

Photographic credits: fig. 3, left, J. Rigbie Turner; figs. 26, 33, 34, and 35, Depart-
ment of Special Collections, UCLA Research Library; all other photography,
David A. Loggie.

Front cover: Aldus's map of Gaul, colored by stencil, in the 1513 Caesar (PML 1192).

Back cover: Florentine (?) entablature binding on a copy of the 1519 Statius
(PML 1610).

CONTENTS

In Memoriam
Franklin David Murphy, M.D.
29 January 1916–16 June 1994

FOREWORD

This catalogue accompanies an exhibition marking the five-hundredth anniversary of Aldus Manutius's first book. The Pierpont Morgan Library has joined with the Department of Special Collections at the Research Library of the University of California, Los Angeles to mount this show on both coasts of the United States as a quincentenary homage to Aldus and the Aldine Press. David Zeidberg, in his preface, explains the origins and development of the collection in his charge. I would like to say a few words about the Aldines here at Murray Hill.

Many of our Aldine Press books come from an original foundation collection of this Library, which has evolved from Pierpont Morgan's private library of a century ago into the public institution of today. The Aldines derive in largest part from a single, en bloc purchase by Mr. Morgan of a famous nineteenth-century collection, itself incorporating the best components of several famous collections. The immediate provenance string is cited locally as Gosford–Toovey–PML; each copy typically contains the leather book labels of Gosford (a cockerel with the motto VIGILANTIBUS), Toovey (his monogram or the composite monogram/Burnham Abbey label), and Pierpont Morgan (his heraldic charges).

In 1899, J. Pierpont Morgan (1837–1913) purchased the select private library of James Toovey (1814–93), London bookseller and collector, from his son and heir, Charles J. Toovey. (The collection as a whole at some time acquired the sobriquet of a "library of leather and literature," a phrase that has come to be canonized at the Morgan Library while defying any proof of its origins.) It comprised choice pieces that the elder and younger Tooveys had withheld from earlier dispersals of the father's books. The father had begun collecting around 1873. He issued an Aldine sales catalogue in 1880 and anonymously sold a large French collection at auction in Paris in 1882; the son sold his father's other books at auction on at least three dates in 1894.

The largest single group among the Toovey books was the Aldines, many of them in fine contemporary bindings. Shortly after their acquisition, they were all described summarily in the *Catalogue of a Collection of Books formed by James Toovey principally from the library of the Earl of Gosford the property of J. Pierpont Morgan* (New York: privately printed, 1901). The catalogue is of historic, rather than bibliographic, importance. It lists the entire Toovey col-

lection in short-title fashion, and the Aldines, arranged alphabetically by author, take up the first sixty-seven pages of this large quarto; many of the bindings are reproduced by chromolithography. Toovey had purchased most of his Aldines from the fourth earl of Gosford (1841–1922) by private treaty in 1878; many of the books carry the signatures Acheson and Gosford, which reflect the same family.

Archibald Acheson, third earl of Gosford (1806–64), assembled his Aldines at Gosford Castle, Ireland, in the 1820s, '30s, and '40s, mainly through the London firm of Payne & Foss; he bequeathed the library to his namesake son, the fourth earl. Lord Gosford had sought out distinguished copies, and many of his Aldines had been the property of such bibliophiles as Grolier, Mahieu, Lauweryn, Grimaldi, de Thou, Wodhull, Butler, Heber, Sykes, Grafton, and frequently Antoine-Augustin Renouard (1765–1853), the Aldine bibliographer. The Gosford-Toovey Aldine collection, which Toovey enhanced selectively, thus manifests a strong English tradition, with important French and Italian antecedents.

Since 1913, when J. P. Morgan, Jr. (1867–1943) inherited the library, to this day, the initial Morgan Aldine collection has been augmented in deliberate ways through carefully selective purchases or gifts to fill perceived gaps. We continue to seek not completeness but important representative copies that tell the story of significant events in the history of the Aldine Press over the century of its existence, with a focus on its earliest era. A census of our Aldine holdings is included in this catalogue as something of an accounting of our stewardship.

We have drawn on this wonderful collection, which in itself represents a significant moment in American bibliophilia, for our part in this American homage to Aldus. The exhibition and catalogue have been prepared by H. George Fletcher, the Astor Curator of Printed Books and Bindings, for whom Aldus is a particular interest.

We are indebted to our colleagues in Los Angeles, especially David S. Zeidberg, James Davis, and their associates, for their enthusiastic support and cooperation in making this exhibition a reality, and to their guiding spirit, the late Franklin D. Murphy, for all he has done in support of Aldine scholarship.

Charles E. Pierce, Jr.
Director, The Pierpont Morgan Library

PREFACE

Three years ago, George Fletcher and I had almost simultaneous thoughts about exhibitions to mark the quincentenary of Aldo Manuzio's first book. In a telephone conversation, we shared our ideas and asked each other if we could borrow materials from our respective Aldine collections. We were each reluctant to part with unique items, wanting to hold these for our own exhibitions. But then we hit upon the idea of a joint exhibition, first in New York and then in Los Angeles, which would be more informative than either of us could have mounted separately and would give us the best of both collections. The books and manuscripts in the resulting exhibition have been acquired by The Pierpont Morgan Library and the UCLA Library by distinctly diverse paths of collection development, but the end result is an American homage to Aldo.

Among the world's major Aldine collections, the Ahmanson-Murphy Aldine Collection at UCLA is relatively "new." It has been developed over the past thirty-four years through the collaboration of a principal benefactor, the Ahmanson Foundation; several librarians; and the vision of one man, Franklin D. Murphy. In 1961, my predecessor Wilbur Jordan Smith brought to Dr. Murphy's attention the availability of forty-five Aldine imprints from the collection of Templeton Crocker, which was being offered by the San Francisco bookseller Warren Howell. Dr. Murphy had recently assumed the position of chancellor at UCLA, and the development of the University Library's research resources was at the center of his plan to bring UCLA into the forefront among academic research institutions. Dr. Murphy reflected upon his vision thirty years later in the first Robert Nikirk Annual Lecture at The Grolier Club:

> I wanted to strengthen the resources to support scholarship at UCLA and in southern California. After all, the library is the laboratory for humanistic studies and with the incomparable resources at the Huntington and Clark libraries and with the extraordinary growth of the library at the Getty Center, we are putting together a major center for study and research in the humanities in the Los Angeles area. ["A Journey from Campo San Paternian in Venice to Westwood in Los Angeles . . .," *Gazette of The Grolier Club*, N.S. 43 (1991), p. 22.]

The emphasis was, and continues to be, on developing a "center for study and research in the humanities. . . . " Dr. Murphy knew that resources attract scholars, so while the Library developed the collection at UCLA, academic departments and research centers at the University, such as the Center for Medieval and Renaissance Studies, developed the curriculum, awarded visiting scholarships and fellowships, and eventually chaired faculty positions under Dr. Murphy's guiding hand. Today, Carlo Pedretti holds the Armand Hammer Chair in Leonardo Studies, and Carlo Ginzburg holds the Franklin D. Murphy Chair in History.

On the Library front, the journey, to use Dr. Murphy's metaphor, has been an extraordinary one. Since the 1961 purchase, the Ahmanson-Murphy Aldine Collection has grown to more than one thousand books and related manuscripts from the 1480s (the work of Aldo's father-in-law, Andrea Torresano, published before Aldo's marriage to his daughter) to 1597. Numerically, the collection consists of 114 titles of Aldo's publications of the 139 listed by Renouard, plus 23 "duplicate" copies. There are 133 copies by Aldo's heirs, between 1515 and 1529; 494 copies published by Paolo Manutio between 1533 and 1574; 142 copies by Aldo the Younger, between 1575 and 1597; 51 copies by the Torresani branch of the family, between 1480 and 1599; and 46 "Contrefactions," from about 1502 to 1587. Seven titles fall under Renouard's category of *alia*. The collection also includes more than a dozen titles not recorded by him in the 1834 third edition of his *Annales de l'imprimerie des Alde*.

As Charles Pierce and George Fletcher note elsewhere in this catalogue, our aim is to show as many Aldine items with unique features as possible. Some highlights of the selections from the UCLA collection include Aldo's Greek Psalter of ca. 1498 with a manuscript line of text in a contemporary hand added on leaf ιιr (*A Catalogue of the Ahmanson-Murphy Aldine Collection at UCLA*, no. 19; hereafter cited as CAMAC). Our copy of the 1499 Dioscorides belonged to Scipione Forteguerri ("Carteromachus") and contains his annotations [CAMAC, no. 26]. The 1499 *Hypnerotomachia Poliphili* was John Ruskin's copy [CAMAC, no. 28 (shown at UCLA)]. Manuscript notes in the 1514 commentaries on Aristotle by Alexander of Aphrodisias are in a hand closely resembling Aldo's [CAMAC, no. 100].

UCLA holds not only both recorded variants of the 1514 Virgil but also a unique third variant on blue paper [CAMAC, no. 110]. The 1515 Dante is annotated by Pietro Vettori [CAMAC, no. 118], and our 1534 Themistius was also part of his library [CAMAC, no. 234]. Our first folio edition of the 1564 Council of Trent *Canones* is annotated by Angelo Massarello, bishop of Telesio, and also possibly by Paolo Manutio [CAMAC, no. 529b]. Several works illustrate important bindings in the collection: viz., the "alla Greca" binding on the 1518 Artemidorus; the Grolier binding on the 1521 Polybius; and the Royal Binder of Henri II on the 1555 Cicero [CAMAC, nos. 148, 172a, and 415

(exhibited at UCLA; comparable bindings shown in New York are different Aldine titles from The Pierpont Morgan Library)].

Among materials associated with the Ahmanson-Murphy Aldine Collection are four items appearing in this exhibition. The denarius coin from the reign of Vespasian, A.D. 69–79, depicts the dolphin-and-anchor device that Aldo adopted as his printer's mark. Albertinus de Lissona of Vercelli's 1502 Venetian edition of Pomponius Mela's *De situ orbis* contains seventeen pages with annotations in a hand closely resembling Aldo's [CAMAC, no. 796]. A manuscript of Archimedes, translated by Federico Commandino and partly in his own hand, also contains Paolo Manutio's notes for casting off the type for his 1558 edition [CAMAC, no. 797]. The manuscript contract between Paolo Manutio and the Vatican, 1 May 1561, gives Paolo exclusive and unprecedented rights to print Church publications [CAMAC, no. 798].

My reference to the *Catalogue of the Ahmanson-Murphy Aldine Collection at UCLA* demonstrates another aspect of the Aldine program at UCLA. In 1987, we embarked upon a publications program principally relating to the Aldine collection, with the main effort devoted to publishing a catalogue of our holdings. The first edition of the catalogue was completed in five fascicles (in six volumes) in the spring of 1994. A revised second edition is under way. The publications program has also issued a series of occasional papers related to the Aldine collection and to our collateral collection of early Italian printing (1465–1600), including *Cartolai, Illuminators, and Printers in Fifteenth-Century Italy. . . by* M. A. and R. H. Rouse (1988); *Aldus Manutius: Mercantile Empire of the Intellect* by Nicolas Barker (1989); and two works by Martin Lowry—*Book Prices in Renaissance Venice: The Stockbook of Bernardo Giunti* (1991) and *Facing the Responsibility of Paulus Manutius* (in press). The programs of our academic departments and centers, their publications, and those of the Library reflect the academic setting in which the UCLA collection has developed. As Dr. Murphy noted in his Nikirk lecture, the development of the Ahmanson-Murphy Aldine Collection "has been for me a great experience in continuing education. And, in the end, I suppose my greatest satisfaction comes from the fact that the collection is being used" (op. cit., p. 22).

To begin the quincentenary celebration of Aldo's first book, Harvard University's Villa I Tatti organized a conference entitled "Aldus Manutius and Renaissance Culture: International Conference in Honor of Dr. Franklin Murphy," held in Venice and Florence, 14–17 June 1994. George Fletcher, Nicolas Barker, Martin Lowry, and I, as well as many other international Aldine scholars and librarians, were participants. Originally, Dr. Murphy was to give the final address, but by the spring of 1994 he was too ill to travel, and he died in Los Angeles on 16 June while we were convened at I Tatti.

The foregoing summary of Aldine collecting and related scholarly activity at UCLA can provide only the most superficial view of Franklin

Murphy's vision brought to reality. Our work at the UCLA Library is one of scores of endeavors he initiated for Los Angeles's cultural and intellectual community, every one of them touched with excellence. To appreciate him, look at the books.

David S. Zeidberg, Head
Department of Special Collections
University Research Library
University of California, Los Angeles

INTRODUCTION

> The sixteenth century in its typography clearly reflects the spirit of the
> Renaissance, especially in Italy and France. In the former country, the
> great figure of Aldus Manutius at Venice opens the century with his
> stream of first editions of the . . . classics. His roman, greek, and newly
> introduced italic types . . . were of pure Renaissance inspiration and
> design. The Aldine style was to dominate the typography of Europe
> for upwards of two centuries.
>
> *Printing and the Mind of Man* (1st ed.), p. 21.

The rebirth of learning in the West at the end of the Middle Ages operated
within a distinctly limited sphere for many of its early decades. The need and
the desire for the works of antiquity were there; the means for their wide
dissemination were not. One technological advance only exacerbated the sit-
uation. The achievement of Western papermakers in finding a reliable and
less costly substitute for vellum—animal skins prepared as writing surfaces for
documents and books—heightened the frustration. Now the underlying
materials to produce books were in abundance, but the scribes, professional
or amateur, could function only at their wonted pace.

By about 1455, Gutenberg's galvanic invention of printing from mov-
able type produced the enabling change. In perfecting a practical means to
reproduce books mechanically—"writing with type" remained a standard
descriptive phrase for years—he caused the Renaissance to change Europe,
and thus the West, forever. When printing moved south of the Alps, by about
1465, it met and joined forces with humanism in Italy. Supply and demand
came together to spread Renaissance ideals. Italy rapidly came to the fore-
front in printing, and Venice, the great commercial center linking East and
West, North and South, dominated the craft in Italy, starting in 1469. Aldus
Manutius moved to Venice to join this campaign a quarter century later, issu-
ing books just thirty years after the beginnings of printing in Italy.

Aldus represents in a real sense the first great advance over Guten-
berg's invention—the humanist scholar-printer, working in a predominantly
secular intellectual milieu, issuing a myriad of books for learning and books
for pleasure in active demand from an eager readership. Moreover, he pro-
duced these works in formats that permitted their use outside the constraints
of institutional quarters.

ALDUS AND HIS SUCCESSORS

The Manutius or Manuzio Family

ALDUS MANUTIUS (CA. 1452–1515)

Aldus Manutius was born in Bassiano, an insignificant Latian hill town some sixty-five kilometers southeast of Rome, in about 1452 and remained a Roman citizen throughout his life. Although his forebears seem to have been resident at Bassiano in the Monti Lepini since the fourteenth century, his origins are completely obscure. Aldus was a student of Domizio Calderini and Gaspare da Verona at Rome and then of Battista Guarino at Ferrara. In about 1483, after he had come under the influence of Pico della Mirandola, he began tutoring Pico's nephews, the Pio di Savoia princes of Carpi, Alberto and Leonello. The vernacular form of Aldus's name was apparently Aldo Manuzio, but he worked almost exclusively in the learned tongues, Latin and Greek, and was universally known by the Latin form, Aldus Manutius.

Aldus indicated in his writings that he moved to Venice in the summer of 1490 to undertake a new career. He set himself the task of making available the works of classical Greece not yet published in their original language—a heroic enterprise. He chose Venice because it was the great commercial center and home to the greatest concentration of printers the world had yet known, and the sole efficient way to disseminate knowledge, of course, was through the new art of printing. Additionally, Venice was the home-in-exile of Greek émigré scholars—both the Byzantines driven from Constantinople by the Turks and the free Greeks from Crete. By mid-decade, when Aldus began to issue books, he was in his early forties, a private teacher or tutor by profession and a Roman who was granted denization by the Venetian Republic.

The productive working years of Aldus's publishing career in Venice, those that saw the issuing of the numerous famous books inseparable from his name, can be proved from the books themselves and from the few documents for three inclusive periods: February 1494/5–December 1505, October 1507–May 1509, and October 1512–January 1515. It is most likely that these spans can be expanded slightly and still embrace active periods of editorial work.

Between the summer of 1490 and the spring of 1495, his time was doubtless taken up with preparations. He came into Andrea Torresani's orbit no later than 1493, when Torresani published the first edition of Aldus's Latin grammar, and thus came to know an experienced member of the Venetian publishing world. He was also involved in working up, if not yet perfecting, the tremendously (and probably excessively) complicated system of greek typefounding that he invented.

He seems to have taken no real break for the first ten years of his work and to have maintained the first location of the Press, at Sant'Agostino

(San Stin, in Venetian), for two consecutive five-year lease terms, from about February 1496 until December 1505. He married Maria Torresani, Andrea's daughter, who was at least thirty years his junior, in about February 1505; they were married for ten years and had five offspring, four of whom survived to maturity.

He gave up the lease on the house at San Stin, and he and his wife left Venice during Christmas 1505; we have no indication that Aldus intended to resume publishing. We do know that he was back in Venice as early as January 1506, living in his father-in-law's house at San Paternian, which would later become the second location of the Press, but his intentions appear to have been directed toward scholarly pursuits, perhaps with an eye to subsequent editorial work. He would be away from Venice and active publishing on occasion over the next year and a half, between March 1506 and September 1507. While on one of his hunting expeditions for reliable textual manuscripts, he was even imprisoned briefly, through mistaken identity by overzealous border guards, in July 1506.

Erasmus, staying with mutual friends in Bologna, proved the instrument that brought Aldus back to publishing in the autumn of 1507, and, after a slightly fitful start, Aldus worked fairly steadily until the spring of 1509, when the War of the League of Cambrai drove him, a resident but now suddenly an enemy alien, from Venice. He would not return until 1512, when he took up the printer's profession for the third and last time. For a while, it seemed as though he would give it up forever. But enough of his friends appear to have swayed him at last to change his resolve. We believe that when his last child, Paulus, was born in Venice in June 1512, Aldus was present. Certainly by that autumn Aldus resumed publishing; he was now about sixty years of age.

Aldus's final working stretch was intense and extremely productive; indeed, it proved a killing pace for him. He worked until the end, despite failing health, and died in his father-in-law's house on 6 February 1515, in about his sixty-third year. He was buried provisionally in Venice, within the neighboring church of San Paternian, which may have become his grave, but his final resting place is unknown.

Aldus was clearly a man of strong character, concentration of purpose, and an achiever. His temperament was varied. Occasionally he was a creative visionary, forging ahead regardless of persons and things in his way. He was the author of stringent scholarly writings; he composed novel Latin and Greek grammars that sought to be accessible to, rather than ordeals for, their users; and he assembled pious and unchallenging religious works. He worked incessantly at publishing and took two lengthy and intended final breaks from printing to return to the scholar's craft. He remained a scholar while spending long days amid the racket of the printing floor, producing an

I. ALDINE FAMILY TREE

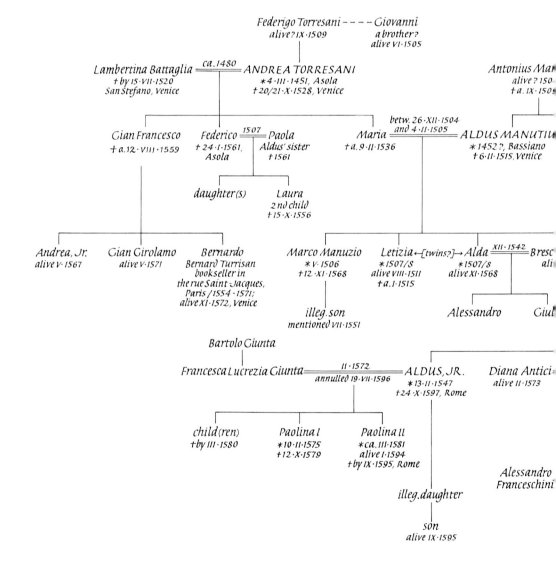

Federigo Torresani – – – – Giovanni
alive? IX·1509 a brother?
 alive VI·1505

Lambertina Battaglia ══ca.1480══ ANDREA TORRESANI Antonius Ma[...]
† by 15·VII·1520 *4·III·1451, Asola alive? 150[...]
San Stefano, Venice †20/21·X·1528, Venice †a. IX·1509

 betw. 26·XII·1504
 and 4·II·1505
Gian Francesco Federico ══1507══ Paola Maria ══════════ ALDUS MANUTIU[...]
†a.12·VIII·1559 †24·I·1561, Aldus' sister †a.9·II·1536 *1452?, Bassiano
 Asola †1561 †6·II·1515, Venice

 daughter(s) Laura
 2nd child
 †15·X·1556

Andrea, Jr. Gian Girolamo Bernardo Marco Manuzio Letizia←[twins?]→Alda ══XII·1542══ Bresc[...]
alive V·1567 alive V·1571 Bernard Turrisan *V·1506 *1507/8 *1507/8 ali[...]
 bookseller in †12·XI·1568 alive VIII·1511 alive XI·1568
 the rue Saint-Jacques, †a.I·1515
 Paris /1554 ·1571;
 alive XI·1572, Venice
 illeg. son Alessandro Giul[...]
 mentioned VII·1551

 Bartolo Giunta
 Francesca Lucrezia Giunta══II·1572══ ALDUS, JR. Diana Antici[...]
 annulled 19·VII·1596 *13·II·1547 alive II·1573
 †24·X·1597, Rome

 child(ren) Paolina I Paolina II
 †by III·1580 *10·II·1575 *ca.III·1581 Alessandro
 †12·X·1579 alive I·1594 Franceschini
 †by IX·1595, Rome

 illeg. daughter

 son
 alive IX·1595

4

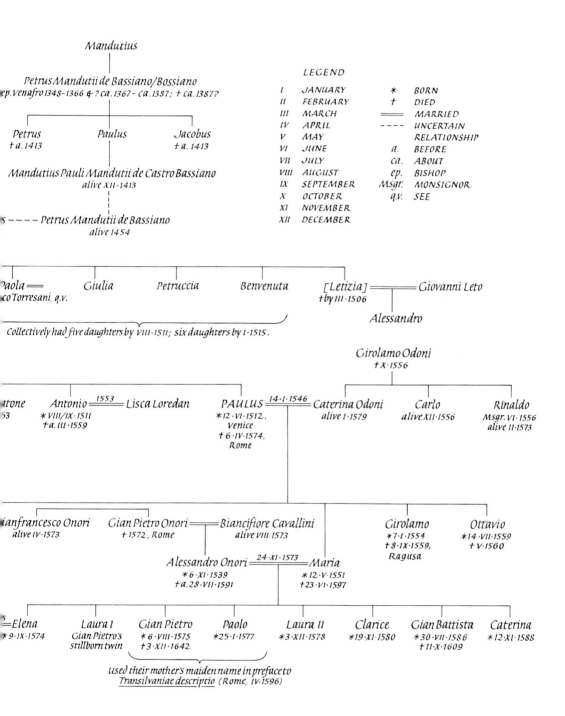

Mandutius

Petrus Mandutii de Bassiano/Bossiano
ep.Venafro 1348-1366 & ? ca.1367- ca.1387; † ca.1387?

Petrus
† a.1413

Paulus

Jacobus
† a.1413

Mandutius Pauli Mandutii de Castro Bassiano
alive XII·1413

s – – – – Petrus Mandutii de Bassiano
alive 1454

Paola ═══
co Torresani, q.v.

Giulia

Petruccia

Benvenuta

[Letizia] ═══════ Giovanni Leto
† by III·1506

Alessandro

Collectively had five daughters by VIII·1511; six daughters by I·1515.

Girolamo Odoni
† X·1556

tone
53

Antonio ══1553══ Lisca Loredan
*VIII/IX·1511
†a.III·1559

PAULUS ══14·I·1546══ Caterina Odoni
*12·VI·1512, alive I·1579
Venice
†6·IV·1574,
Rome

Carlo
alive XII·1556

Rinaldo
Msgr. VI·1556
alive II·1573

ianfrancesco Onori
alive IV·1573

Gian Pietro Onori ══════ Biancifiore Cavallini
† 1572, Rome alive VIII·1573

Girolamo
*7·I·1554
†8·IX·1559,
Ragusa

Ottavio
*14·VII·1559
†V·1560

Alessandro Onori ══24·XI·1573══ Maria
*6·XI·1539 *12·V·1551
†a.28·VII·1591 †23·VI·1597

s
═Elena
*9·IX·1574

Laura I
Gian Pietro's
stillborn twin

Gian Pietro
*6·VIII·1575
†3·XII·1642

Paolo
*25·I·1577

Laura II
*3·XII·1578

Clarice
*19·XI·1580

Gian Battista
*30·VII·1586
†11·X·1609

Caterina
*12·XI·1588

used their mother's maiden name in preface to
Transilvaniae descriptio (Rome, IV·1596)

5

enormous body of work. Erasmus, the detached and ideal wandering scholar, watched him with awe for the first eight or nine months of 1508 and seems to have become exhausted by the sight. The twin theme of the demands of the printers and the need to keep the presses fully occupied, regardless of the editor's time and inclinations, recurs. In Italy this began with Sweynheym and Pannartz's house editor, Giovanni Andrea Bussi, and it became somewhat commonplace with Aldus and those in his circle.

Clearly the ideas man behind the publishing enterprise, Aldus was not a professional printer in the sense that he actually stood at the press and pulled the lever, and I doubt that he ever viewed himself as one. But he became especially involved over the years in the technology of typefounding, and he was heavily engaged in daily operations, working in proximity to the noisy pressroom. He *was* a printing professional, earning his living solely through working in a printing establishment—one, moreover, that was known under his name, even though he was not a major owner. In our terminology, we would think of him properly as a combination editor, proofreader, and publisher.

Aldus would publish a remarkable body of work in Greek within a score of years, 1495–1515, a period also marked by intermittent interruptions totaling about four years. He produced some thirty-one *editiones principes* in thirty-eight volumes, the most notable including Aristotle, Aristophanes, Thucydides, Sophocles, Euripides, Demosthenes, Plutarch, Pindar, and Plato. His Latin production, which was diversified and as expected much more extensive, included many standard editions, but only one *editio princeps*, that of the ancient Christian poets in three volumes, and the Greek part of Nonnus, which was probably to have formed part of a fourth volume with an unrealized Latin version. The editions of Virgil, Horace, Lucretius, Pliny's letters, Ovid, Caesar, and Catullus are notable in a variety of ways. His work in the vernacular may be limited for all practical purposes to Dante and Petrarch, but, it should be added, these were produced in a novel small format.

He began an extremely ambitious program to provide texts of Greek antiquity, many issued for the first time in type, and several works of grammar and reference as preparatory aids. The enormous Aristotle, five royal folios in six volumes—the major instance of Greek publishing in the fifteenth century—alone would suffice to establish Aldus's reputation. He brought about, in the new century, a revolution in publishing with his "portable library" of the classics in a handy format.

At Sant'Agostino, he created an academy by assembling a group of friends and acquaintances to produce learned Greek editions. He issued a number of great books from this academy, although its existence as a physical entity has been strongly questioned, and it indeed may have existed mainly in

his own mind. We need only note the humanistic priorities and goals that the *idea* of the Aldine Academy represents: re-creating in Venice the methods and purposes of the Stoa, using the learned tongues but especially Greek for all discussions, preparing and publishing editions of the classical Greek authors.

Aldus the humanist scholar-printer also published his own work. There were the learned treatises appended to books by others—for example, his study of Horatian metrics, his long introduction to his 1509 second edition of Horace, is an outstanding example and a major contribution on its own. He was well known for his own Latin grammar and produced four editions in twenty-one years. The first was the one printed in 1493 by his future business partner, Andrea Torresani. The Aldine Press issued editions in 1501, 1508, and 1514 and would continue to reissue them after Aldus died, until practically the end of the century. He left his Greek grammar unfinished on his death and left orders for the destruction of the manuscript. But his principal Greek editor, Marcus Musurus (ca. 1470–1517), completed it as a homage to his late friend and published it, dedicating it to Jean Grolier (1478 [or 1486?]–1565), in the autumn following Aldus's demise.

In the last quarter century of his life—his publishing years in Venice—Aldus printed a vast number of the Greek and Latin classics, with an admixture of ancillary works in the form of grammars and dictionaries, and his own books and treatises, while often enhancing the books he published with his own teaching aids. He issued these books in typefaces that appealed to, indeed in part derived from, the humanists; he made literature accessible.

Though the location of Aldus's grave has been lost to knowledge for centuries, and even the church in which he was first buried vanished a century and a quarter ago, his monument is worldwide and probably immortal so long as the human intellect endures.

THE SONS OF ALDUS

From the time the younger Manuzio generation took over the control of the Press at the end of the 1530s until well into the 1550s, the generic imprint was The Sons of Aldus. This signified publicly that Aldus's three sons were allied in keeping the firm alive and indicated technically that the Torresani relatives were not directly involved in the House of Aldus. But it was essentially a pious fiction within the Manutius family itself. Paulus complained periodically in his personal letters that he did all the work, while his brothers' activities were limited to sharing the income from his labors. His brother Antonio, about a year his elder, was involved with one book at Venice and published a few books on his own in the second half of the 1550s at Bologna, where many other members of the family lived. It has been suggested that Paulus in fact printed for him, but Paulus has indicated

that this was not the case. Antonio's activity was, at any rate, relatively minor in the overall history of the firm.

Paulus Manutius (1512–74)

Aldus's fifth child was born on 12 June 1512, and was not yet three years old when his father died. He favored Paolo Manutio as the vernacular form of his name and became his father's sole practical successor. Aldus's friends and colleagues looked upon Paulus as a promising youth. He fulfilled their expectations to the extent that he became head of the Press, led it for decades, and earned a reputation as a scholar, specializing in Cicero, whose works he edited and glossed for many years. Cicero dominates the Aldine imprints during Paulus's tenure as head of the firm.

He began work within the Aldine Press in early 1533, issuing his first book three months short of his twenty-first birthday. He worked with his Torresani uncles until falling out with them over the ownership and use of the famous italic type, of which his father had been, in his words, the author and inventor. After a lull marked by a successful, if protracted, lawsuit and a long stay at Rome, he took up the Press for himself and his brothers in 1539 and remained its functioning or nominal head until his death thirty-five years later. Paulus was the contract printer to the short-lived Accademia Veneziana for its few years of existence. He lived and worked in Rome during the 1560s, running both an independent printing operation and the establishment In Aedibus Populi Romani, a publishing venture founded by the Vatican and consigned to the Commune of Rome to print a variety of books supporting the work of the Council of Trent and combating Protestant scholarship in both secular and theological disciplines. Paulus entered into this task enthusiastically, seeing it as the fulfillment of family dreams going back to his father's day, but he found himself caught up in factional disputes, and the whole venture ended badly; he was relieved to return to Venice in 1570. He was made an imperial knight, which he described as an empty honor because no pension came with the title. The Roman publishing enterprise effectively marked the end of his working career, and he returned to Rome, in failing health, to end his days in quiet. He died there on 6 June 1574, less than a week before his sixty-second birthday, and was buried in Santa Maria sopra Minerva.

It was symbolic of the times that Paulus also cooperated with two publisher-printers outside Italy. Their presses sequentially claimed the lead in the history of printing. The first was Henri II Estienne (1531–98), with whom he struck up a friendship when the French scholar-printer visited Venice and some of whose work he printed in the 1550s. The second was Christophe Plantin, the French émigré printer in Antwerp, with whom he cooperated on several occasions during the 1560s, from Rome. Paulus

licensed reprints by Plantin for his market in the Low Countries and in Spain for some of the service books that Paulus was issuing for the Church. Plantin, skilled in two-color liturgical printing, would in fact make a much better job of it; the Aldine Press was never known for black-and-red liturgical printing, and the successive generations of the firm had virtually no experience in such production.

ALDUS MANUTIUS THE YOUNGER (1547–97)

Paulus's son showed some early promise as a scholar in his grandfather's and father's mode and even began to study law at one point. He spelled his name in a bewildering variety of ways and may have settled on Aldo Mannuccio as his favored vernacular guise. He was the author of several precocious grammatical treatises and enjoyed a reputation as a grammarian throughout his life. But his talents were ultimately modest, and he seems to have been a reluctant leader of the corporation. During the decade of his father's work in Rome, Aldus Jr. was involved, in an unclear capacity, in the Press at home in Venice, and he succeeded to the principal's place during the last couple of years of his father's life. But his father had contracted with Domenico Basa, who began his career as a printer at Venice ca. 1535, to operate the Press for five years from June 1568, and Basa seems to have been something like the foreman of the operations at Rome during the Press's final years. Aldus Jr. married Francesca Lucrezia of the Giunti printing dynasty in 1572 and lived for some years in her family's Venetian home. The union, however, generated only limited Aldine-Giuntine cooperation, and the marriage itself did not last, being annulled in 1596, fifteen months before his death. His varied career included the position of Secretary to the Signoria in 1577–79. He occasionally issued a book at Bologna, where he had many relatives and where he spent much time. One of his own writings, printed under undetermined circumstances at Lucca, shows that he was there in October 1587. His final years were spent in Rome, where he resided in the Vatican and was in charge of the burgeoning Vatican Press. His last major works, a series of editions of the Bible, at least saw his grandfather's press approach the grand scale on which it had begun just about a century previously.

On balance, it is unfortunately rather easy to perceive a steady diminution of scholarly and personal attainments, from Aldus through his immediate offspring to his namesake grandson. Whatever the continuing force of the reputation deriving from his grandfather, the forefront of publishing had long since moved away from Italy.

The Torresani Family

In the golden years, the Manuzio and Torresani families were linked both professionally and through marriage. Andrea took Aldus on as a junior

partner in 1494 or 1495. When Maria Torresani married Aldus, Andrea was presented with five grandchildren in something over seven years. His son Federico married Aldus's sister Paola in 1507, and at least one of their offspring survived into adulthood. Andrea's three grandsons through his elder son, Gian Francesco, all became involved, to varying degrees, in publishing. There seems to have been as much successful and unsuccessful interaction within the family as is the norm in any extended family, especially one linked by a substantial business. A serious rupture in the professional relationship occurred in the second half of the 1530s, with a final division of the material holdings of the printing corporation founded a half century earlier taking place on 6 May 1544. But the personal interrelationships continued, and some forms of professional publishing interplay resumed. There has been a tendency, by bibliophiles if not by scholars, to see all good in the Manuzio faction and all bad in the Torresani. This makes no allowance for the personal side, which remained demonstrably strong in certain areas, and gives insufficient credit to the many accomplishments of the Torresani family.

Andrea Torresani (1451–1528)

Of the several members of the Torresani family, originating from Asola in Venetian-controlled Lombardy, who played crucial roles in the history of the Aldine Press, none exceeded in importance the founder of the printing family, Andrea. He claimed that he became active in Venetian publishing in 1474, and he continued to publish independently, at least sporadically, for about half a century. The publishing venture that ensured his immortality began when Andrea became one of two general partners, with Pier Francesco Barbarigo, in founding a printing firm in 1495 that we call the Aldine Press. He and Barbarigo acquired half-interests each, and he was doubtless the technical manager; Aldus became his junior partner, purchasing twenty percent of his half-ownership. By this time, Andrea had at least fifteen and possibly twenty years' practical experience within Venetian publishing.

Andrea Torresani must have been a man of substantial business acumen, to judge by his attainments and longevity, his contacts, and the dynasty he founded. While his reputation is not flattering, it derives from a partisan piece by Erasmus, who, for all his scholarly attainments and reputation, was embroiled in a feud involving Andrea and his sons. There is evidence that Andrea invested much of his time in raising his young grandchildren left half-orphaned by Aldus's death.

Gian Francesco and Federico Torresani; Gian Francesco's Sons

From the mid-teens until 1529, Andrea's sons Gian Francesco and Federico were the principal operatives of the Aldine Press, though most of the work

fell perforce to Gian Francesco. Federico got himself in serious difficulties with the Venetian authorities over gambling debts, was heavily fined, and was banished from the republic in 1523 until 1527. Gian Francesco seems to have been the primary contact with Jean Grolier, who has a strong traditional connection with the Aldine Press and played a crucial international role in the middle decades of the century. (Certain important Aldine manuscripts now at Paris in the Bibliothèque Nationale found their way there via Grolier, having come to him as gifts from the Torresani.) The two brothers continued to publish sporadically for decades, employing a variety of printers, including Padovano and several members of the prolific Nicolini da Sabbio clan.

Gian Francesco's sons—Gian Girolamo, Bernardo, and Andrea the Younger—all became involved in the family enterprise to some degree, one of them most importantly. Andrea the Younger published with the imprint Andrea Torresani and Brothers in 1562, even employing the Aldine dolphin-and-anchor device.

More importantly, the Torresani seem to have retained the official "export" side of the Aldine Press, even during the years of contention with the Manutius relatives. The principal outlet was Paris, where Gian Francesco's son Bernardo was set up for many years and where Grolier was the local manager. The export imprint was the Bibliotheca Aldina, which resurfaced in Venice at the end of the '60s and beginning of the '70s as Ex Bibliotheca Aldina, used by Gian Girolamo and Bernardino (that is, Bernardo) Torresani, who billed themselves as Aldus's nephews in 1571. They also used the dolphin-and-anchor device as their shop sign, whereas the Manutius side appears to have adopted a profile portrait of Aldus to identify its publications and shop.

Paris and the Torresani

Jean Grolier's name became increasingly prominent within the Aldine enterprise from the time of Aldus's death. As a crucial figure to booksellers and a strong patron of bookbinders, Grolier must have been the most important link with Paris and the local markets in France after his Italian years ended, and the supervision of the Parisian business was entrusted to him. It is noteworthy that Jean Picard was the local representative of the Torresani export business in Paris from 1540. Picard has been identified as the "Entrelac Binder," prominent in the period 1540–43. He was a Parisian bookseller and binder, active in the trade until he left Paris suddenly, in the early autumn of 1547, to avoid his creditors.

The Aldine connection with Paris during the 1540s was exclusively an export enterprise—that is to say, selling copies of books printed in and shipped from Venice. Venetian Aldines, drawn apparently from older stock in inventory, were shipped to France for binding and local sale. In assessing the

1544 division of property between the Manuzio and Torresani relatives, I am tempted to conclude that the Torresani won the exclusive right to conduct the export business, including the sale of Aldines printed by Paulus. It is also possible that the inventory they claimed at the time may have been the source of the large number of 1530s Aldines that are found in Grolier "commercial" bindings, put on the books in Paris as sample wares. Whatever the facts, the next decade would see a personal Torresani presence in Paris.

Between 1554 and 1571, Bernardo Torresani, under the Gallicized form Bernard Turrisan, was the publisher at a shop in the rue Saint-Jacques at the sign of the dolphin and anchor. The device appeared on the books, and the imprint varied slightly in Latin, In Aldina Bibliotheca dominating, with the occasional variant, Sub Aldina Officina; the French form seems to have been uniformly à la Boutique d'Alde. The books were printed locally and reflected standard French typography, not reproducing the Italian fashion of the Venetian editions from which they often derived. Local privileges were sought and granted. Several local printers are known to have produced books for Bernardo, including Guillaume Morel, Maurice Menier, and Jean Dallier.

The use of the Aldine imprint and device reappeared in Paris throughout the 1580s and 1590s at two locations, under Robert Columbel, with printing carried out by at least Pierre Chevilot and Estienne Prevosteau, but the connections with Venice are unclear.

THE ALDINE PRESS: A THUMBNAIL SKETCH

The technical origins of what we call the Aldine Press began with the inception of printing in Venice and with its protean figure, the French émigré printer, Nicolas Jenson. (For that matter, if a traditional story is true—and it may be—identifying Jenson with a royal French mintmaster sent by his sovereign to investigate a marvelous new discovery reported in Mainz, our firm's roots ultimately go back to Gutenberg himself.)

Jenson began the first of his various printing corporations at Venice in 1470, but he may have cut the font used by the sole and short-lived predecessor firm, that of Johann from Speyer on the Rhine, in 1469. He quickly rose to the top of his profession, and his final firm outlived him. It was within the confines of this last firm that Andrea Torresani seems to have begun to expand his work. Jenson's posthumous firm of John of Cologne, Nicolas Jenson, and Associates may have been capitalized, at least in part, by Peter Ugelheimer, landlord of the Fondaco de'Tedeschi and factor of the German merchants at Venice, who long supported elements of the printing industry. (His widow, Margareta, as late as 1499, subvented Aldus's edition of the letters of St. Catherine of Siena.) Ugelheimer was Jenson's personal (as opposed to corporate) executor from 1480, and some of Jenson's printing

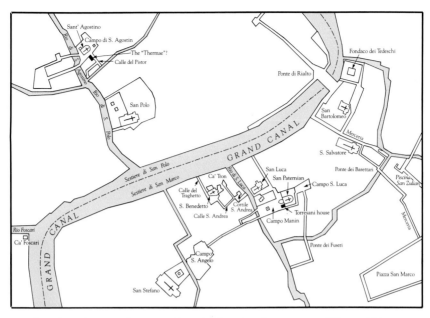

2. Fifteenth- and sixteenth-century Venetian locations important to Aldus and his successors.

materials came into Andrea's possession. Andrea claimed to have begun his Venetian career in about 1474.

The inspirational origins of the Press can be assigned to one determined visionary only, Aldus himself. Around the time of the publication of Aldus's Latin grammar in 1493, Aldus must have convinced Andrea Torresani of the soundness of his proposed venture because it was Torresani who found the necessary and necessarily large capital. Aldus's four or five years of preparations for issuing books finally bore fruit in 1495, when Torresani and Pier Francesco Barbarigo capitalized the new firm between them, the 134th to take up printing in Venice. Barbarigo, son of a late doge and nephew of the ruling one, provided at least half the capital; Torresani provided substantial capital and probably all the technical expertise. By this time, Andrea had weathered the storms of a score of years in the rough-and-tumble atmosphere of Venetian publishing, and he was clearly a survivor. The roles seem to have been venture capitalist for Barbarigo, technical expert for Torresani, and ideas man for Aldus, for whom the establishment was named. Torresani and Barbarigo were the two general partners; Aldus acquired a one-fifth share of Torresani's half. So it is all the more interesting to realize that what we call the Aldine Press is named for a limited partner with a decidedly minority interest in what was probably the lesser of the general-partnership blocs. Barbarigo's continuing activities within the firm, if any, are unknown, and he died in 1499.

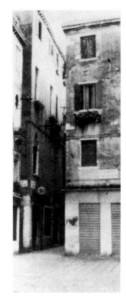

3. A recent photograph of the building at San Polo 2343, possibly the "Thermae," as Aldus's house—the first location of the Press—was called, indicated on the De'Barbari map of 1500.

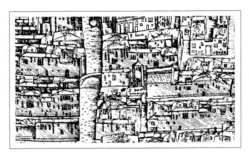

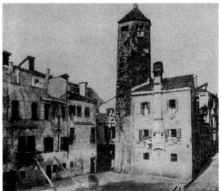

4. The second location of the Press: the Torresani house at San Paternian, photographed shortly before its 1871 demolition, indicated on the 1500 De'Barbari map.

1495–1529

The first "generation" of the Press's existence falls into two general spans, 1495–1515 and 1515–29, divided by Aldus's death, although not by any cessation of work, in February 1515. Allowing for the watershed of Aldus's passing, we see that the other participants are essentially the same, with the expected generational progression from age to youth and with the occasional participation of different editorial outsiders. The greatest change, beyond the personal, is in the dominance of emphases: the contrast between the *editiones principes* of the Greek authors for the first twenty years and the more mixed and predictable books of the concluding decade and a half. The first imprint of the firm was the equivalent of the House of Aldus.

1495–1515

The new firm launched an extremely ambitious program of Greek classical texts, many issued for the first time, and allied works of grammar and reference. With relatively few exceptions, the balance of the fifteenth century saw the issuance of stately Greek folios, which caused a great deal of financial worry, since they were extremely expensive to produce, were offered at very high prices, and did not sell as well as planned.

The new century heralded the arrival of the Renaissance in publishing with the issuance from April 1501 of Aldus's *libelli portatiles*: straight classical texts, in a convenient small format, set in novel typefaces that mimicked the standard Greek and Latin scripts of the humanists. Work progressed until the end of 1505, when Aldus gave up the house at San Stin and left Venice to search for manuscripts. Now about fifty-three years of age and newly married, he had completed a decade of uninterrupted work as a scholar-printer. More than a year and a half later, when Erasmus brought him back to printing, the Press resumed operations from the Torresani house at San Paternian. The same basic publishing program continued, and the Press underwent a name change to the House of Aldus and of Andrea of Asola, His Father-in-Law. Warfare in the spring of 1509 caused the end of most Venetian commercial enterprise for the duration, and the Aldine Press closed as an immediate consequence of the War of the League of Cambrai. Aldus's third venture into the profession began with his return to Venice by the summer of 1512 and lasted until his death. Work did not cease upon Aldus's demise, and the year 1515 as a whole was quite active.

The Press worked at two certain locations during Aldus's lifetime. The first was in a house that may still be standing. It was located on the square at Sant'Agostino, at the corner of the Calle del Pistor (fig. 3). If this was the structure at San Polo 2343, it still may be viewed, if not easily visited, in its much-cramped state, badly hemmed in by later construction. The second was the Torresani house, cheek-by-jowl with the ancient church of San Paternian

and the official home of the Press from November 1508 until many years after Aldus's death (fig. 4). Most of its neighborhood is unchanged and provides an excellent idea of what Aldus saw when he looked out at the canal, but the building and church have long since vanished.

1515–29

Productivity remained very strong for the next few years and reasonably healthy for more than a decade, when Andrea's sons Gian Francesco and Federico Torresani, perhaps in their thirties, undertook most of the executive responsibility for the Press. The period immediately following Aldus's death witnessed a growing connection with Jean Grolier, and several books that Aldus and Erasmus had jointly begun to edit a decade before, Seneca and Plautus among them, appeared at this time. The most significant achievement of these years was probably the gigantic edition of Galen, issued in five royal folio volumes in 1525 (an edition Aldus had first promised in February 1497).

The nominal head of the firm continued to be Andrea, but he apparently spent a good deal of his time with his young grandchildren, mostly at Asola. When Andrea died, aged seventy-seven, during the night of 20–21 October 1528 at Venice, a tradition of nearly forty-five years rapidly came to an end. One more book issued from the Press, dated 1529, before the business closed, with every sign of finality.

1533–36

This interim period began on a hopeful note on Paulus Manutius's part and ended in a protracted lawsuit, which seems to have led to a professional rupture between the Manuzio and Torresani sides of the Aldine family.

The firm had been quiescent for some three years, and it is not at all clear that the Torresani brothers, now middle-aged, had any interest in continuing as publishers, let alone as printers. The incentive may have come from their young nephew Paulus, who had been studying and living in Padua during the first years of the 1530s. What is clear is that the first book issued by the Heirs of Aldus and of Andrea of Asola, which appeared in March 1533, was Paulus's editorial work. But within two to three years, matters had disintegrated sufficiently between nephew and uncles for Paulus to seek a dissolution of their business ties. He initiated a lawsuit to gain sole control of his father's italic typeface, and the lawsuit dragged on into the end of the decade, finally being resolved in Paulus's favor at Rome. The Torresani brothers kept their business activities alive, but barely so, by engaging a few Venetian printers to complete projects undertaken at the Aldine Press up to 1536 and by issuing a very few titles with their own imprint.

The long stretch of nearly sixty years between 1539 and 1597 embraced several distinct phases of the Press's operations as well as substantial stretches of inactivity. The Torresani activities, which were quite vital on occasion, have already been treated within the biographical discussion.

The Manuzio side resuscitated the Aldine Press in 1539 with the imprint of The Sons of Aldus. There was an agreement among Aldus's three sons, but in fact the executive side was the sole responsibility of Paulus; Manutius, in Asola, had no hand in anything; and Antonius, who lived in Bologna, would publish only a small handful of books there in the later 1550s.

The final division of the various material holdings of the original printing corporation that took place on 6 May 1544 ceded four-fifths to the Torresani and one-fifth to the Manuzio relatives. Some of the professional relationship resumed with time. Federico Torresani, for example, financed the six-volume octavo Aristotle published by his Manuzio nephews during the years 1551–53 under the Sons of Aldus imprint. He also issued several books under his own imprint and with the Aldine dolphin-and-anchor device from the end of the 1540s to the early '50s. And Gian Francesco's sons, Andrea the Younger and his brothers, published under their own imprint in 1562, also using the dolphin-and-anchor device.

Paulus, the prominent Ciceronian scholar, worked steadily at the Press over the years, developed a strong network of influential supporters, and established strong ties with papal Rome. In the last years of the 1550s, he became the first contract printer to the visionary Accademia Veneziana or Accademia della Fama, which became an important source of work and income until its predictably early demise.

1561–70

A long campaign during the 1550s, with its origins in the 1530s, finally got Paulus the position he longed for in Rome; he spent from 1561 to 1570 there, under contract to the papacy and the Commune of Rome, printing a wide variety of books, both scholarly and theological, required by the Council of Trent. But he also spent too much time contending with the conflicting interests that controlled his activities and thus returned to Venice worn out and disillusioned. The conclusion of his Roman career effectively ended his publishing years as well.

1571–97

The last generation of the Press belonged to Aldus the Younger as the principal of the firm. Aldus Jr. is traditionally credited with producing much of the Venetian work issued during the 1560s while his father was working in

Rome, when he himself was between fourteen and twenty-three years of age. While it is unclear just how much executive authority he had, we know of no one else acting as manager of the Venetian enterprise for most of the 1560s. His father's letters reveal Paulus directing his son in the activities of the Press at Venice, and Aldus Jr., who apparently accompanied his father to Rome at first, had certainly returned to Venice not later than 1563. Further, Paulus engaged the Venetian printer Domenico Basa to operate the Aldine Press at Venice for five years, from June 1568.

At the end of the 1560s and beginning of the '70s, no fewer than five distinct imprints were employed by as many persons. There was In or Ex Aedibus Manutianis, which was possibly employed by Domenico Basa to begin with but was used by Aldus Jr. by 1571; Ex Bibliotheca Aldina, used by Gian Francesco's sons Gian Girolamo and Bernardo or Bernardino Torresani, who billed themselves as Aldus's nephews (which they were) in a colophon; In Aedibus Aldinis, by an undetermined practitioner; Aldus Manutius, Pauli Filius, Aldi Nepos, as well as Appresso Aldo Manutio, which was, obviously, Aldus Jr.

We find the younger Aldus's own imprints from 1569, when he began to issue books with a simple imprint that evolved into Aldus, Son of Paulus, Grandson of Aldus, by 1571. He also regularly used the imperial charge of arms as his new printer's device, later employing images of his grandfather and father and a large baroque version of the dolphin-and-anchor device.

Two famous, if by now no longer prominent, Italian printing dynasties, rivals much earlier in the century, became allied when the younger Aldus married Francesca Lucrezia Giunti in 1572. He printed a few books in Bologna in the 1580s. In his final years, he was in Rome, in charge of the developing Vatican Press.

Aldus Jr. employed a number of printers. Domenico Basa seems to have worked for him in both Venice and Rome. Aldine books were produced at Venice by Giovanni de Gara in Aldina Bibliotheca and by Giorgio Angelerio, at Bologna by Alessandro Benacci, and at Rome by Giacopo Ruffinelli for the Librai Compagni, as well as by Antonio and Francesco Zanetti.

Finally, two of his sister Maria's eight children, who suppressed their own family name of Onori for the occasion, listed themselves as Gian Pietro and Paolo Manucio when they published their study of Transsylvania at Rome in 1596.

It is ironic but true that, virtually from the moment of Aldus's death, the focal point of printing moved away from Venice and indeed from Italy. It migrated first to France, the dominant center during Paulus's day, which we can readily perceive by noting that Paulus imported his new typefonts from France at the end of the 1550s. Then it moved to the Low

Countries, which dominated during the younger Aldus's day. It would be fatuous to insist that the Aldine Press in its later generations can pretend to any real scholarly or bibliophilic significance in the history of printing. It is unfortunately rather easy to plot a steady decline in the Press's accomplishments over three generations.

THE HUMANIST SCHOLAR-PRINTER

A brief word is in order on this important concept, which has been mentioned in this introduction. Having written recently at some length on this topic ("The Ideal of the Humanist Scholar-Printer: Aldus in Venice," *Printing History* 30 [Vol. 15 No. 2, 1993], 3–12), I shall limit myself here to a summary description, which depicts the ideal of the humanist scholar-printer. One of Aldus's places on the intellectual map is as *the* great scholar-printer of the Renaissance; in my view, at least, he is the true original of the type. Prior to Aldus's day, only Johann Amerbach in Basel can contend for this role, but he confined himself to theological works, essentially patristics—the writings of the fathers of the Church—and thus can be eliminated from the category. After Aldus's day, with the focal point of printing shifting to France and then to the Low Countries, the successive candidates include Badius and the redoubtable Estienne dynasty. It is traditionally held that the category becomes extinct with the death of Christophe Plantin at Antwerp in 1589.

The humanist printer is by definition a Renaissance-era scholar, a professional who printed his own works or had some hand in the editorial content of the books that issued from his press, either as editor, commentator, or translator; moreover, he was thoroughly trained in the classical languages and printed classical and Biblical texts from manuscripts that he himself edited, emended, or translated into Latin from Greek, occasionally writing commentaries on them; finally, he is someone whose reputation in typography is as great today as is his renown in scholarship.

Humanistic scholarship addressed primarily the matter of restoring classical texts; this scholarship was further developed in restoring Scripture to its original form and languages, and, by extension, to patristics. This area would become a specialty in Basel, where it would be very important for Amerbach as well as for Froben and the Erasmian circle; its heyday would come after Aldus's death.

THE ALDINE COLLECTIONS AT PML AND UCLA

Messrs. Pierce and Zeidberg have already touched on some of the factors determining how these two collections have developed over time. Each collection reflects interesting differences in motivation and tastes while showing

the abiding importance of Aldus's achievement in the history of the printed book and the rise and fall of the appeal of Aldines through various generations of collectors. I might note here the classic forms of collecting at both institutions. Mr. Morgan purchased at one time the core of a deceased collector's library, itself assembled by acquiring the collection of a deceased nobleman who had purchased many of Renouard's own Aldines. The PML collection has since been added to selectively, and the requirements for condition and quality have remained unchanged. The UCLA collection is the result of a policy vigorously pursued to assemble the largest and most representative collection of Aldines that could be put together in only the last three decades. Primarily concerned with the interiors of the books—the texts—it rightly reflects the purposes of its custodian, a major research library at a major university.

THE EXHIBITION

There has been no lack of important and even landmark exhibitions in Europe and America to mark the quincentenary of the inception of the Aldine Press. Each one has rung interesting changes on uniform themes, and each one, to our knowledge, has confined itself predominantly, if not exclusively, to Aldus himself. We have sought to give a deliberately American note to our contribution by offering our assembly in the great metropolis on each coast, in two accessible and intellectually based institutions annually visited by many thousands of people from around the world. Moreover, we have sought to give a picture of what happened to the Aldine Press from its origins to its close, in its various guises and locales, by its strong, weak, or indifferent operatives and even by its piratical competition.

Limitations of space in both venues, of course, have dictated great selectivity. Nonetheless, we believe that we have achieved a reasonable coverage of the main events and principal achievements. We candidly admit that we have taken every opportunity to show great rarities, feeling an obligation to share with the public stellar pieces from our respective collections. The only cautionary note we have is to encourage you to see the exhibition at both venues: not all the books displayed will be seen both in New York and in Los Angeles, so you will miss some wonderful and instructive items if you do not view both shows. And quincentenaries are very rare birds.

1–2. Miniatures in the 1501 Petrarch on vellum (PML 17585) attributed to Benedetto Bordon: *left*, Petrarch crowned with a laurel wreath by Apollo, beneath the overpainted Johnstone-Hopetoun arms; *above*, Apollo with Daphne half-metamorphosed into a tree, with a blindfolded Cupid in the lower compartment.

3. Jean Grolier's heraldic charges, in his illuminated copy of the Quintus Smyrnaeus Calaber of ca. 1505 (PML 1195).

4. A page of the blue-paper Virgil of 1514, with unique typographic settings (CAMAC 110).

ſcabrata putreſcat humoribus, nec plagæ conſanentur. Quare ma-
gnopere monendus putator eſt, ut prolixet aciem ferramenti, & quan
tum poſſit, nouaculæ ſimilem reddat. Nec ignoret in quaque re, qua
parte falcis utendum ſit. Nam plurimos per hanc inſcitiam uaſtare
uineta comperi.

Figura falcis. Cap. XXV.

EST autem ſic diſpoſita uinitoriæ falcis figura, ut capulo pars pro-
xima, quæ rectam gerit aciem, culter ob ſimilitudinem nominetur.
Quæ flectitur ſinus, quæ à flexu procurrit, ſcalprum. Quæ deinde
adunca eſt, roſtrum appellatur. Cui ſuperpoſita ſemiformis lunæ ſpe-
cies, ſecuris dicitur. Eiuſq; uelut apex pronus imminens, mucro uoca-
tur. Harum partium quæque ſuis muneribus fungitur, ſi modo uini-
tor gnarus eſt. Nam cum in aduerſum preſſa manu deſecare quid de-
bet, cultro utitur. cum autem retrahere, ſinu. cum adleuare, ſcal-
pro. cum incauare, roſtro. cum ictu cædere, ſecuri. cum in angu-
ſto aliquid expurgare, mucrone. Maior autem pars operis in uineam
ductim potius, quàm cæſim facienda eſt. Nam ea plaga, quæ ſic ef-
ficitur, uno ueſtigio alleuatur. Prius enim putator applicat ferrum,
atque ita quæ deſtinauit præcidit. Qui cæſim uitem petit, ſi fruſtra-
tus eſt (quod ſæpe euenit) pluribus ictibus ſtirpem uulnerat. Tu-
tior igitur, & utilior putatio eſt, quæ (ut retuli) ductu falcis non ictu
conficitur.

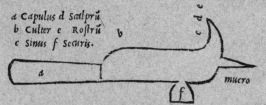

a Capulus d Scalprũ
b Culter e Roſtrũ
c Sinus f Securis.
mucro

De cura adminiculandæ, iugandæq; uineæ. Cap. XXVI.

HIS peractis, ſequitur (ut ante iam diximus) adminiculandæ,
iugandæq; uineæ cura, cui ſtabiliendæ melior eſt ridica palo, neq; ea
quælibet. nam eſt præcipua cuneis fiſſa olea, quercus, & ſuber, ac ſi
qua ſunt ſimilia robora. Tertium obtinet locum pedamen teres. Idq;
maxime probatur ex iunipero, & lauru, & cupreſſu. Recte etiam fa-
ciunt ad eam rem ſylueſtres pinus, atq; etiã ſambuci probabilis uſus.
tamen in his hæc, eorumq; ſimilia pedamenta poſt putationem retra=

5. The first book printed on blue paper, the *De re rustica* of 1514 (PML 79276).

EPISTOLARVM
PAVLI. MANVTII
LIBRI. XI
Vno nuper addito.

Eiusdem quae Praefationes appellantur.

MAXIMILIANI. II.

EX . PRIVILEGIO IMP . CAES . AVG .

VENETIIS . ∞ DLXXIII
In Aedibus Manutianis.

6. The Rantzau copy of Paulus Manutius, *Epistolarum libri xi* of 1573, on large blue paper; the title page bears an early appearance of the imperial charge of arms granted the author in the spring of 1571 (PML 1447).

rram, effundere in pessimū hoc genus hominum, qui ut pri-
mū ferè in lucem suscipiuntur, et hoc caelesti spiritu augeri
incipiūt, se in Italia ortos esse obliuiscuntur, et deínceps qd̃
illius dignitas postulet, non uident , & maiorum nomen,
sacra, memoriam ueterum , patriæ gloriam, religionis de-
cus, & illustrium uirorum monimenta suis flagitijs euer-
tunt. Sed hæc aliàs pluribus, nunc ad propositum reuer-
tamur. Celebrantur quidem multa dicta Pythiàdos filiæ
Aristotelis grauissima, ut appareat eandem ipsam nó tam
in gremio educatam, quàm in sermone patris , quo nemo
unquam fuit uel acumine præstantior, uel festiuitate, & le-
pore politior, uel suauitate códitior. Ex illis autem id etiam
accepimus. Nullum esse pulcrius coloris genus in facie ho-
minis ingenui, quàm id, quod ob uerecundiam superuenи-
ret. Musonij quoq̃: recentum Stoicorum longe clarissimi
eulogum est, hominem uenerationem ab alijs facile conse-
qui posse, si se ipsum primum uereretur. Atque huiusce rei
fructum, nam uerecundiam inter uirtutes non recipit Ari-
stoteles, expressit Theophrastus alio tamē sensu, cum dicat,
te ipsum ueretor, & alium non uerebere. Hæ sunt præci-
puæ uirtutes, ad quarum plane sonum animi obsorduisse
uidentur necessariorum. loquor autem de ijs necessarijs, qui
ante oculos sunt, quos uidemus, aut de quibus recentem me-
moriam accepimus, aut quos nouit uita communis . in istis
enim raro uirtutis decus inest, è quo honestatis lumen appa-
reat. Suauitas autem in cósuetudine condimentum esse ne-
cessitudinis ueteres iudicabant . Sed uideamus etiam quem-
admodum illa frui possimus. Primum illa aut ex pari, mu-
tuáque beneuolentia oritur, aut ex communitate studioru̅,
uoluntatum´que sine ulla exceptione, aut ex sermone, qui
urbanitate redundet, & sale, ac lepore affluat. Quis ho-
die quæso est, à quo hæc separatim, aut coniunctim exspe-
ctari possint? omnes enim tandiu se beneuolos ostendunt,
quoad fructum aliquem ex ea beneuolentia se perceptu-
ros confidunt. omnes adulationib. blanditijs, & assentationi-
bus student, & in congressionibus, conuictu'que, et sermo-
nib.

Aristot. filia

Verecūdia

vene=
ratio

Necessarij

Suauitas ōsu=
etudinis

Beneuoli ætatis
nr̄æ, quales

7. Annotations by a youthful Paulus Manutius in his copy of the Alcyonius of 1522 (PML 1144).

8. The secretary and notaries of the Council of Trent certify the authenticity of this copy of the 1564 folio edition of the Council's *Canones et decreta* (PML 1214).

9. (*below*) The title of one session is radically emended by the Fathers of the Council of Trent, perhaps in the autograph of Paulus Manutius (PML 1214).

SESSIO XXIII
QVAE EST SEPTIMA
SVB PIO IIII, PONT. MAX.
CELEBRATA DIE XV IVL.
M. D. LXIII.

~~Doctrina de Sacramento Ordinis.~~ ~~Cap. I.~~

SACRIFICIVM, & facerdotium ita Dei ordinatione coniuncta funt, ut utrumque in omni lege extiterit. cum igitur in nouo teftamento fanctum Eucharistiæ facrificium uifibile ex Domini inftitutione Catholica Ecclefia acceperit; fateri etiam oportet, in ea nouum effe uifibile, & externum facerdotium, in quod uetus translatum eft. Hoc autem ab eodem Domino Saluatore noftro inftitutum effe; atque Apoftolis,

Vera, et catholica doc... de facramento ordin... ad eodemnandos error... nri temporis à S. Sy... Tridentina decreta, ... publicata fefsione f... Cap. IV.m

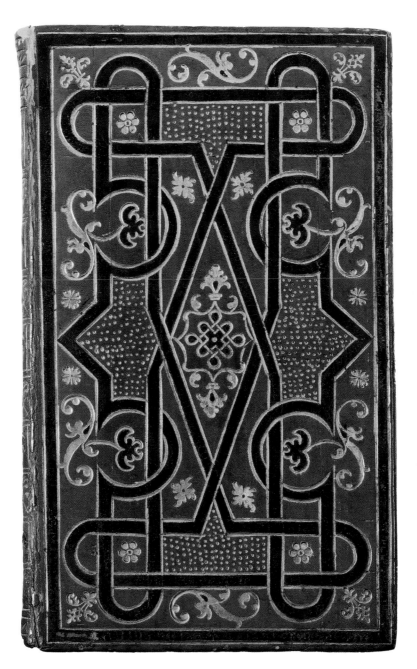

10. Parisian polychrome strapwork binding, ca. 1550s, on a copy of the 1540 edition of Machiavelli, *Il Prencipe* (PML 1435).

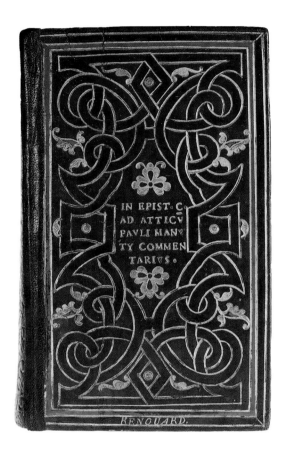

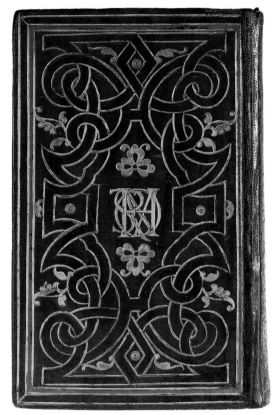

11–12. Thomas Mahieu's copy of Paulus Manutius, *In Ciceronis epistolas ad Atticum commentarius* of 1547 (PML 1279): *left,* front cover, showing the title in the central compartment, with A.-A. Renouard's name added in the bottom border; *right,* back cover with Mahieu's intricate monogram.

CATALOGUE

In Venice, just five hundred years ago, sometime during the late winter and early spring of 1495, the first book was issued from the Aldine Press, the brainchild of Aldus Manutius (ca. 1452–1515), the first and most famous of the humanist scholar-printers of the Renaissance. The Venetians, characteristically an independent lot, idiosyncratically began the year on the 1st of March, so Aldus's typographic venture was, appropriately enough, a new beginning at the inception of the new year.

To celebrate this quincentenary, The Pierpont Morgan Library and the University Research Library at the University of California, Los Angeles have organized a bicoastal exhibition. Each venue will have distinctive features, with different copies on view, as well as slightly differing thematic emphases. This catalogue covers both locations.

As is fitting, the exhibition pays predictably strong attention to Aldus's achievements and the activities of the Press during his lifetime. But it also covers the entire century of the Press's existence, highlights various eras and locales, provides examples of related works—whether legal or piratical—and pays particular attention to extraordinary copies. The thematic labels intended to guide viewers sequentially through the exhibition are reflected in the organization of this catalogue.

Every entry consists of a general description of the object on view, with special details, where appropriate, pertinent to the particular copy or copies selected; each is identified by its unique institutional number. Further information—provenance, for example—can be garnered from the *Catalogue of the Ahmanson-Murphy Aldine Collection at UCLA* or from the census of PML Aldines at the end of this catalogue.

The brief concluding references are to the basic literature, cited in full in the bibliography, and to the occasional specialized study, both current and superseded. Interested readers are directed to the wider literature that exists for many Aldine topics. The Laurenziana and Marciana/Sansoviniana catalogues of their respective 1994 exhibitions, on the books published by Aldus himself, are particularly recommended; both contain a wealth of information and illustration. The original books are available for study at their parent institution, upon application by scholars and specialists.

VENICE IN ALDUS'S DAY

The maritime republic was a crowded, cosmopolitan city of some 100,000 people during Aldus's era and the capital of a proud, dominant world power. It controlled trade with the East and was the residence of international commercial and financial communities. Its trade routes functioned quickly and efficiently, and Venice controlled large areas of the mainland in Italy and in the lands bordering the eastern shore of the Adriatic as well as a scattered island empire in the eastern Mediterranean. It was respected and feared, as well as regularly loathed, and the *Serenissima*'s enemies rarely passed up opportunities to engage in or renew warfare.

[JACOPO DE'BARBARI (ca. 1450?–b. 1516)]. *Venetie.*
M. D. (woodblock-printed prospective map).
[Venice: Anton Kolb, ca. 30 October 1500].
Facsimile; detail.

The map is a famous bird's-eye view of Venice at the end of the fifteenth century and a forerunner to the isometric maps that have become so justly popular. The aerial prospect was made by a Venetian artist with ties to Germany and Dürer and was published by a Nuremberg merchant resident in Venice. The woodblocks still exist, and at least three states of the map were printed up to about 1514, though predictably few survive. This facsimile edition was made in 750 copies to provide wide access to this fascinating achievement.

This extraordinary and extremely accurate detail, which shows both locations of the Aldine Press in Aldus's day, pinpoints the houses at Sant'Agostino and San Paternian, above and below the Grand Canal (see figs. 3 and 4). Aldus worked at the former location from about February 1496 until December 1505 and at the latter from 1506 until his death in February 1515.

PML 53136 (Gift of the Cassa di Risparmio di Venezia)
REFERENCE: *La pianta prospettica di Venezia del 1500 disegnata da Jacopo De' Barbari*, illustrata da Giuseppe Mazzariol e da Terisio Pignatti. Venice: Cassa di Risparmio di Venezia, [1962 for] 1963.

THREE GENERATIONS OF THE MANUTIUS FAMILY

The Press was headed at various times by three male members of the Manutius or Manuzio family: Aldus the Elder; his third son and final child, Paulus; and his namesake grandson, Paulus's only son, Aldus the Younger.

Aldus Manutius in: ALDUS MANUTIUS JR. *Epitome orthographiae.* Venice: Aldus Manutius Jr., 1575.

Some sixty years after his death, Aldus is depicted by an unknown artist to grace the title page of an edition of one of the grammatical works by his grandson. This is probably the closest thing to an official portrait of Aldus that we possess (fig. 5). A profile portrait bust of a middle-aged man in Italian Renaissance attire, preserved in the Kupferstichkabinett at Berlin, has been described for a century as a portrait of Aldus. It is a fairly large woodcut portrait, probably reworked with pen and ink, but its origins and authorship are unknown.

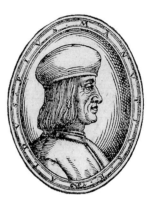

5. Aldus Manutius (ca. 1452–1515), as portrayed for his grandson sixty years after his death (PML 1456).

PML 1456

REFERENCES: Renouard p. 218; see also Lowry, *World of Aldus* between pp. 24 and 25 for the Berlin portrait.

Aldus Manutius in: PUBLIUS VERGILIUS MARO. *Opera.* Venice: Aldus Manutius Jr., 1576.

The same woodcut portrait is employed again in the following year by Aldus's grandson for a new edition of one of Aldus's noteworthy publications.

CAMAC 627

REFERENCE: Renouard p. 223.

Paulus Manutius in: PAULUS MANUTIUS. *Antiquitatum Romanarum liber de comitiis.* Bologna: Aldus Manutius the Younger, 1585.

Paulus worked on his studies in Roman antiquities for many years, beginning in the 1550s, and probably conducted research during the decade he spent in Rome, the 1560s. During his lifetime, he published only the section *De leg-*

ibus, in 1557, but he completed four treatises; the other three—*De senatu*, the present work, and *De civitate*—were published in the period 1581–85.

Aldus Jr., at this time professor in the humanities at Bologna, decorated this edition with an imposing and most handsome etched portrait of his father on the title page (fig. 6). Paulus was dead a decade by this time, and it is not known if the etching is a posthumous portrait or copied from a likeness in the family's possession.

PML 1445
REFERENCE: Renouard p. 237.

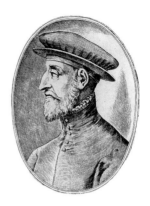

6. Paulus Manutius (1512–74), depicted for his son a decade after his death (PML 1445).

Paulus Manutius in: PAULUS MANUTIUS. *Epistolarum libri xii*. Venice: Aldus Manutius Jr., 1580.

A smaller version of the portrayal of Paulus above; the publication date is half a dozen years after his death in Rome.

CAMAC 639
REFERENCE: Renouard p. 228.

Aldus Manutius the Younger in: TERENTIO. *Locutioni*. Ed. Aldus Manutius Jr. Venice: Aldus Manutius Jr., 1585.

Aldus the Younger clearly was not given to flattering his physical appearance (fig. 7). He looks rather more careworn than one would expect for a man of 38, but his health had not been good when he was a boy; he was occasionally indisposed by illness and was only fifty when he died in Rome in 1597.

CAMAC 659
REFERENCE: Renouard p. 236.

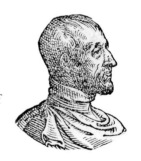

7. Aldus Manutius the Younger (1547–97), at the age of 38 (CAMAC 659).

THE ALDINE PRINTER'S DEVICE

The most famous emblem in the history of the printed book is the dolphin-and-anchor motif adopted by Aldus to mark his publications. It is also the longest lived, with a version of it still in use in publishing today. It has been adopted and adapted, copied and counterfeited, myriad times.

We offer a brief survey of the device in its various early manifestations, along with the silver denarius of Vespasian that engendered the whole sequence. A broad sampling of later versions of the device is included in this catalogue. (For all the above, see figs. 8–25.)

Model on: Titus Flavius Vespasianus (A.D. 9–79, r. 69–79). Denarius of the Emperor Vespasian.

Vespasian, a survivor both politically and militarily, was the final leader to emerge from the Year of the Three Emperors, A.D. 69. The inscriptions on the coin, made in the customary Roman shorthand, summarize his achievements in civic and military life: on the obverse, IMP TITVS CAES VESPASIAN AVG P M; on the reverse, COS VIII P P TR PI X IMP XV—in other words, "Emperor Titus Caesar Vespasian Augustus, High Priest"; "eight times Consul, Father of his Country, ten times Tribune of the People, fifteen times a victorious general."

The standard Roman currency was the silver *nummus denarius*, its name deriving from its unit, ten, and from its signification of ten fingers. The equivalent of the Attic drachma, it comprised originally 10 and later 18 *asses*. The influence of its name continues in coinage: the dinar and the penny (collective, pence), for example, derive from it. The symbol for the penny in sterling currency, *d.*, is the suspension of *denarius*, and *penny/pence* is the way in which the word seems to have evolved in Germanic-Anglicized pronunciation.

Vespasian, crowned with a laurel, is portrayed in profile on the obverse (fig. 8). On the reverse is an anchor entwined by a dolphin (fig. 9). One interpretation of the contemporary significance of the emblem for the Romans is as a prayer to Poseidon to prevent the recurrence of an earthquake or tidal wave. The Renaissance connotation of these symbols was the fusion of graceful speed (the dolphin) with stability (the anchor). Tradition has it that Pietro Bembo gave Aldus one of these

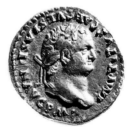

8–9. Silver denarius A.D. 69–79 of the Emperor Vespasian: *top*, obverse, with Vespasian's portrait; *bottom*, reverse, with dolphin-and-anchor motif (2× magnification; CAMAC).

coins; Aldus showed Jean Grolier the coin in about the summer of 1511, and Grolier drew a copy of it. The motif is, of course, particularly apt for a printer working in the great maritime republic of Venice. As early as 1499, Aldus mentioned to Alberto Pio of Carpi that he was keeping as his companions the dolphin and the anchor—that he was producing much, slowly but steadily.

UCLA Special Collections 150/50
REFERENCE: Hobson, *Humanists* p. 117. I am grateful to Martin Lowry for his counsel.

Prototype in: [FRANCESCO COLONNA (1433–1527)].
Hypnerotomachia Poliphili. Venice: Aldus Manutius
[for Leonardus Crassus], December 1499.

The prototype of the dolphin and anchor appears here, with brief descriptive copy about its significance, and its pertinent motto in Greek and Latin: *festina lente* or "Make Haste Slowly." Within three years, Aldus worked out practicable versions of this device to add to his books as a hallmark.

This is a particularly elegant configuration, but its horizontal orientation made its use on the dominantly vertical format of the printed page inappropriate. (See also p. 48.)

PML 373 (ChL [f]1017)
REFERENCES: Renouard p. 21; Goff C-767; Fletcher p. 44.

Original octavo version in: SEDULIUS.
Poetae Christiani veteres II. Venice: Aldus Manutius, January 1501 and June 1502.

This is the guise Aldus originally devised for the smaller books and used for the first time in June 1502. But the border was quite fragile, as can be seen from the breaks resulting from its first employment, and had to be adjusted (fig. 10).

PML 1546
CAMAC 46
REFERENCES: Renouard p. 39; AME no. 23; Fletcher p. 45.

10. Aldus's original design for the octavos, June 1502 (55 × 48 mm; PML 1546).

Standardized octavo version in: OVID. *Metamorphoses*. Venice: Aldus Manutius, October–November 1502.

Aldus's solution (effected in intermediate stages not exhibited) was to cut away and gradually eliminate the double border (fig. 11). This form of the device, and probably the woodblock itself, was used for more than a quarter century.

PML 1508

CAMAC 53

REFERENCES: Renouard p. 37; AME no. 43; Fletcher p. 47.

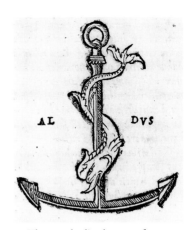

11. The standardized octavo form, November 1502 (53 × 47 mm; PML 1508).

Smallest early version in: *Horae B.M.V.* (Greek). Venice: Aldus Manutius, July 1505.

This guise was developed for use solely in this miniature book (fig. 12). It happened to be reused in the same year on the crowded title page of the octavo Pontanus as a convenient solution to a problem that otherwise would have precluded the use of any device. It would be re-employed, two or three times more—on the 1521 reprint of this Book of Hours, on the miniature *Brevissima introductio ad litteras Graecas* of 1526, and reportedly on a Latin Horae of 1534.

PML 1070

CAMAC 74

REFERENCES: Renouard p. 49; AME no. 58; Fletcher pp. 47–48; cf. Laurenziana no. 92 re the 1534 Horae.

12. The smallest guise, designed for a miniature book in 1505 (39 × 30 mm; PML 1070).

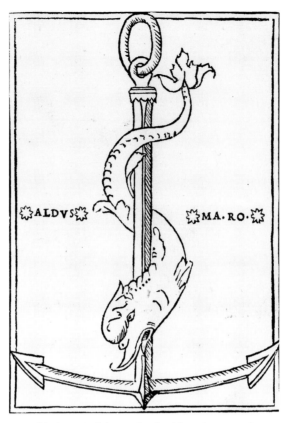

13. Aldus's original design for the folios, from March 1503
(107 × 75 mm; PML 1523).

Original folio version in: PHILOSTRATUS. *De vita*
Apollonii. Venice: Aldus Manutius, March 1501,
February 1502, and May 1504.

Aldus developed this large format for his folios, first employing it in this
guise in the Origen of February 1503. His name, ALDUS MA[NUTIUS]
RO[MANUS], is printed from type that has been fitted into the woodblock (fig.
13). The original block, showing increasingly noticeable wear and damage in
its extremities, would be employed for some thirty-three years.

PML 1523

CAMAC 65

REFERENCES: Renouard p. 26; AME no. 26; Fletcher p. 53.

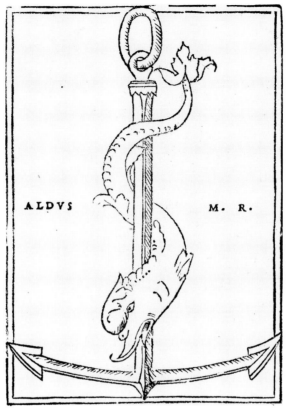

14. The original folio device in a somewhat battered state, following a decade's hard use (107 × 75 mm; PML 1124).

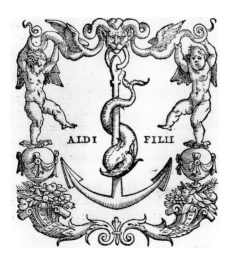

15. The Sons of Aldus version, used in Venice from the beginning of the 1540s (62 × 57 mm; PML 3114).

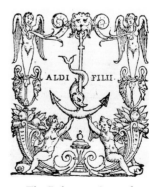

16. The Bolognese Sons of Aldus variant, used by Antonio Manutio in the late 1550s (45 × 40 mm; PML 1465).

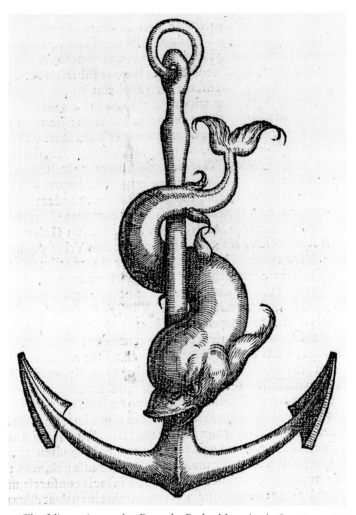

17. The folio version used at Rome by Paulus Manutius (128 × 90 mm; PML 1214).

18. Paulus Manutius In Aedibus Populi Romani (138 × 117 mm; PML 1138).

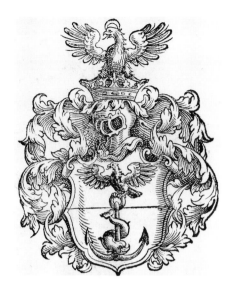

19. The octavo size showing the imperial charge of arms granted Paulus in 1571 (69 × 58 mm; PML 1199).

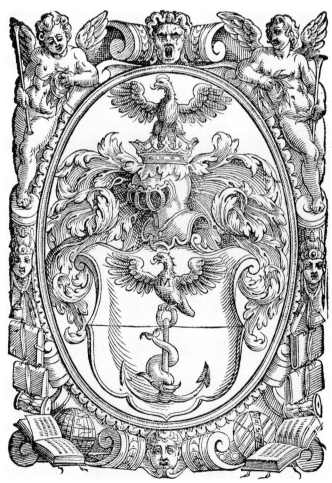

20. The folio version of the imperial device (129 × 92 mm; PML 1229).

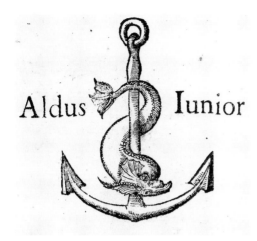

21. A pattern employed at Venice in the early 1570s by Aldus the Younger (57 × 45 mm; PML 1290).

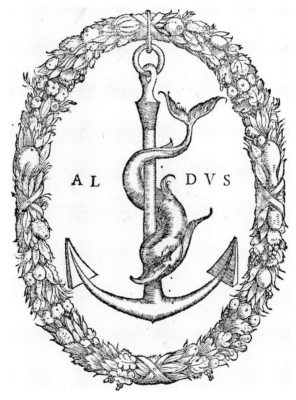

22. The enwreathed folio version used by Paulus at Venice in the 1550s (102 × 78 mm; PML 1444).

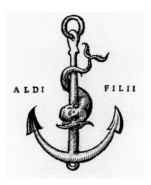

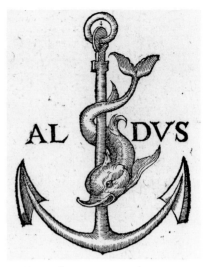

23. A counterfeit device, here in a "Sons of Aldus, 1548" guise, variously attributed to Sebastian Gryphius at Lyon or Johann Gryphius at Venice and ultimately to an anonymous printer at Geneva as late as ca. 1620 (44 × 29 mm; PML 1519).

24. Bernardo Torresani, working at Paris as Bernard Turrisan, employed this guise in his smaller books; the arrow within the anchor ring is part of the woodcut (68 × 50 mm; PML 1139).

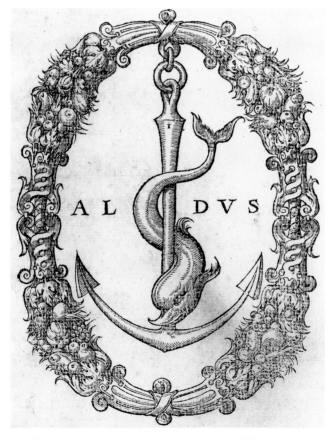

25. The enwreathed folio version used by Bernard Turrisan at Paris (122 × 94 mm; PML 1554).

ALDUS THE TEACHER

Raised a scholar, Aldus had two careers in his lifetime: tutor and scholar-printer. Clearly he never relinquished the scholar's role—working hard at establishing texts, producing learned treatises that he appended to many of the books he printed, and seeking to instill habits of learning and scholarship in the young. This last area he addressed particularly through his grammars.

Those interested in this topic should read John J. Bateman, "Aldus Manutius' *Fragmenta grammatica*," in *Illinois Classical Studies* I, ed. Miroslav Marcovich (Urbana: University of Illinois Press, 1976), ch. 16: pp. 226–61. This study is crucial to our understanding of Aldus's purposes and priorities as a scholar and teacher during the last thirty years of his life.

ALDUS MANUTIUS. *Musarum Panagyris* (with other works). [Venice: Baptista de Tortis, a. March 1487 and b. March 1491].

Aldus calls himself Aldus Mannuccius Bassianas, or Aldus Manutius from Bassiano, his village birthplace in the hills of Latium. This copy, the only one in America, formerly belonged to Renouard.

This work is a compendium of a variety of smaller pieces addressed to Caterina Pio and her two young sons, Alberto and Leonello, whom Aldus tutored at Carpi between 1483 and ca. 1490. In both verse and prose, he touches on the value of a classical education and on the teacher's tasks and goals; the contents can be dated internally to the period 1483–84. It has been proposed that the finished work furnished a propaganda instrument through which Aldus made his presence in the Venetian publishing world known.

PML 22035 (ChL 904)
REFERENCES: Renouard pp. 257, 538–41 (text); Goff M-227; Bühler, "The First Aldine," *Early Books and Manuscripts,* pp. 128–37, and his "Aldus's *Parae-nesis* to His Pupil, Leonello Pio," ibid., pp. 299–302; C. Scaccia Scarafoni, "La più antica edizione della Grammatica Latina di Aldo Manuzio finora sconosciuta ai bibliografi," in *Miscellanea bibliografica in memoria di don Tommaso Accurti,* ed. L. Donati (Rome: Storia e Letteratura, 1947), pp. 193–203.

ALDUS MANUTIUS. *Rudimenta grammatices Latinae linguae.* Venice: Aldus Manutius, February and June 1501.

The first edition of Aldus's Latin grammar, published by Andrea Torresani in 1493, survives in a unique copy at the Biblioteca Marciana, Venice. This is Aldus's first edition under his own imprint and the first to include his very

brief Hebrew alphabet and grammar. It is issued in quarto format, which Aldus reserved for what we might call school texts, and contains various components that help to explain Aldus the man: religious texts and prayers, lengthy messages of encouragement to teachers and students, painstakingly careful expositions of the elements of Latin, a comprehensive appendix on the elements of Greek grammar, and a brief appendix on the Hebrew alphabet. This is a particularly elegant copy of a very rare work.

PML 1439
REFERENCES: Renouard p. 31; AME no. 25; cf. Piero Scapecchi, "Manuzio dagli inizi al nuovo secolo," in Laurenziana pp. 13–23 at 16.

ALDUS MANUTIUS. *Institutionum grammaticarum libri quattuor.* Ed. Jucundus Veronensis. Venice: Aldus Manutius, October 1507 and April 1508.

Aldus's Latin grammar enjoyed great success during his lifetime and for many years thereafter; he published editions—under differing titles—in 1501, 1508, and 1514. The Press issued reprints at distant intervals, until well toward the end of the sixteenth century.

Portions of the text were completed in October and April, and it is noteworthy that this, the second of Aldus's own editions, came out when it did. By April 1508 he had been back at the publisher's trade for perhaps six months. His time was being taken up to a significant degree by Erasmus of Rotterdam, who had descended upon Aldus in December 1507, had taken up residence in the Torresani household, and would spend the first eight months of 1508 overseeing the huge new edition of his *Adagia*, which was completed, if not actually issued, in September. It would seem that Aldus set aside the new edition of his grammar to work with Erasmus. This is Aldus's penultimate work bearing his own imprint. In the following November, the imprint would change to the House of Aldus and of Andrea of Asola, His Father-in-Law.

PML 1440
CAMAC 80
REFERENCE: Renouard p. 52.

ALDUS MANUTIUS. *Institutionum grammaticarum libri quattuor.* Ed. Jucundus Veronensis. Venice: House of Aldus and of Andrea of Asola, His Father-in-Law, December 1514.

The final edition of Aldus's Latin grammar to be published in his lifetime finished composition less than two months before his death, at a time when

he was gravely ill. It is a new issue of the 1508 edition, prepared by Fra Giocondo of Verona. The next Aldine Press issue would come nearly a decade later, in 1523, and incorporate a small amount of Erasmus's grammatical work as well (see pp. 94–95).

PML 28263

CAMAC 111

REFERENCE: Renouard p. 69.

ALDUS MANUTIUS. *Institutionum grammaticarum libri quattuor.* Ed. Jucundus Veronensis. [Paris]: Jodocus Badius Ascencius, 1 May 1517.

There was no lack of non-Aldine editions of Aldus's Latin grammar, both during and after his lifetime. Among the earliest was a reprint of the 1508 edition, produced by the learned Flemish proprietor of the Ascensian Press at Paris. Josse Bade, scholar-printer and friend of Erasmus, printed his first edition of Aldus's Latin grammar in April 1513. Badius's edition was subsequently copied by at least three other Parisian printers, who published four issues between 1513 and 1516. The demand in the great university city must have been considerable, both locally and within the wider French market, for Badius to reissue his 1513 edition in the spring of 1517.

PML 1442

REFERENCE: Philippe Renouard, *Badius* III p. 72.

ALDUS MANUTIUS. *Grammaticae institutiones Graecae.* Ed. Marcus Musurus. Venice: House of Aldus and of Andrea of Asola, His Father-in-Law, November 1515.

Unlike his Latin grammar, Aldus's Greek grammar was never completed in his lifetime. His first will, signed on 27 March 1506, had contained instructions to destroy his incomplete manuscript, which was still unfinished nine years later. But his friends and colleagues, knowing the value of their mentor's work, knew better than to respect his wishes. Marcus Musurus, Aldus's principal Greek editor on many occasions over more than a decade, completed the task within nine months following Aldus's death.

This is the first edition of the Greek grammar, a work virtually as extensive as its Latin forerunner. (It, too, would enjoy considerable fame, though copies are predictably scarce: grammar books have always been subject to extremely rigorous use.) Musurus dedicated the grammar to Jean Grolier, citing past favors from the French treasurer. In a highly successful bid

for Grolier's future support of the Press, Musurus stressed Aldus's lifelong devotion to sound education for the young.

PML 1441

CAMAC 120

REFERENCES: Renouard p. 73; Fletcher p. 161 (will); Barker, *Aldus and Greek*, esp. pp. 17–18.

The hand of Aldus? in: POMPONIUS MELA. *De situ orbis*. Ed. Hermolaus Barbarus. [Venice]: Albertinus de Lis<s>ona of Vercelli, 13 May 1502.

The authorship of the scattered annotations, citations, and minor emendations in this copy of Pomponius Mela has been assigned to Aldus for about three centuries (fig. 26). Certain letters resemble those known to have been executed in his hand, but the crucial evidence—Aldus's minuscule *r*, characteristically shaped like a broken 7—is lacking. Since the *r* employed by the writer is uniformly of a different ductus, one cannot be absolutely certain about the attribution.

An Aldine edition would not appear until October 1518. The Torresani brothers and their father issued a few works in the years immediately following Aldus's death that were based in part on texts he had worked on many years before. Girolamo Avanzio's edition of Seneca's *Tragedies* (1517), in which Erasmus also had been involved years before, was one. Gian Francesco Torresani recorded in his preface to the edition of Plautus's *Comedies* (1522) that Aldus and Erasmus had worked together on the text. This cooperative editing could have occurred only during the period from December 1507 to August 1508. The question whether the Aldine edition of Pomponius Mela should be added to this select group remains.

CAMAC 796

REFERENCES: F. L. A. Schweiger, *Handbuch der classischen Bibliographie* II: Lateinische Schriftsteller (Leipzig, 1832) pt. 2 p. 606 col. 1 (with incorr. date 14 May); cf. Isaac p. 26 and F. J. Norton, *Italian Printers 1501–1520* (London, 1958) pp. 157–58 for the printer. Schweiger cites the location of his copy as "Halle?"; this edition, an unprepossessing reprint, appears to be otherwise unrecorded in the literature. Three other copies are recorded in America. I am grateful to Fred Schreiber for his counsel.

parua flumina emittit:folo q̃ uiris melior: & fegnitie gentis obfcura.
Ex iis tamen : q̃ cõmemorare nõ pinget,Mõtes funt alti: qui cõtinen-
ter & quafi de induftria ĩ ordinẽ expofiti obnumeꝝ feptem ob fimili-
tudinẽ fratres uocantur.Tam uada fluuius:& rufigada & figna paruæ
urbes:& portus:cui magno eft cognomen ob fpatium.Mulucha illæ:
quẽ diximus amnis eft ingentium olim regnoꝝ terminus Bocchi iu-
gurthæꝗ.Ab eo Numidia ad ripas expofita fluminis Ampfagæ fpatio
quidẽ q̃ Mauritania anguftior ẽ.Verũ & culta magis & ditior.Vrbiũ
quas hẽt maximæ funt Cyrtha procul amari:nunc Sittianoꝝ colonia:
quondam regum domus Iubæ & Siphacis:cum foret opulẽtiſsima.Iol
ad mare aliquãdo ignobilis.Nunc quia Iubæ regia fuit:& q̃ Cæfarea
uocitatur illuftris.Citra hanc:nam in medio ferme littore fita eft.Car-
téna & Arfenaria funt oppida & ampfa caftellũ & laturus finus & far-
daballe fluuius ultra monumenrũ cõmune regiæ gétis.Deide ifcohũ
& uthifia urbes effluétes inter eas Ancus & Nabar:aliaꝗ q̃ taceri nũl-
lũ reꝝ famæue difpendiũ eft.interius & longe Tatis a littore:fi fidẽ res-
capit:mirũ admodũ fpinæ pifciũ:muricũ oftreorumꝗ fragmenra : fa-
xa attrita uti folent fluctibus & nõ dría,marinis infixæ cautib⁹ancho-
ræ,Alia & huiufmodi figna atꝗ ueftigia effufi olim ufꝗ ad ea loca pe-
lagi ĩ cãpis nihil alétib⁹eẽ inueniriꝗ narranṭ.Regio q̃ fequiṭ a ꝓmon-
torio,Metagonio adaras philenorũ ꝓpriæ nomẽ Africæ ufurpat,In ea
funt oppida Hipporeius & Ruficade & Tabraca,Deinde tria ꝓmonto-
ria:cãdidũ,Appollinis,Mercurii: uafte ꝓiecta in altũ duos grádes finus
efficiũt hipponefem uocat proximũ ab hippone:diarryto:quod littori
eius appofitũ eft,in altero funt caftra lælia:caftra cornelia,flumẽ Bra-
gada.Vtica & Carthago:ambæ inclytæ:ambæ a phœnicibus cõditæ.
illa fato Catonis infignis.Hæc fuo nunc populi Romani colonia:olim
iperii eius ptinax æmula,iam qdem iteꝝ opulenta:etiã nunc tã prioꝝ
excidio reꝝ q̃ ope plentium clarior Hadrumétũ.Leptis.Clupea,Abro-
tonũ:Taphiæ.Neapolis hinc ad fyrti adiacent:ut inter ignobilia cele-
berrimæ Syrti finus eft centũ fere milia paſsuũ: qua mare accipit pa-
tens:trecenta:qua cingitur,Veꝝ importuofus atꝗ atrox:& ob uadoꝝ
frequentiũ breuia magifꝗ etiã ob alter nos motus pelagi affluentis &
refluétis infeftus.Super hunc ingens palus amnẽ Tritona recipit. ipfa,
Tritonis.Vnde & Mineruæ cognomẽ inditũ eft:ut icolæ arbitrantẽ ib⁹
genitæ,faciuntꝗ ei fabulæ aliquã fidé:ꝗ quẽ natalẽ eius putant:ludi-
cris uirginũ iter fe decertátiũ celebrant. Vltra ẽ Oea oppidũ & Cinyps
fluuius ꝑ uberrima arua decidens.Tum leptis altera & fyrtis nomine

26. The annotations in this 1502 edition of Pomponius Mela have been attributed to
Aldus (CAMAC 796).

THE INCUNABULAR PERIOD

The books that were issued by the Aldine Press beginning in 1495 may be divided broadly into newly edited texts of major authors and ancillary works. Several of these books contain notable illustrations, and all are characterized by innovations in typography, especially in Greek. This is to be expected, since the Greek alphabet, with its varied forms, accents, and breathings (quite apart from the numerous ligatured sorts that mimic the written hand), presents many more obstacles for development into type than does the Latin alphabet.

Aldus's monumental Greek folios from the last half dozen years of the fifteenth century constitute a high watermark in the history of the Renaissance in Italy. These works are emblematic of the unsurpassed power of print—which was still quite new—to spread Renaissance ideals. Crucial to Western thought, most of them, the *editiones principes*, such as the editions of Aristotle and Aristophanes, offered the works of classical antiquity for the first time in print.

There is an admixture of books, including significant works in Latin. The major work in the vernacular, the *Hypnerotomachia Poliphili*, is a folio noted for being the most harmonious illustrated printed book of the Renaissance.

CONSTANTINUS LASCARIS (1434–1501). *Erotemata.*
[Venice: Aldus Manutius, 28 February 1494/5–
8 March 1495].

This is Aldus's first book to carry a date and in all likelihood his first publication. The composite date reflects Old Style for the first date (the year beginning on the 1st of March in Venetian usage) and New Style for the second. It is the fourth edition of the *Erotemata* ("Questions"), corrected by the author and printed from a manuscript brought to Venice from Messina by Pietro Bembo and Angelo Gabriele.

Aldus intended this grammatical treatise to serve as preparation for his great texts of the Greek authors. The volume is thus a composite, comprising various small works, including Aldus's own *De litteris Graecis et diphthongis*.

PML 1407 (ChL 988)

CAMAC 1

REFERENCES: Renouard p. 1; AME no. 1; Goff L-68; Babcock and Sosower no. 24 and cf. no. 29.

Musaeus. *Opusculum de Herone et Leandro* (Greek
and Latin). Ed. Aristoboulos Apostolios. Trans.
Aldus Manutius. [Venice: Aldus Manutius, b.
November 1495 and 1497–98].

The Greek part of this book is often cited as a prototype and the first of
Aldus's publications, which is not the case. Aldus listed it eighth in his first
catalogue of 1498 but in the version that includes the Latin translation,
which is Aldus's own work. In his preface, Aldus describes it as a prelude to
his forthcoming Greek books. Probably printed in the summer of 1495,
before the first volume of Aristotle, the Greek section may in fact be a work
commissioned for Aristoboulos, an opportunist who eventually was awarded
the bishopric of Monemvasia, a Venetian colony, only to be repudiated by an
unwilling flock.

The book is found in two versions—Greek alone or with a Latin
translation—and only the complete version contains the famous woodcuts.
The Latin translation dates from ca. 1498, or at least not before 1497. Aldus's
autograph manuscript of the word-for-word Latin translation, which served
as the setting copy, is preserved at Beatus Rhenanus's library at Sélestat. The
Musaeus is also exemplary of Aldus's painstaking attention to textual details.
There are at least two distinct states of the book, with stop-press corrections
to vocabulary, grammar, and typographic meter as well as manuscript correc-
tions (presumably in Aldus's hand). All the corrections appear in the octavo
edition published by the firm in 1517, two years after Aldus's death, along
with the reprinted woodcuts.

PML 264 (ChL 987)

CAMAC 10

REFERENCES: Renouard p. 257; AME no. 2; Goff M-880; Barker, *Aldus and
Greek* pp. 17, 52, 109 and pl. 17; Bühler, "Aldus Manutius and His First Edi-
tion of the Greek Musaeus," *Early Books and Manuscripts* pp. 162–69; Wolfen-
büttel no. 46.

Aristotle. *Opera* (Greek). Venice: Aldus Manutius,
1 November 1495–June 1498.

The central achievement of the Italian Renaissance was the reintroduction of
the literary and learned works of classical antiquity, particularly Greek, in
their original languages. Aldus's edition of Aristotle—the first major Greek
prose to have been printed in its original language—was the greatest symbol
of this achievement.

Aldus issued his Aristotle in the one-volume *Organon*, comprising the
six treatises on logic, in late 1495, and then in four additional volumes com-

ΑΡΙΣΤΟΤΕΛΟΥΣ ΑΝΑΛΥΤΙΚΩΝ ΠΡΟ
ΤΕΡΩΝ. ΔΕΥΤΕΡΟΝ.

27. The opening of Book 2 of *Prior Analytics*, in the 1495
first volume of the monumental Aristotle (PML 1126).

prising the rest of the Aristotelian corpus, in 1497–98 (fig. 27). This earliest,
and in many ways most important, of the Aldine Greek folios heralded the
achievement of the Aldine Press over many decades. Substantial fragments of
the setting-copy manuscripts survive, most at the Bibliothèque Nationale, in
Paris, with a significant portion preserved in the Houghton Library at Harvard.

PML 1126 (ChL ᶠ989)

CAMAC 4

REFERENCES: Renouard p. 7; AME no. 3; Goff A-959; Wolfenbüttel no. 47;
Marks in Books no. 2; Nixon p. 168; Needham, *Twelve Centuries* no. 70.

PIETRO BEMBO (1470–1547). *De Aetna dialogus.*
Venice: Aldus Manutius, February 1495/6.

Aldus devoted his greatest typographic attention to his four fonts in Greek and nearly as much to the first italic face. He essentially built upon the best experiences of the preceding four decades in developing a roman font. He continued to develop this one, achieving the results of better color or weight of letters in the *Hypnerotomachia Poliphili.* The substantive changes in manuscript likely were made by Aldus himself.

The *Aetna* is basically an occasional publication, a memoir of a Sicilian trip in the form of a dialogue between Pietro (BF, "Bembus Filius") and his father, Bernardo (BP, "Bembus Pater"). So it is perhaps ironic that this relatively slight piece was set in the face that launched at least a thousand typographic ships. Of all the splendid twentieth-century typographic revivals of classic faces for which we have Stanley Morison and the Monotype Corporation to thank, the supremely elegant Monotype Bembo—upon which the type in this book is based—is surely the best.

PML 431 (ChL 992)

CAMAC 6

REFERENCES: Renouard p. 7; Goff B-304; Bühler, "Manuscript Corrections in the Aldine Edition of Bembo's *De Aetna*," *Early Books and Manuscripts* pp. 170–75.

[PSALTER. GREEK]. *Psalterion* (Greek). Venice: Aldus
Manutius, [1497].

This Psalter was part of Aldus's program to provide familiar texts in Greek as teaching aids. A line of text was dropped at the top of folio ιιr in the course of printing and obviously was not discovered until later. It has been added, at the top of the page, in what is probably Aldus's hand.

This manuscript correction survives intact in the UCLA copy. The PML copy, on the other hand, is the unfortunate product of unthinking preservation efforts. Early printed books rebound during the late eighteenth and early nineteenth centuries, especially in England and France, were often "cleaned." All traces of former ownership and annotation were routinely eradicated, destroying both the historical record and, as in this instance, original work from the printer's shop.

CAMAC 19

REFERENCES: Renouard p. 260; Goff P-1033.

28. Beatus Rhenanus's copy of the unique trial leaf of
Athenaeus of ca. 1496–97 (MA 1346-230).

A scholar's proof sheet of: ATHENAEUS. *Opera*
(Greek). [Venice: Aldus Manutius, ca. 1496–99 and
b. 15 April 1498 (1496–97?)].

This sheet, printed on one side only, contains the opening of the prolegom-
ena to the *Deipnosophistae* of Athenaeus (fig. 28). Aldus would publish an edi-
tion in August 1514; but this sole known survivor may be a proof setting of a
much earlier attempt to issue Athenaeus or at least a trial setting of a new
typographic combination using an available text that would appear as an edi-
tion nearly twenty years later. It is set in the second Aldine greek font, the
shortest lived of the four, having been used only between August 1496 and
July 1499 to produce six books. The decorative elements are those found in
Aldus's earliest typography: the Hellenistic border in the *Organon* of Novem-
ber 1495 and the white-vine capital alpha in the Theocritus of February
1496. The combination suggests a date closer to 1496 than to 1499, and a let-
ter written in Bologna on 15 April 1498 may refer to this setting.

Beatus Rhenanus (Beatus Bild of Schlettstadt, or Sélestat, Alsace; 1485–1547), scholar, historian, and collaborator of Erasmus, studied in Paris and then lived in Basel from 1507 to 1527. His circle included the scholar-printers Froben, Amerbach, and Herwagen, and he edited Livy, Pliny, Seneca, Tacitus, Tertullian, and Velleius Paterculus. He signed this trial, or proof, sheet at Basel in 1513: *Beati Rhenani sum, nec muto dominum* (I am Beatus Rhenanus's, and I am not changing my owner!). He owned a heavily annotated copy of the 1514 Aldine Athenaeus. This single leaf may have served as a pastedown endsheet in a binding, thus explaining the ownership inscription. Most of his manuscripts and printed books are preserved in his own library, renamed the Bibliothèque Humaniste, at Sélestat, but some items are scattered throughout the world, their dispersal the result of loans and mishaps. The eighteenth-century Strasbourg classicist Brunck borrowed certain materials for his work and had not returned them at his death; they eventually came into Renouard's collection and subsequently into Firmin Didot's. They have been further scattered since then, and some allied manuscript material was found after a fire in Paris just a generation ago.

MA 1346 (230) (ChL ᶠ1017A)
REFERENCES: Renouard pp. 67–68; cf. AME no. 85; Goff A-1175; Bühler, "Aldus Manutius and the Printing of Athenaeus," *Early Books and Manuscripts* pp. 220–22 and pl. 14; Laurenziana no. 24; cf. Marciana/Sansoviniana no. 126. I am grateful to André Jammes for his counsel.

Aldus as editor: ALEXANDER BENEDICTUS
(Alessandro Benedetti, 1450–1512). *Diaria de bello Carolino*. Venice: Aldus Manutius, [not before 27 August 1496].

Many of the years of Aldus's publishing career were plagued by warfare and the concomitant disruption of trade and travel, which he lamented in several prefaces. This is Benedetti's account of the invasion of Italy by Charles VIII of France, a work dedicated to the reigning doge, Agostino Barbarigo. The doge was the uncle of Pier Francesco Barbarigo, the silent partner and major financial backer of the Aldine Press. The copy displays an example of Aldus's editorial work, after a book came off the presses.

This portion of Benedetti's account says that Charles, in moving his army north to meet the enemy at Fornovo, marched his troops from Naples to Siena to Rome to Pisa—a quite impossible route. There are written notations indicating that the text should be rearranged to make the course of the march Naples, Rome, Siena, and Pisa. They are believed to be in Aldus's own hand and demonstrate his commitment to accuracy, even to the detriment of

aesthetics. The late Curt F. Bühler, Keeper of Printed Books at the Morgan Library for half a century, reported four decades ago that he had personally examined two dozen copies and had found these corrections in every one of them.

PML 442 (ChL 994)

CAMAC 9

REFERENCES: Renouard p. 260; Goff A-389; Bühler, "Stop-press and Manuscript Corrections in the Aldine Edition of Benedetti's *Diaria de Bello Carolino*," *Early Books and Manuscripts* pp. 138–44 and pl. II.

[HORAE B.M.V. USE OF ROME. GREEK]. *Horae beatiss[imae] Virginis secundum consuetudinem Romanae Curiae*. [bound with] *Brevissima introductio ad litteras graecas*. Venice: Aldus Manutius, 5 December 1497.

This book, small in both format and scope, set partially in roman and mostly in the second Aldine greek font, encapsulates much of what motivated Aldus. A devout and probably unchallenging Christian committed to education through pious means, he occasionally filled blank pages in grammatical works with Greek/Latin religious texts to educate the young. This is Aldus's Greek translation of the Roman-rite Hours of the Virgin, which is of no liturgical significance but nonetheless furnished its users with a familiar text in the rediscovered language of the humanists.

It is preceded by the *Brevissima introductio ad litteras graecas*, or "Very Brief Introduction to the Greek Alphabet." This shorter work, which is not present in all copies and is invariably catalogued separately, probably was intended to accompany the Greek Hours as part of Aldus's scheme of combining learning with meritorious texts. The introduction carries the same Annunciation woodcut facing the first page of text. Aldus is recorded as having sent a copy to Conrad Celtis on 3 October 1498.

PML 21863 (ChL 1005 and 1002)

CAMAC 801

REFERENCES: Renouard p. 15; Goff H-391; Laurenziana nos. 19–20.

Hebrew type in: ANGELUS POLITIANUS (1454–94).
Opera omnia. Venice: Aldus Manutius, July 1498.

Angelo Ambrogini came to be called, after his native Montepulciano, Politianus, which became Poliziano by back-formation in Italian and Politian in English. One of the most accomplished of the Florentine humanists, he

attended Landino's lectures, became professor of Latin and Greek at Florence, was the tutor to Lorenzo de' Medici's children, and was prominent in the Platonic Academy, where he esteemed Lorenzo for his patronage. Attending Savonarola's sermons, he heard himself singled out for his learning: the Dominican thundered that Poliziano with his Neoplatonism knew less about the eternal verities than an old peasant woman.

This first, albeit posthumously published, edition of Poliziano's collected works includes a memorial to Lorenzo, who had died in 1492. It also contains Aldus's first use of Hebrew type, which was the first Hebrew type to have been used in Venice. Aldus would begin to issue a brief, separate Hebrew "grammar," consisting of the alphabet and a few short pieces, within three years. Also at this time he began preparations to publish a polyglot Bible, which was ultimately unrealized and of which a unique trial sheet, with typefonts for Latin, Greek, and Hebrew, survives in Paris.

PML 1555 (ChL ᶠ1010)

CAMAC 23

REFERENCES: Renouard p. 17; Goff P-886; cf. Laurenziana no. 52 for Aldus's polyglot Bible.

29. Carteromachus's annotations in the 1499 Dioscorides (CAMAC 26).

Carteromachus's annotations in: DIOSCORIDES. *De materia medica* (Greek). Ed. Hermolaus Barbarus. Venice: Aldus Manutius, 8 July 1499.

Renouard reported that the extensive annotations in this copy of Dioscorides were the work of one of Aldus's most faithful collaborators (fig. 29). Scipione Forteguerri, better known by his humanist name, Carteromachus, was an Italian Hellenist from Pistoia. He was named by Aldus as one of his academicians and had a long association with Aldus and the Press.

An element in Aldus's brief series of medical works issued in the 1490s, Dioscorides' compendium is antiquity's most important guide to pharmacy and medical botany, comprising some 827 entries on plants, minerals, and animal products.

CAMAC 26

REFERENCES: Renouard p. 21; AME no. 19; Goff D-260.

[FRANCESCO COLONNA]. *Hypnerotomachia Poliphili*. Venice: Aldus Manutius [for Leonardus Crassus], December 1499.

This book is widely regarded as the most sympathetic and harmonious blend of typography and illustration achieved during the Renaissance. That is also virtually the only point on which scholars agree. Every few years debates arise over new proposals for identifying the author of the work, the artist who created the woodcut illustrations, and even over the nature of the work itself. Suffice it to say that the work is a peculiar hybrid: an erotic fantasy written in a Latinate Italian or an Italianate Latin. It is the sort of overwritten hothouse variety of romance that seems to find a wide audience in every fin de siècle era. Colonna, who remains the likeliest candidate for author, was a cleric much given to the sins of the flesh. Recent discoveries point with increasing conviction to Benedetto Bordon as the artist behind the illustrations.

This book is well outside the scholarly mainstream of Aldus's work, for whom it constituted what modern publishing refers to as a commissioned work, published by one entity for another and remaining the property of the sponsor.

PML 1550 (ChL ᶠ1017)

CAMAC 28

REFERENCES: Renouard p. 21; Goff C-767; Helena K. Szépe, *The* Poliphilo *and Other Aldines Reconsidered in the Context of the Production of Decorated Books in Venice*, Cornell Ph.D. diss. (Ann Arbor: University Microfilms, 1992); Lilian Armstrong, "The Hand-illumination of Printed Books in Italy, 1465–1515," in *The Painted Page* pp. 35–47 at 45–46. I am grateful to Lilian Armstrong for her counsel.

THE PORTABLE LIBRARY

Aldus's greatest innovation was his production of the *libelli portatiles*, or "portable little books," a phenomenon that is analogous to the paperback revolution of the past half century. He called his creation (later misnamed pocketbooks) the *enchiridion*, or "handbook," meaning a book that could be held comfortably in the hand. He thought of them as noble instruments (he referred to pseudo-Virgilian pornographic verse as "unworthy of the enchiridion") and intended the series to be composed only of good literature: the "classics" in Greek, Latin, and, very selectively, in Italian. His tripartite achievement consisted simultaneously of (1) an edited text issued without commentary, (2) printed in a novel typeface that mimicked chancery script, the humanist's cursive handwriting, (3) produced in a light, small book of elongated format that would sit comfortably in the hand.

In my view, the portable octavo is *the* quintessential Aldine and is probably what first comes to mind when the books of the Press are mentioned, even if thereafter one quickly thinks of the imposing Greek folios from the incunabular period. The portable library set new goals for Aldus's contemporaries, and publishers have been inspired to honor Aldus's revolution by imitating his achievement ever since.

30. The revolutionary Virgil of 1501 (PML 1664).

Publius Vergilius Maro. *Opera*. Venice: Aldus
Manutius, April 1501.

With this work, Aldus launched his "portable library" of the Greek and Latin classics, notable for containing straight texts issued without commentary and in a small size hitherto used only for works of private devotion (fig. 30). The format allowed readers to carry their books with them, wherever work might require or leisure permit. It made literature more accessible and overturned the norms of publishing learned works in large volumes.

In the history of printing, this modest book speaks volumes—not only because of its handy size but also as the harbinger of the Italian Renaissance in printing. It is the first book printed in italic type, mirroring humanistic manuscripts of the age. This typefont was in limited use in September 1500, and the complete font was certainly ready no later than the first month or two of 1501. The type may be based on Aldus's own handwriting. It was cut by Francesco Griffo da Bologna, a skilled artisan and tumultuous character who finished at the end of a rope for murdering his son-in-law.

PML 1664

CAMAC 32

REFERENCES: Renouard p. 27; AME no. 27; cf. Barker, "The Aldine Italic," the appendix in his *Aldus and Greek* pp. 109–18.

Francesco Petrarca. *Le cose volgari*. Ed. Pietro
Bembo. Venice: Aldus Manutius, July 1501.

This is the first book in the vernacular to have been printed in Aldus's new italic type, three months after its first appearance; it is also the first edition of Petrarch in the revolutionary small format. Petrarch deemed his Latin works to be his most significant; the Aldine title of this famous edition of the *Canzoniere* alludes to this sentiment by indicating that this volume comprises Petrarch's vernacular works. Pietro Bembo issued this edition from a manuscript, still extant, that is a fair scribal copy prepared under Petrarch's supervision and completed by Bembo himself.

This copy is particularly beautiful. Richly illuminated, it is one of the very few printed on vellum; the artist of the miniatures is probably Benedetto Bordon. The frontispiece portrays Petrarch crowned with a laurel wreath by Apollo and precedes the *Canzoniere* (pl. 1). The original arms, not identified, have been overpainted with those of the Johnstone family (marquisate of Annandale), allied by intermarriage with the bibliophilic earldom of Hopetoun, from the early nineteenth century. The second miniature precedes the *Trionfi* and carries two motifs (pl. 2). Above, the artist portrays Apollo with Daphne half-metamorphosed into a tree; lower on the page is

Cupid, blindfolded. The illuminations are stylistically similar to miniatures found in a Venetian (non-Aldine) 1493 Lucian at the Österreichische Nationalbibliothek, Vienna, and a 1501 Aldine Martial at The British Library.

PML 17585

REFERENCES: Renouard p. 28; AME no. 30; Fletcher pp. 95–99; cf. Armstrong, "The Hand-illumination of Printed Books in Italy, 1465–1515," in *The Painted Page* pp. 35–47, esp. 45–47; cf. A. Dillon Bussi, "Le Aldine miniate della Biblioteca Medicea Laurenziana," in Laurenziana pp. 201–28 and col. pls. on 209–24; cf. Susy Marcon, "Una aldina miniata," in Marciana/Sansoviniana pp. 107–33, illus. I am grateful to Lilian Armstrong and Cecil Clough for their counsel.

SOPHOCLES. *Tragoediae*. Venice: Aldus Manutius, August 1502 [but probably issued winter 1502–03].

The *editio princeps* of Sophocles was the first of the Greek classical texts issued in the portable format. It is set in the fourth of Aldus's greek fonts, very likely based upon his own Greek script. This font, like all Aldine greek typography, was very complex and expensive to employ, and its diminutive size must have increased the complexity of its composition; so it is not surprising that the Sophocles was originally priced at double the cost of the Latin texts. Aldus issued it from his Academy and dedicated it to Janus Lascaris, mentioning that the Academicians had been sitting around braziers against the winter's foggy chill, fondly recalling Lascaris.

The editorship, traditionally attributed to Marcus Musurus, has now been credited to Ioannes Gregoropoulos. Most of the copies of Sophocles are on relatively thin paper, which was doubtless intentional, to keep the volume as slender and portable as possible.

PML 1604

CAMAC 48

REFERENCES: Renouard p. 34; AME no. 38; Wolfenbüttel no. 51.

Uncut copy of: EURIPIDES. *Tragoediae* (Greek). Ed. Ioannes Gregoropoulos. Vol. II. Venice: Aldus Manutius, February 1503.

The Greek classics required more preparation than did the Latin volumes in the series, but they began to appear shortly thereafter. The first edition of Euripides, although a work of poor scholarship, would not be superseded until the eighteenth century. This volume is particularly interesting because it allows us to see the new elongated format that Aldus devised for the portable library.

Although this copy was bound in straight-grain black goatskin by Jean-Claude Bozerian late in the eighteenth century, the bookblock itself has remained completely uncut, disclosing the maximum size sheet used for the octavos of Aldus's portable library. This copy measures 17.6 × 10.8 cm, which equates with a "narrow median" sheet of about 33 × 45 cm, folded for octavo. It would have approximated the size of the historical sheet measuring 450 × 315 mm and called the *Reçute* in the Bologna paper statute of 1389 but was specially manufactured for Aldus's revolutionary format.

PML 1328

REFERENCES: Renouard p. 43; AME no. 46; Wolfenbüttel no. 52; P. Needham, "Aldus Manutius's Paper Stocks: The Evidence of Two Uncut Books," *Princeton University Library Chronicle* 55 No. 2 (Winter 1994), 287–307 at 304.

PUBLIUS VERGILIUS MARO. *Opera*. Venice: Aldus Manutius, December 1505.

This edition of Virgil, the first to contain all the authentic works along with the so-called *Appendix Virgiliana*, marks the end of an era for the Press. When he finished editing and printing this composite volume, Aldus left Venice for a brief time.

Aldus's preface states that this book is printed "in our small font, so that you can carry it conveniently with you as a traveling companion." Aldus further notes that the priapic material will be uncensored in this edition, even though he deems obscene material unworthy of the small portable format. This is the first of the octavos with numbered folios.

CAMAC 78

REFERENCES: Renouard p. 50; AME no. 61; Fletcher p. 120.

EURIPIDES. *Hecuba* and *Iphigenia in Aulis* (Latin). Trans. Erasmus. Venice: Aldus Manutius, December 1507.

Erasmus was responsible for Aldus's return to publishing in the autumn of 1507, and this little book was the catalyst. The preeminent scholar was staying with mutual friends in Bologna when he was inspired to write to Aldus in October, proposing this edition and asking that it be printed in the extremely elegant small italic font. Erasmus had been in Paris earlier in the year, and Badius Ascensius printed the first edition of these translations, from Erasmus's manuscript, after Erasmus left for Italy.

Erasmus arrived in Venice the same month this book was completed and moved in with Aldus for the next nine months. Together they completed

the huge September 1508 edition of Erasmus's *Adagia*. During this period
they also jointly edited the works of authors that would not appear in Aldine
editions for another decade or more.

PML 1326

CAMAC 79

REFERENCES: Renouard p. 51; AME no. 62; Fletcher p. 125.

PINDARUS. *Olympia, Pythia, Nemea, Isthmia* (Greek).
Venice: House of Aldus and of Andrea of Asola,
His Father-in-Law, January 1513.

Aldus was forced to flee Venice in the spring of 1509, to escape the dangers
of the War of the League of Cambrai, and was unable to publish anything
until 1512. In his dedicatory preface, Aldus relates that Andrea Navagero was
instrumental in bringing him back to the trade. This particularly elegant edi-
tion is the *editio princeps* of Pindar. The aesthetic distinction is largely the
result of the combination of the portable-library format with the large greek
typeface heretofore reserved for use in folios.

While recent scholarship has rejected the traditional attribution of the
editorship of this work to Marcus Musurus, it remains an important edition
in the textual history of Pindar's works.

PML 1526

CAMAC 92

REFERENCES: Renouard p. 64; AME no. 72; Wolfenbüttel no. 55.

Color printing in: GAIUS JULIUS CAESAR
Commentarii. Ed. Jucundus Veronensis. Venice:
House of Aldus and of Andrea of Asola, His
Father-in-Law, April, November, and December
1513.

All of Caesar's Gaul was divided into three parts, but Aldus's map is tinted in
six colors that Aldus names: purple, tawny, red, golden, green, and the water
in sky blue (see front cover). The colors appear to have been applied by hand
stencil, and the shades vary from copy to copy; here they seem to be red, buff
or beige, two shades of green, and blue. Aldus takes great pains to explain
the color scheme in his preface. He gives the names of the six colors in both
Latin and Greek, explaining in an introduction that color terms are particu-
larly uncertain. Aldus was extremely sparing in his use of color as a rule, only
rarely adding red as a second color to his typography; this is the only instance
in which he employed a polychrome method.

31. The Roman fortifications at
Marseilles in the 1513 Caesar, the caption
probably in Aldus's autograph (PML 1192).

32. The siege of Uxellodunum,
similarly labeled (PML 1192).

This work is an underappreciated example of the seriousness of
Aldus's scholarly practices and requirements. It was at least a year and a half
in the making. Fra Giocondo of Verona received the Venetian ten-year privi-
lege for his editorial work on 28 June 1512, and the text finished printing the
following April. But Aldus then added the multicolored map, other woodcut
illustrations (figs. 31 and 32), a scholarly introduction on colors and place-
names in Latin and the French vernacular, and a general preface. Many sur-
viving copies seem to carry manuscript corrections and improvements by
Aldus.

PML 1192

CAMAC 99

REFERENCES: Renouard p. 60; AME no. 74; Mortimer, *Italian* no. 96 (I 134);
Fletcher pp. 116–19.

PSEUDO-ALDINES AND QUASI-ALDINES

By the end of the fifteenth century, publishing, equipped to benefit from each advance in style and technique, had firmly established its practices and goals. Aldus's portable library of the classics found an immediate market, and other printers recognized their importance and commercial potential. His various privileges extended in truth only as far as Venice's dominions and the practicable enforcement of its laws. But the maritime republic, which was soundly hated in many other regions, was the welcome target of foreign competition in many endeavors. Aldus's competitors "honored" him in their own way by pirating his books. Some printers, however, would embrace the enchiridion format as a legitimate tribute to Aldus's creative genius.

The earliest counterfeiting of typography, format, and texts can be found, within Italy, by Soncino in Fano and the Giunti in both Florence and Venice (this, at least, Aldus quashed by lawsuit). Outside Italy, the great commercial center of Lyon was a burgeoning printing locale, and the counterfeiting enterprise was only the beginning of an era that would see Lyon become a dominant location during the first half of the sixteenth century. We should also note that because so many copies of these piracies are still found in contemporary Italian bindings, the Lyonese must have sold into the Italian market deliberately, and this tactic must have been part of their agenda from the beginning.

The earliest practitioners to issue Aldine piracies came, significantly, from the international ranks of the German and Italian émigrés: Barthélemy Trot (i.e., Bartholomäus Troth), Jacobus Myt (i.e., Jakob Muth, whom the Giunti backed), and Balthasar (or Baldassare) de Gabiano, whose Compaignie d'Ivry in Lyon was a local branch of his family's Venetian bookselling enterprise. As early as 16 March 1503, Aldus published his broadside *Monitum*, a warning citing errors in the pirated books and complaining about their ugly Gallicized typography as well as the smell of the paper. The counterfeiters, of course, used his list to emend their typographic errors when they issued reprints. (See also p. 96.)

MARCUS ANNAEUS LUCANUS. [*Opera*]. [Lyon: ?Guillaume Huyon, 1502 (a. April 1502)].

Lucan's fortunes as a popular author, which have fluctuated considerably, were high in this era. The Aldine Lucan, however, either was printed in an excessive number or went seriously unsold because it is one of the most commonly encountered of the octavos. It is in all major and minor collections, and copies constantly appear in the market. Ironically, this counterfeit is far rarer than the genuine article.

PML 1426

CAMAC 752

REFERENCES: Renouard p. 306; Shaw no. 8.

A warning flouted: MARTIALIS. [*Epigrammata*].
[Lyon: ?Barthélemy Trot, 1502 (a. December 1501
and b. 16 March 1503)].

This is possibly the most flagrant flouting of a warning that one is likely to
find among the counterfeits. Reprinted in this copy is the blunt admonition
that Aldus placed, in capitals, at the end of his edition of Martial: WHOEVER
YOU ARE, WHATEVER WAY YOU MISUSE THIS EDITION WILL CAUSE YOUR CONDEM-
NATION AS A CRIMINAL BY THE ILLUSTRIOUS VENETIAN SENATE. DON'T SAY YOU
HAVEN'T BEEN WARNED. WATCH OUT! The Lyonese did not reproduce Aldus's
December 1501 colophon, of course, but one wonders what motivated them
to reprint the warning.

 This counterfeit Martial is mentioned in Aldus's *Monitum* of 16 March
1503, so this edition probably was issued in 1502. Later printings of this text
are emended, reflecting the Lyonese appropriation of Aldus's *Monitum* as a
corrigenda list.

PML 1464
REFERENCES: Renouard p. 306 and cf. 321–23 (text of *Monitum*); Shaw no. 7.

FRANCESCO PETRARCA. *Le cose volgari*. Ed. Pietro
Bembo. [Lyon: ?Barthélemy Trot, ca. 1502 (a. July
1501)].

Aldus's "classics" in the new format extended to the works of Dante and
Petrarch, and the works in the vernacular were equal grist to the counterfeit-
ers' mill. The existence of this Petrarch reminds us that the pirated Aldines
were also exported back to Italy; a surprising number are still found in con-
temporary Italian bindings.

 Both the PML and the UCLA copies are from the first edition of this
piracy, without foliation.

 Another PML copy, preserved in a very fresh state, has eluded the
depredations of the binder's knife (its present binding was made by François
Bozerian early in the nineteenth century). Its shape thus mirrors the elongat-
ed, quasi-ledger format that was introduced by Aldus. The second pirated
Lyonese edition of Petrarch, it is foliated, dates from ca. 1508, and is tenta-
tively attributed to Gabiano.

PML 5070
UCLA Z 233 A41P44 1502
REFERENCES: Renouard p. 308; Shaw no. 2.

GAIUS SALLUSTIUS CRISPUS. *Opera*. Ed. Benedictus
Ricardinus. Florence: Filippo Giunta, 27 January
1503 (1504 N.S.?).

Even allowing for the unfair competition that the Lyonese counterfeiters
brought to his market, including exporting their piracies to Italy, Aldus prob-
ably viewed the Giuntine competition as the greater threat to his portable
library. The Giunti were strong and active and operated keenly from their
headquarters in Florence, from their local subsidiary in Venice, and soon
enough from a distant subsidiary in Lyon. But in Italy, Aldus was able to take
effective action through litigation; he seems to have been successful in his
lawsuit against Giuntine infringements of his invention, in the summer of
1503, at least enough to cause the Giunti to retrench.

 Riccardini, called Philologus, was a Florentine cleric and Giuntine
house editor for about ten years, up to his death in 1507; he edited several
Greek texts and then produced a string of octavo editions of classical
authors, claiming each to be a vast improvement on all earlier editions. The
Sallust is similar to most of these early Giuntine knockoffs of Aldus's
portable books, imitating the format and typeface but not an edition of an
author already in Aldus's repertoire. Aldus would not publish Sallust until
1509, but the Giunti reprinted his editions of both Horace and Catullus. The
Giuntine Catullus of 5 August 1503, among these exceptions, is excessively
rare, possibly because Aldus's legal success caused the Giuntine inventory of
the title to be destroyed. This copy is illuminated and contains the Borgia
arms.

PML 1584
REFERENCES: Renouard p. xxxiv; Pettas p. 195; Fletcher pp. 103–4.

AULUS GELLIUS. *Noctes Atticae*. [Lyon]: [?Jacobus
Myt] for Barthélemy Trot, 1512.

The colophon of this edition of Aulus Gellius contains the comment that
these works constitute peaceful bedtime reading and that they will be the
reader's "*manuale enchiridionque*"—both the Latin and the Greek form of the
term that Aldus used to describe his octavo format as a literally handy size.

PML 1342
CAMAC 765
REFERENCES: Renouard p. 312; Shaw no. 50.

Portable Hebrew: [ALDUS MANUTIUS]. *Alphabetum
Hebraicum*. [?Venice: by or for Melchiorre Sessa,
ca. 1533].

The first printings of this small-format Hebrew "grammar" can be found in
some of the quarto grammars published by Aldus during the first dozen years
of the sixteenth century. Typically, the *Alphabetum Hebraicum* was added both
to his own work and to Constantine Lascaris's grammar. This is a word-for-
word reprint of a work that first appeared in the February-June 1501 edition
of Aldus's Latin grammar, reprinted at intervals over the succeeding years.
(The quarto version is also a self-contained eight-page work, appended to
the main work and consequently found in varying degrees of completeness
and repair, or occasionally not at all, in a particular copy.) Aldus gives the
Hebrew alphabet, combinations of letters, the familiar text of the Lord's
Prayer in interlinear translation, and ends with the inscription on the Cross in
all three learned languages. He presents this work as essential to the study of
Scripture. Aldus's introductory paragraph mentions his plan to issue, "God
willing," a series of Hebrew books: a grammar, a dictionary, and a Bible.
None of this came to pass, and only trial leaves of a polyglot Bible, unique
survivals at Paris, exist to bear witness to any further attempts along these
lines; otherwise, we have only the brief Hebrew passages in the 1498 edition
of Politian (see pp. 35–36, 46–47, 63–64).

A number of slightly variant copies of the *Alphabetum Hebraicum* in
this format survive, but so many have distinct typesettings that it has not been
possible to assign priority. The portable Hebrew alphabet, printed separately
for insertion on binding, probably began as a self-standing appendix to Las-
caris's grammar, published in octavo at Venice by Melchiorre Sessa at least in
the years 1533 and 1539. Moreover, G. A. Nicolini da Sabbio printed an octa-
vo Lascaris, though without the Hebrew appendix, for Aldus's brothers-in-
law, Gian Francesco and Federico Torresani, in 1540. The present work is of
significance not least for its portable-library format and typefonts allied to
Aldine cuttings. An interesting switch on the customary misappropriation of
Aldus's inventions, however, is the reported tradition that Aldus himself had
appropriated a youthful work by Girolamo (or Gershon) Soncino to create
his own Hebrew alphabet in 1501. If that were indeed the case, this would
represent Soncino's recovery of his own intellectual property but with a
vengeance. The small-octavo format of the Hebrew alphabet, moreover,
appears to derive from the Griffo-Soncino connection; Soncino had stolen
Griffo and his type-cutting skills away from Aldus in about 1503. Here we
find the raids on Aldus's creation continuing into a new generation, in the
hands of additional printers.

PML 58721

REFERENCES: G. Manzoni, *Annali tipografici dei Soncino* (Bologna, 1886) pp. 256–65, esp. 260–61 and 261n.; A. Marx, *Studies in Jewish History and Booklore* (New York, 1944) pp. 308–9, as well as his "Aldus and the First Use of Hebrew Type in Italy," *Papers of the Bibliographical Sociey of America* 13 (1919), 64–67; J. Bloch, "Venetian Printers of Hebrew Books," *Bulletin of the New York Public Library* 36 (1932), 70–92. Cf. Renouard p. 31; Anna Campos, "La grammatica ebraica di Aldo Manuzio," Marciana/Sansoviniana pp. 103–6. I am grateful to T. Kimball Brooker for his counsel.

OTHER DEVELOPMENTS, 1501–29

The Press developed along homogeneous lines during the first three decades of the sixteenth century, with the portable library being its most characteristic element. It continued basically as Aldus knew it until some months after the death of Andrea Torresani; the type, number, and format of the publications continued along established lines. New and revised editions of titles in the portable library appeared steadily, and important editions in the stately folios were issued occasionally. The imprint was maintained as the House of Aldus and of Andrea of Asola, His Father-in-Law, and the principal operatives of the Press were Aldus's two brothers-in-law, Gian Francesco and Federico Torresani. Neither their scholarly attainments nor their editorial efforts were to approach Aldus's, but they had the sustained support of a number of able scholars and do not deserve the summary dismissal accorded them by bibliophiles. Thanks to them, Jean Grolier became increasingly important to the Press and its continued successes.

HIERONYMUS DONATUS. *Ad Christianissimum ac invictissimum Gallorum regem oratio.* Venice: Aldus Manutius, December 1501.

Throughout his career as scholar-printer, Aldus issued commissioned works and occasional pieces that were not crucial scholarly elements of his publishing program. The most famous in the former category is the *Hypnerotomachia*; those in the latter category are much more diffuse and rare. Some of these books were produced as favors, some were to prove politically worthwhile, and some may have generated financial rewards not apparent to us from the records.

The rarest are certainly the occasional pieces that consist of only a few small leaves of text. Reuchlin's *Oratio ad Alexandrum VI pro Philippo Bavariae duce* of 1 September 1498 is the first known clear instance of the genre. The practice of issuing these fugitive pieces would continue throughout most of the existence of the Press.

The PML copy of the present work is especially noteworthy because it is printed on vellum. It is a speech made at Blois on 1 December 1501 before Louis XII by the Venetian diplomat Girolamo Donato (Donà), congratulating the French on their victory over the kingdom of Naples.

PML 1269
REFERENCES: Renouard p. 32; Laurenziana no. 51.

ADRIANO CARDINAL [CASTELLESI] (Adriano da
Corneto, 1461–ca. 1526). *Venatio*. Venice: Aldus
Manutius, September 1505.

This occasional piece, the publication of which must have been an attempt
to encourage favor at Rome, was issued in 1505, a busy year for Aldus. Nearly
thirty years later, it was reissued under Aldine auspices as part of the *Poetae
tres egregii*, a collection of poems about the chase by Grattius, Nemesianus,
and Ovid. This work, dedicated to Ascanio cardinal Sforza, records a hunt
that Castellesi guided at Acque Albule in about 1503.

Castellesi was a cardinal-magnate and reasonably prolific author as
well as a wealthy Church diplomat who led an adventurous life marked by
extremes of success and failure. Although he spent most of his life in his
native Italy, his immense wealth derived from his years as collector of papal
revenues in England, where he was naturalized in 1492 and held such ecclesi-
astical preferments as the bishoprics of Hereford and of Bath and Wells. He
eventually fell afoul of Wolsey, who persuaded Henry VIII to deprive
Castellesi of his benefices and confer them on Wolsey. Castellesi was created
titular cardinal of St. Chrysogonus in 1503, but was deprived of his cardi-
nalate from 1518 until 1521 by Leo X. Preferred by some pontiffs and
entrusted with the most delicate missions and assignments, he was con-
demned by others and forced into exile. He thus survived many Roman and
foreign political entanglements, and he advanced French, English, and impe-
rial causes; he was welcomed in Venice as a refugee on several occasions, even
though the Venetian diplomat Marino Zorzi had once characterized him as
"*duro e sinistro uomo*" in his attitude toward Venice. His writings include liter-
ary, grammatical, and philosophical treatises.

CAMAC 76
REFERENCES: Renouard p. 49; AME no. 59; Laurenziana no. 94; Ciaconius III
col. 206; *Dizionario biografico degli Italiani* XXI 665–71.

PLATO. *Opera omnia* (Greek). Ed. Marcus Musurus.
Venice: House of Aldus and of Andrea of Asola,
His Father-in-Law, September 1513.

This is the last of Aldus's *editiones principes* and one of his most important
Greek editions. He had been planning it since at least 1506, when he was
seeking manuscripts of certain of Plato's works in Florence.

Aldus prefaces this edition with a lengthy address to the new Medici
pope, Leo X, pleading the cause of publishing. At this time, one of Leo's
two private secretaries was Aldus's old friend Pietro Bembo. This volume is
also significant for Musurus's hymn to Plato and his petition to the pope to

free the Greeks from Turkish oppression. By this time, Musurus had gained a public lectureship in Greek.

GNR 5308

CAMAC 97/1–2

REFERENCES: Renouard p. 62; AME no. 78; Wolfenbüttel no. 56.

The Hand of Aldus? in: ALEXANDER
APHRODISIENSIS. *In Topica Aristotelis commentarii.*
Venice: House of Aldus and of Andrea of Asola,
His Father-in-Law, 15 February 1514.

The manuscript corrections have been attributed to Aldus or to someone whose Greek hand was remarkably like his. The corrections note errors of typography or offer variant readings.

It would have been characteristic of Aldus to work on one of his published texts, seeking further improvement. If these annotations are his, he must have worked on the text shortly after it came off the press. He would be dead within the year, and his last few months were clouded by illness that prevented him from keeping his wonted pace.

CAMAC 100

REFERENCES: Renouard p. 62; AME no. 79.

Piero Vettori's copy of: DANTE ALIGHIERI.
[*Commedia*]. Venice: House of Aldus and of Andrea
of Asola, His Father-in-Law, August 1515.

The Renaissance had its own Victorian Age—the *saeculum Victorianum,* which was named for the greatest classical Greek scholar in Italy, the Florentine known throughout the learned world as Petrus Victorius. Piero Vettori (1499–1585) produced a prodigious number of distinguished editions from antiquity. He was most famous in Greek for his Aristotle and in Latin for his Cicero. Scholars and students from all over Europe traveled to Italy to study with him and mourned his death as the end of an age.

His copy of Dante, which he annotated extensively, contains many variant readings (fig. 33) and includes quotations from Aristotle, the author from whom he earned his greatest renown. This second Aldine edition of Dante, a reprint of the 1502 original, now concludes with woodcut illustrations in a separate signature at the end. These final pages regularly seem to be shorter, and bibliographers have long wondered whether they were printed on a smaller (i.e., standard) sheet rather than on the special size required for

33. Piero Vettori's annotations in his copy
of the 1515 Dante (CAMAC 118).

the portable-library format. The UCLA copy, however, is uncut (like another
of Vettori's books, in the PML) and resolves the issue by showing that the
woodcut pages are integral.

CAMAC 118
REFERENCES: Renouard p. 73; cf. Mortimer, *Italian* no. 149 (I 214); Lauren-
ziana no. 133.7.

[BIBLE. GREEK]. *Sacrae Scripturae veteris novaeque
omnia*. Venice: House of Aldus and of Andrea of
Asola, His Father-in-Law, February 1518.

A parallel development to the recovery of classical literary texts was a renewed
interest in the text of Scripture. The early sixteenth century saw a flurry of
activity to produce the Bible in its original languages, and the important text of
the Septuagint, in Greek, was accorded suitably prominent attention.

This Aldine, as it happens, is the first published edition of the Greek
Bible. Aldus's projected polyglot Bible, which did not pass the trial stage in

the summer of 1501, would have included the Septuagint. The Compluten-sian Polyglot, the work of a battalion of learned Spanish editors, was printed between the years 1514 and 1517 but was not published until after the grant-ing of papal approval on 15 March 1522. Erasmus's Greek and Latin New Testament, a much poorer text than the Greek New Testament included in the Complutensian, appeared in 1516. (It is possible that Erasmus learned of the completion of the Complutensian Polyglot and, expecting its imminent release, rushed his own version into print to win the day.)

The editors responsible for the Aldine Greek Bible are not known. Renouard attributed the work to Aldus himself, but there is no proof or even any particular likelihood of this. Gian Francesco Torresani dedicated the Bible to Egidio da Viterbo and prefaced the New Testament with a long let-ter to Erasmus, whose edition, it seems, provided the basis for this part of the Aldine Greek Bible. In any event, this Bible, which is very rare, is a substan-tial piece of liturgical publishing and one of the relatively few Aldines print-ed in black and red.

PML 895

CAMAC 142

REFERENCES: Renouard p. 84; BMC Bible 1 16; Darlow and Moule no. 4594; Laurenziana no. 52 (polyglot trial leaves).

GALENUS. *Opera omnia* (Greek). Ed. Giovanni
Battista Opizzoni (ca. 1485–ca. 1532) et al. Five
vols. Venice: House of Aldus and of Andrea of
Asola, His Father-in-Law, April and August 1525.

This is the most substantial Greek edition published by Aldus's father- and brothers-in-law in the fourteen years between Aldus's death and the closing of the Press in 1529. In its huge physical scope, it rivals the Aristotle as a major piece of Greek printing and is in fact the lengthiest Aldine Greek work published. These volumes made available Galen's vast corpus of med-ical writings in the original Greek. Despite its flaws as a critical edition, it was the basis for medical scholarship and advances for many years.

Aldus's own medical series of the 1490s provided the original scholar-ly contacts for this edition, which was produced by a large and international editorial team, with notable English representation.

PML 1346–1350

CAMAC 202, 203, 204, 206, 207

REFERENCES: Renouard p. 101; Vivian Nutton, *John Caius and the Manuscripts of Galen* (Cambridge: Cambridge Philological Society, 1987), esp. pp. 38–49; Babcock and Sosower no. 55.

HEIRS OF ALDUS AND OF ANDREA OF ASOLA

Between 1533 and 1536, the firm recommenced publishing under this imprint. The heirs working in the shop were Paulus Manutius, who was only twenty years old at first, and his middle-aged Torresani uncles, Gian Francesco and Federico. It was probably Paulus who initiated the enterprise. Within two years, he began to strive for exclusive control of his late father's italic type, which led to a protracted lawsuit and the eventual severing of professional ties between the Manutius and Torresani sides of the Aldine family for at least a few years.

MARCUS TULLIUS CICERO. *Rhetorica.* Venice: Heirs of Aldus and of Andrea of Asola, March 1533.

This was the first issue of the Press's second—and, it would develop, short-lived—era. Paulus, the Ciceronian scholar, described it as his first work.

CAMAC 224

REFERENCES: Renouard p. 107; Martin Lowry, "Aristotle's *Poetics* and the Rise of Vernacular Literary Theory," *Viator* 25 (1994), 411–25, esp. 412.

Large-paper copy of: BALDASSARE CASTIGLIONE (1478–1529). *Il Cortegiano.* Venice: Heirs of Aldus and of Andrea of Asola, May 1533.

Special copies, printed on vellum or an unusual type of paper, or in non-standard formats, were produced occasionally throughout the years. Large-paper copies were somewhat in vogue during the 1530s and '40s. This copy of the 1533 Castiglione in octavo, reprinted from the folio first edition of 1528, is an example of the trend. (The PML copy of the standard octavo version was bound for Jean Grolier.)

The sheet size had to be larger than that normally employed for the standard octavo. The standard sheet permitted substantial but proportional and relatively modest margins. The folio sheet generated a finished copy that could be trimmed to this elongated, ledger shape, with its characteristically oversized lower margin. Although scholarly readers were accustomed to annotating their copies in the margins, a large-paper copy such as this was not produced for that purpose. It was intended to be a patron's presentation copy, subject to minimal use.

PML 28071

REFERENCE: Renouard p. 107.

THEMISTIUS. *Opera* (Greek). Ed. Vettore Trincavelli
(1496–1568). Venice: Heirs of Aldus and of Andrea
of Asola, May 1534.

Relatively few works were issued during this era of the Press and even fewer
were of significance. This is probably the most important book published in
the midst of the deteriorating relationship between Paulus Manutius and his
uncles. It is the *editio princeps* of Themistius's important paraphrases of Aris-
totle, edited by an Italian humanist-physician.

The setting copy is a manuscript that was presented by Reginald car-
dinal Pole to New College, Oxford, where it is preserved. It had once been
in Linacre's possession and may have come to Pole from Paulus. Paulus dedi-
cated the edition to the French ambassador at Venice, Georges de Selve, who
was another link in the strong international network within which the Press
operated.

The PML copy was in the collections of de Thou and Renouard. The
UCLA copy, which is heavily annotated, was certainly in the possession of
Piero Vettori. The annotations are of significance for the textual tradition of
Themistius. Most are likely in the hand of one of Vettori's students, but the
editorial work derives directly from Vettori, and at least some of the Greek
reflects certain of his idiosyncratic forms. Vettori is known to have had a
manuscript of Themistius, which he must have collated against this copy and
another now at the Bayerische Staatsbibliothek, Munich.

PML 1634.1

CAMAC 234

REFERENCES: Renouard p. 111; Schreiber cat. 7 [1979], no. 89 (this copy);
Lowry, *Facing the Responsibility* p. 22; idem, "Aristotle's *Poetics*," art. cit., at 414
and 424.

SONS OF ALDUS AT VENICE AND BOLOGNA

The lawsuit he initiated against his Torresani uncles was decided in Paulus's favor, at Rome, in the summer of 1539. Later that year, he and his two older brothers, Manutius and Antonius, formed a new corporation known as the Sons of Aldus, with Paulus the apparent sole executive. The firm, based in Venice, would continue officially in this guise for two decades. Antonio, who lived in Bologna, used the family corporate imprint during his brief fling with publishing there.

The Venetian output of the Press was enormous and steady. The most significant issues were the numerous editions of Ciceronian works and commentaries—Paulus's area of specialization and the basis of his scholarly reputation.

[BENEDETTO RAMBERTI (1503–46)]. *Delle cose de Turchi*. Venice: Sons of Aldus (Paolo Manutio), 1539.

Following Paulus's successful lawsuit, the reconstituted family firm opened with this modest little book in the second half of 1539. The choice of this book—in spite of its slight dimension—as the inaugural work of the re-established Press could not have been accidental or random. Ramberti (or Rhamberti), secretary of the Venetian senate, who had traveled to Constantinople in 1534, was an influential man, and his anonymously published discourse on Venetian trade routes and contacts treated a topic crucial to the republic's commercial interests. Paulus had been cultivating his friendship since 1533, when Ramberti had introduced him to Reginald Pole, the powerful English cardinal.

The PML copy once belonged to Lord Gosford and bears his characteristic annotations from 1827. But it was separated at some point from the collection, and his family name, Acheson, was erased.

PML 53863 (Gift of Mr. and Mrs. James A. Finn)

CAMAC 260

REFERENCES: Renouard p. 117; Lowry, *Facing the Responsibility* pp. 21, 33; idem, "Aristotle's *Poetics* and the Rise of Vernacular Literary Theory," *Viator* 25 (1994), 411–25 at 412, 414–15, and 421.

BERNARDUS GEORGIUS. *Epitome principum Venetarum*. Venice: Sons of Aldus, 1547.

It is assumed that each of the Aldine occasional publications existed in one very special, if not sumptuous, copy. This copy of Venetian patrician Bernardo Zorzi's concise history of the doges of Venice proves the contention in at least

one instance. The presentation copy to the reigning doge, Francesco Donà (or Donato, 1468–1553; r. 1545–53), it is printed on vellum and illuminated.

PML 1354
REFERENCE: Renouard p. 142 (citing this copy).

PIETRO MASSOLO (Don Lorenzo, O.S.B.; 1520–90).
Sonetti morali. Bologna: Antonio Manutio, 1557.

This is a slender work by a Venetian native who was at the time a monk at Monte Cassino. It is dedicated to Alessandro cardinal Farnese, an influential friend of the Manutius family and the Aldine Press for many years.

Antonio Manutio occasionally combined his own imprint with the Sons of Aldus corporate name. On the title page is a smaller variant of the Sons of Aldus device with different details in the elaborate surround and with the figure of the dolphin reversed (see fig. 16).

PML 1465
CAMAC 445
REFERENCES: Renouard p. 172; Sorbelli p. 117.

[GIULIO CASTELLANI (1528–86)]. *Stanze in lode delle gentili donne di Faenza*. Bologna: Antonio Manutio, [a. 25 January] 1557.

This publication, which is even thinner than the aforementioned work, is on an equally elevating, if less pious, theme. A native of Faenza who had a long clerical career, Castellani was called to Rome by Gregory XIII in 1577 to be professor of philosophy at the Sapienza; he died there as the titular bishop of Cariati in Calabria. He wrote on a variety of subjects. The scarcity of the present work is such that it was reprinted in typographic facsimile by Tosi at Milan in 1841. The PML copy is a quarto; the UCLA copies, both folio and quarto, are one or more facsimiles.

Antonio seems to have limited his publishing to a few works of local or particular interest. The title page carries the large dolphin-and-anchor device within a wreath, as used by Paulus, and it has been suggested that Paulus in fact printed this for his elder brother, but Paulus himself disavowed the claim.

PML 1201
CAMAC 142184* and 142185 (facs.)
REFERENCES: Renouard p. 172 (erroneously citing the author as "Antonio" Castellani); Sorbelli p. 117.

AENEAS VICUS (Enea Vico, 1523–67). *Augustarum imagines aereis formis expressae.* Venice: [?Paulus Manutius for the author], a. 30 September 1558.

Illustrated Aldines are found very infrequently, and even rarer are Aldines that are also Renaissance portrait books containing metal-cut engravings. This is a Latin translation, by Natale de' Conti (1520–82), of Vico's *Le imagini delle donne auguste intagliate in istampa di rami,* which he had published with Valgrisio in Venice the previous year. This edition reuses many of the same copperplates. It is, as its title in both languages indicates, a portrait volume of the leading women of Augustan Rome.

Vico appears to have been his own publisher and thus had control over the physical appearance of his work. Plate XI did not turn out as intended, and a paper patch was applied to obscure the central roundel with the medallion portrait of Julia, Drusus's daughter. In the UCLA copy, the cancel has long since vanished, enabling us to see most of what the engraver initially accomplished. The PML copy, on the other hand, has had all of the figure and most of the inscription eradicated. Since the copy is in a famous grotesque-style Genevan polychrome-mosaic binding of the period, this mutilation appears to have been undertaken very early.

PML 1660

CAMAC 455

REFERENCES: Renouard p. 176; Mortimer, *Italian* no. 533 (II 739–40); Clough, "Italian Renaissance Portraiture," pp. 188–89; Needham, *Twelve Centuries* no. 88.

FEDERICO COMMANDINO (1509–75). Manuscript of his Latin translation of Archimedes' works. Venice, ca. 1558.

This was the printer's copy used for setting the 1558 Aldine edition (fig. 34). It is marked with casting-off and page-break indications, contains variant readings and improved translations, and is smudged with ink from the compositor's hands. It belonged at one time to Clement XI (Giovanni Francesco Albani, 1649–1721; r. 1700–21).

CAMAC 797

REFERENCES: Pamela Neville, "The Printer's Copy of Commandino's Translation of Archimedes, 1558," *Nuncius* I No. 2 (1986), 7–12; cf. Renouard p. 173.

34. The setting copy for Commandino's translation of
Archimedes, printed in 1558 (CAMAC 797).

ARCHIMEDES. *Opera* (Latin) and *Commentarii*. Trans.
Federico Commandino. Venice: Paulus Manutius,
1558.

This is the published form, issued with a notice that it is protected by a ten-year privilege. Each component of this edition is dedicated to an influential member of the Farnese family: the former, to Cardinal Ranuccio; the latter, to Duke Ottavio.

PML 1122.1–2

CAMAC 448

REFERENCE: Renouard p. 173.

ACCADEMIA VENEZIANA

The last years of the 1550s saw Paulus engaged as contract printer to the Academy, called Academia Venetiana in its own day, and also known as the Academia della Fama from its emblematic device. The Academy was the brainchild of Federico Badoer, who envisioned a vast program for the issuance of works in most fields of contemporary human knowledge. Like all such undertakings, its grasp far exceeded its reach, and its early demise was inevitable.

PAOLO MANUTIO. *Polizze* and *Conti con l'Academia Venetiana intorno le stampe.* [Venice: Paolo Manutio, 18 January 1557/8–28 January 1558/9].

During the years just prior to his departure for Rome, Paulus was the contract printer to the Academy. This was a source of much work and considerable income for him: he recorded a weekly retainer, Saturday to Saturday, of 20 ducats. He produced a limited number of typically slender books, works marked by chaste typography and austerity of treatment. The Academy's *Fama* device graced the title pages in at least a half dozen engraved versions.

Paulus's work for the Academy, familiar to us from the books he produced, also involved considerable job printing—documents, agreements, statements, contracts, and the like—issued as single leaves or very small, ephemeral pieces. The PML safeguards a substantial group of these, bound as booklets, of which this may be the most interesting. It comprises four letters written on 6, 21, 22, and 30 July 1558—the *Polizze*, or proposed policies—to decide such matters as the titles to be printed, the sequence of publications, formats, and materials. He suggests three typefaces: for the folios, the font that graced many of his father's books; for the octavos, a new one he had had cut a year earlier; and for the quartos, a new face imported from France. Paulus's regular statements of account record his work as well as the costs of materials and labor, with tallies for the print runs.

PML 40660
REFERENCE: Renouard p. 278.

[Giulio Raviglio Rosso (fl. 1550s–60s)]. *Historia delle cose occorse nel Regno d'Inghilterra, in materia del Duca di Notomberlan dopo la morte di Odoardo VI.* Venice: [Paolo Manutio for] Academia Venetiana, 1558.

This first edition of this English history (yes, that is the Duke of Northumberland and Edward VI in the title) contains an interesting account of the landing of Philip of Spain at Southampton, his journey to Winchester, and his marriage there to Queen Mary. It was issued anonymously, without the Ferrarese author's approval; he reports in his own edition of 1560 that his manuscript had fallen into the hands of Venetian gentlemen during the course of a 1554 embassy to Emperor Charles V. The preface opens with praise of Federico Badoer, the Venetian patrician who founded the Academy. Paulus printed 1,100 copies of this work, for which he billed the Academy 21 *lire*, 16 *scudi*. One of the PML's two copies is uncut, showing the original, untrimmed size of the sheet.

PML 1576

CAMAC 458

REFERENCE: Renouard p. 271.

Petrus Haedus (Pietro Cavretto, b. ca. 1424). *De miseria humana.* Venice: [Paolo Manutio for] Academia Venetiana, 1558.

Paulus printed 825 copies of this first edition, which includes a lengthy dedication from the Accademia Veneziana to Ippolito II, cardinal d'Este (1509–72), the nephew of Isabella d'Este Gonzaga, marquise of Mantua, sometime patroness of Aldus early in the century. The academicians, of course, were seeking his patronage. One of the many Este Renaissance cardinals, Ippolito II was cardinal-protector of France, and Paul IV appointed him *legatus a latere* to Catherine de Médicis from 1561 to 1563. He was a great patron of the arts and established the Villa d'Este at Tivoli. The last thing he had to worry about was the misery of the human condition, except perhaps when he lost his chance at the papacy. He was voted down because of his support of French policies and because the reform-minded cardinal-electors found him too worldly.

PML 1362

CAMAC 462

REFERENCES: Renouard p. 272; Mortimer, *Italian* no. 120 (I 171).

PAULUS AT ROME

Paulus had longed to live and work in Rome since the late 1530s; his wish
was finally fulfilled at the beginning of the 1560s. He was brought there
under papal auspices to print a variety of learned books, both theological
and secular, and the funding for his enterprise was subsequently transferred to
the Commune of Rome, over the objections of the secular authorities. Frac-
tious relations between the papal curia and Roman officials engendered sev-
eral unpleasant episodes for Paulus. He returned to Venice in 1570,
embittered over his experiences.

35. Paulus is called to Rome: the Vatican contract of May 1561 (CAMAC 798).

JOANNES MORONUS (Giovanni Morone, 1509–80; card. 1542). [*Contract Between the Camera Apostolica and Paolo Manutio*]. Document signed, *Inc.* "Desiderando la Santità di Nostro Signore . . . di condur' in Roma una stampa . . ."; *Expl.* ". . . tra quindici giorni prossimi da venire." Rome, ca. 1–2 May 1561.

This contract ended Paulus's long campaign to be called to Rome (fig. 35). His first known contact with one of the principals behind this contract had been in 1537, but he spent a half dozen years in the 1550s appealing fruitlessly to his family patron, Rodolfo cardinal Pio di Savoia of Carpi, for a new Roman career. Paulus had pinned his hopes on the Carafa pope Pius IV, who was antipathetic to printing. Following the passing of the Carafa papacy in 1559, his wishes were fulfilled. The patronage of the College of Cardinals, which was more crucial than that of the pope, ensured his Roman career, which would last a decade, 1561–70.

The author of this contract may have been Antonio Bernardi de Mirandola (1502–65), bishop of Caserta, who is named in the document as Paulus's treasurer (*procuratore*). It has been emended, endorsed, and signed by Morone and countersigned by the cardinal-chamberlain, Guido Ascanio Sforza (1518–64; card. 1534). The terms require Paulus to publish books of all sorts in Rome for twelve years, for an annual stipend of 500 gold *scudi*, plus a half share in the division of any profits. He was to be in complete charge of the operation and to conduct himself in a faithful, loyal, and professional manner.

CAMAC 798
REFERENCES: Lowry, *Facing the Responsibility*, passim; Fletcher, "Paulus Manutius in Aedibus Populi Romani" (forthcoming in Villa I Tatti).

MATTHAEUS CURTIUS (Matteo Corti, 1475–1542). *De prandii ac caenae modo*. Rome: Paulus Manutius, 1562.

Paulus was not restricted to publishing books of a particular type; they included theological works generated or required by the Council of Trent as well as learned editions and occasional treatises. The present work falls into the last category, but what is particularly noteworthy is its provenance.

The title page bears the marshaled arms of, apparently, a pair of cardinals. The hat and tassels are printed from one woodblock, the ornate cartouche from another. The charge of arms, painted in with gilt and colors, marshals Alfonso Carafa (1540–65; gules, three fesses azure) with Michele Ghislieri (1504–72; bendy gules and or). Ghislieri and Carafa were both cre-

ated cardinal in 1557; Carafa was the nephew of Pius IV; Ghislieri would be raised to the See of Peter in 1566 as Pius V. We see here graphic evidence of two of the important men who constituted Paulus's primary audience.

CAMAC 511
REFERENCE: Renouard p. 187.

[COUNCIL OF TRENT]. *Canones et decreta.* Rome: Paulus Manutius, 1564.

During his decade in Rome, Paulus was responsible for printing and publishing a variety of works generated or required by the final session of the reform Council of Trent. These included editions of patristics and revised service books. One of Paulus's most important duties was to print the collection of the Council's decrees. The original Roman folio editions are found in at least three categories: completely interleaved and heavily edited, with elaborate certificates of authenticity laid in; extensively edited and signed by the secretary and notaries; and subsequently revised and reprinted with reset text.

This work was published in a myriad of formats, editions, and printings, both in Rome by Paulus and in Venice by Aldus the Younger. There were no fewer than thirteen Aldine issues alone, in folio, quarto, and octavo.

The PML copy falls within the first category and includes the sealed certification of the secretary and notaries (pl. 8). The UCLA copy falls within the second and contains a revision in the title of the first chapter of the twenty-third session (cf. pl. 9). The hand is quite possibly Paulus's, although it also bears a strong resemblance to that of one of the Council's notaries, Cynthius Pamphilus (Cinzio Pamfilo).

PML 1214
CAMAC 529b
REFERENCES: Renouard p. 190; Barberi pp. 130ff.

[ROMAN BREVIARY]. *Breviarium Romanum.* Rome: Paulus Manutius In Aedibus Populi Romani, 1570.

This imposing folio, which has the large composite printer's device (see fig. 18), was Paulus's final work in Rome. It is a handsome example of liturgical printing, in black and red, and quite an achievement for Paulus, for whom this kind of technical feat remained elusive. It may stand as a conclusion worthy of Paulus's Roman hopes, if not accomplishments.

PML 1138
REFERENCE: Barberi pp. 160–61 and illustrated. Not in Renouard.

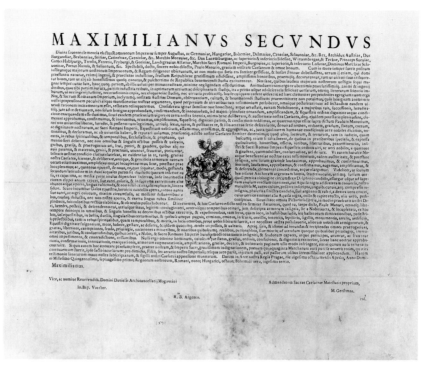

36. Maximilian II confers an imperial knighthood on Paulus and grants a charge of arms that incorporates Aldus's dolphin-and-anchor device (PML 27693).

MAXIMILIAN II (1527–76, r. 1564–76). [*Diploma insignium*]. [?Venice: Dominicus (Domenico) Basa for Paulus Manutius, a. 28 April 1571].

Paulus had hoped for a pension but received what he viewed as an empty honor. At Prague on 28 April 1571, the emperor created him a knight of the Holy Roman Empire, in recognition of his scholarly attainments and to honor the benefits his labors brought to the emperor and his subjects (fig. 36). Two copies of this folio broadside, including this one, seem to be recorded. This copy after the manuscript original is printed on vellum and is probably a product of the Aldine Press. There also exists a nine-teenth-century typographic facsimile of this broadside.

This patent of nobility contains a complete blazoning of arms—the charge of arms itself is reproduced here in woodcut—detailing the particulars of metals and colors. These arms are based, obviously, upon the Aldine printer's mark created for Aldus in the summer of 1502. This new, imperial guise would appear occasionally as the Press's device over the next few years. As such, it would be used by Aldus the Younger.

PML 27693

REFERENCE: Renouard pp. 214, 509–12 (text).

76

[OFFICIUM B. M.V. LATIN. USE OF ROME]. *Officium B[eatae] Mariae Virginis Nuper reformatum et Pii V Pont[ificis] Max[imi] Jussu editum cum Privilegio et Indulg[ent]iis.* Rome: [Fabrizio Galletti] In Aedibus Populi Romani, [a. 5 April and b. 7 July] 1571.

The Officium is the Italian equivalent of the French Horae. This copy, which is unrecorded, has been printed in red and black on vellum for presentation to the pope who brought it into being and was, in effect, Paulus's ultimate patron during the latter half of his Roman publishing years.

Pius V (Michele Ghislieri, O.P., 1504–72; r. 1566–72) entered the papacy with the avowed intention of carrying out the reforms decreed by the Council of Trent. His liturgical reforms have lived on in the editions of the Roman Breviary and Missal issued in his name; this Office of the Virgin is a popular offshoot of the Breviary. This copy is in its original presentation binding of red velvet over pasteboards with silver catches and clasps and cornerpieces, the papal arms in silver and silver-gilt centered on both covers.

The title leaf is fully illuminated by hand in gold and colors. The top panel portrays Pius V kneeling in adoration of the Virgin and Child; the Christ Child is conferring a blessing. The pope is bareheaded and wearing a golden cope, the papal tiara on the floor before him. The lower panel carries the full charge of his mantled arms, supported by cornucopias. The rest of the page carries a calligraphic title and imprint solely in manuscript: that is to say, there is no printing underneath, and the verso of the leaf is blank.

Paulus ceased publishing for the printing house known in the vernacular as the Stamperia del Popolo Romano in 1570, when he sold his interest to Galletti. His publications included a similar Office of the Virgin in 1565, a work recorded only in a letter from Christophe Plantin at Antwerp to his patron Cardinal Granvelle, asking for a copy and for the cardinal to obtain papal permission to reprint this edition in the Low Countries. A 1575 Hours published by Plantin is recorded as bearing a device with the SPQR motto.

PML 18244

REFERENCE: Cf. Barberi pp. 138–40 and illus. (1565 Office).

ALDUS THE YOUNGER AT VENICE, BOLOGNA, AND ROME

Beginning in the mid-1560s, the younger Aldus, despite his youth, appears to have had increasing responsibility for the operation of the Press at home in Venice; he probably enjoyed the services of Domenico Basa, the Venetian master printer whom his father had hired for five years in 1568. Aldus Jr. began to publish with his own imprint from the beginning of the 1570s and worked sporadically in his native Venice, in Bologna, where he was surrounded by relatives and had a brief teaching career, and finally in Rome. Examples of his Bolognese work include editions of his father's writings, and the younger Aldus effectively closed out his Roman career with three great Bibles. A number of these non-Venetian publications are described in other chapters of this catalogue (see pp. 23–24, 80–82).

ALDUS MANUTIUS THE YOUNGER. *Eleganze, insieme con la copia, della lingua Toscana e Latina.* Venice: [Paolo Manutio], ca. April 1558.

This early work suggested a youthful prodigy worthy of his grandfather's name. Aldus the Younger was just two months beyond his eleventh birthday when the preface was dated. Talented boys were capable of considerable linguistic achievements in his era, of course, but the sophisticated arguments employed here have suggested to some that his proud father had a hand in the work.

Aldus Jr. would make something of a name for himself as a linguist; he is credited, for example, with establishing the semiconsonantal distinctions between *i* and *j* and *u* and *v* in Latin. He studied law for a time in Bologna, where the descendants of his grandfather's sisters lived, and he exercised a somewhat desultory and diminishing role in the conduct of the Press. Eventually becoming a valetudinarian, he lived in Rome and died in the Vatican.

CAMAC 450
REFERENCE: Renouard p. 450.

PETRUS JOANNES NUNNESIUS (Pedro Juan Nuñez, d. 1602). *Epitheta Ciceronis.* Venice: Aldus the Younger, 1570.

This early publication by the younger Aldus appeared when the Press was still nominally being operated by Domenico Basa, only two years into his five-year contract. The title page carries a guise of the device that Aldus Jr. used sporadi-

cally (see fig. 21). The final verso of the book carries, in the form of a lapidary inscription, his full Latinate credentials: ALDVS. MANVTIVS | PAVLI. F[ILIVS]. | ALDI N[EPOS].—"Aldus Manutius, Son of Paulus, Grandson of Aldus."

PML 1290
REFERENCE: Renouard p. 209.

A late tally in: VINCENZO PRIBEVO (Vinko
Pribojevic, fl. 1525–32). *Della origine et successi de gli
Slavi*. Tr. Bellisario Malaspalli. Venice: Aldo, 13 May
1595.

Between 1586 and 1597, at Venice, the Press released about two dozen catalogues of books in stock. Issued as appendices to various volumes, they range from one to more than six pages, taking up the last leaf or leaves of the final signature. Their formats are dictated by the size of the books in which they appear and are thus found in octavo, quarto, and folio. This is the penultimate one recorded.

Precisely a century after Aldus began to publish, this catalogue of books in print was issued in his grandson's name. The implication of the phrase in the heading, "*nella Libraria di Venetia*," is that the stock was for sale at home in Venice, rather than in Rome, where Aldus Jr. had taken up his final residence. In fact, all these lists were produced by Niccolò Manassi, who ran the Aldine Press in Venice, under unknown contractual arrangements, between 1585 and 1598. They probably represent attempts to sell off remaining older stock in the course of publishing new books.

The fifth entry is for the younger Aldus's 1576 edition of his grandfather's Latin grammar, the earliest version of which had appeared in 1493, issued by his great-grandfather Andrea Torresani. The list continues with a long run of his own works, in Latin and the vernacular, including his biography of Cosimo de' Medici that he issued in Bologna in 1586.

CAMAC 705
REFERENCES: Renouard p. 253; G. Pollard and A. Ehrman, *The Distribution of Books by Catalogue to A.D. 1800* (Cambridge: Roxburghe Club, 1965), pp. 49, 161–63, 191, esp. Table XXI on 162. I am grateful to Christian Coppens for his counsel and for access to his work in progress.

THE BATTLE OF THE BIBLES

The last phase of the Aldine Press was highlighted by a major textual problem involving the official edition of the Latin Bible, the Vulgate, formally designated by the Church as representing the word of God. The text of the Vulgate had been criticized since the days of Lorenzo Valla and Erasmus, and the strictures of the Protestant Reformers were particularly noted. The reforming Council of Trent had decreed as early as 1546 that a carefully edited version of the authentic text be printed. But the final session of Trent had ended in December 1563 with no progress, and the sitting pope at the end of the 1580s, an eloquent and stern disciplinarian devoted to the internal reform of the Church, decided that it was high time the definitive text appeared.

Sixtus V (Felice Peretti, 1520–90; r. 1585–90) grew so impatient with the commission charged with editing the Vulgate that he undertook the personal supervision of the edition. But the version issued in his name was so riddled with errors and subjected to such criticism that it was withdrawn as soon as he died. The papal bull decreeing anyone anathema who tampered with the sponsored text proved a considerable but not insuperable difficulty. An interim re-edition was issued in progressively more corrected versions in 1592 and 1593 under Clement VIII, though still bearing official indications solely of Sixtus's sponsorship. Clement's name did not appear on a title page until 1604, the year before his death, but the Clementine version became the authoritative text for many years.

All these editions constituted the last major undertaking of the Aldine Press, a full century after its auspicious beginnings. Aldus the Younger, in permanent residence at the Vatican, was responsible for printing the Bibles and dealing with the many internal and external problems. He must have had to contend with more than the usual share of challenges.

[BIBLE. LATIN. 1590]. *Biblia sacra vulgatae editionis.*
Rome: Typographia Apostolica Vaticana [Aldus
Manutius the Younger], 1590.

This first edition of the Sistine Vulgate began a battle of the books. Irked by the long delay in issuing an authoritative edition as required by the Council of Trent, Sixtus undertook to be the editor, with predictable results. The text, meant to fix the Latin Bible, was now available in a highly defective version that carried papal approval and prohibited alterations.

The text in this edition has been corrected in about a dozen places, partially in pen and ink and partially by pasting the corrected reading over the faulty one. These few acknowledged textual problems, though, were

barely the tip of the iceberg in proportion to the many defects. In fact, the edition was so riddled with errors that it was withdrawn from sale as quickly after Sixtus's death as could be decently managed. The PML copy, in an eighteenth-century binding with the arms of Pius VI (Giovanni Angelo Braschi, 1717–99; r. 1775–99), belonged to Antoine-Augustin Renouard, the Aldine bibliographer.

PML 823

CAMAC 683

REFERENCES: Renouard p. 243; BMC Bible 1 56; Darlow and Moule no. 6181.

[BIBLE. LATIN. 1592]. *Biblia sacra vulgatae editionis.*
Rome: Typographia Apostolica Vaticana [Aldus
Manutius the Younger], a. 9 November 1592.

Although it appears to be a reissue of the 1590 Sistine edition, this is in fact a heavily reworked version of the first Sistine Vulgate. In seeming compliance with the late pope's prohibition of any change in his sponsored text, it was made to appear the same as its predecessor. The most prominent clue to changes can be found in the title-page notice, which states that this Bible is "*recognita atque edita*"; the 1590 edition spoke of itself as "*recognita et approbata*." In fact, this is the first Clementine edition issued under the authority of the new pope, Clement VIII (Ippolito Aldobrandini, 1536–1605; r. 1592–1605). His name is conspicuously and deliberately absent, however, and would not appear on the title page of any issue until 1604. A further clue is Clement's letter of 9 November 1592, granting exclusive protection to this edition as the exemplar that all printers were to follow for a period of ten years.

A team of prelates and other clerics produced this revision. Despite the approximately 4,900 changes, this was still a seriously flawed edition. The PML copy is on very large paper. The UCLA copy, also on very large paper, is a most interesting association copy as well. It is in a contemporary Roman binding of red goatskin, gilt with the arms of Alessandro Peretti, cardinal de Montalto (1570–1623), grandnephew of Pope Sixtus V; the pope had been born Felice Peretti in 1520 at Grottammare, near Montalto in the March of Ancona.

PML 824

CAMAC 696

REFERENCES: Renouard p. 248; BMC Bible 1 57; Darlow and Moule no. 6184.

[Bible. Latin. 1593]. *Biblia sacra vulgatae editionis.*
Rome: Typographia Apostolica Vaticana [Aldus
Manutius the Younger], 1593.

With the continued editorial work, it was possible to reissue the Bible once
again, further corrected, though still without credit to the current pontiff.
The only indications that this is the Sistine-Clementine are the repetition on
the title page that the Bible is "*recognita atque edita*" and the reprinting of
Clement's letter of 9 November 1592 reserving authority exclusively to this
edition. This second Clementine reissue of the Sistine Vulgate is published in
large-quarto format, and thus without the elaborate engraved title page. With
periodic re-editing, it would remain the definitive text of the Vulgate for
more than three centuries.

The PML copy is in a handsome contemporary Roman binding of
red goatskin over thin wooden beveled boards, heavily gilt to a strong panel-
and-cornerpiece design, with central gilt-stamped medallions of Christ on
the front cover and of the Virgin Mary on the back; the edges are gilt and
goffered.

PML 825

CAMAC 702

REFERENCES: Renouard p. 250; BMC Bible I 57; cf. Darlow and Moule no.
6184.

THE TORRESANI AS INDEPENDENT PUBLISHERS

Andrea Torresani began to publish in Venice upwards of fifteen, and perhaps twenty, years before the opening of the Aldine Press. Before, during, and after the years of working in the Aldine establishment, Andrea, his sons, and their heirs continued as publishers with their own imprints. The subsidiary that operated at the sign of the dolphin and anchor on the rue Saint-Jacques in Paris "à la boutique d'Alde" was a purely Torresani enterprise.

Along with the numerous exhibited Aldines in which they had a direct and sometimes sole hand, these works enhance our understanding of the independent Venetian achievement of the Torresani and give a view into their foreign undertakings.

PUBLIUS VERGILIUS MARO and SERVIUS. *In Bucolica [Vergilii] Maronis commentariorum liber.* Venice: Bartolommeo de' Blavi and Andrea Torresani of Asola, 1 August 1480.

This edition of Servius's commentary on Virgil's *Bucolics* is among the earliest works signed by Andrea Torresani. It dates from the same year in which he acquired some of Jenson's equipment, sold to him by Jenson's German executor, Peter Ugelheimer.

CAMAC 707
REFERENCES: Renouard p. 282; Goff V-169.

ARISTOTLE. *Opera* (Latin). Venice: Andrea Torresani of Asola and Bartolommeo de' Blavi (in part for Johann of Cologne), 1483.

Early in his publishing career, the books Andrea printed or had printed for him were typical folios of their era, but this copy represents the finest. This luxurious edition, printed on vellum, was called by Henry Yates Thompson, with understandable hyperbole, "the most magnificent book in the world." The spectacular trompe-l'oeil frontispieces are assigned to Girolamo da Cremona, and the additional miniatures throughout both volumes are attributed to Antonia Maria da Villafora and others.

In the first volume, the vellum of the page appears to have been torn away to reveal Aristotle conversing with a turbaned figure, possibly the Cordovan commentator known in the West as Averroës (1126–90). Beneath is a richly decorated architectural façade set into a landscape populated with satyrs, putti, and deer. A Latin inscription on the façade states that one Petrus Ulmer "brought this Aristotle into the world." This is very likely Peter Ugel-

heimer, a Frankfurt entrepreneur resident in Venice, who invested substantially in the publishing world. Torresani purchased printing equipment from Nicolas Jenson's estate, and Ugelheimer, who was Jenson's partner and executor, was the agent. The turbaned figure might be intended as a portrait of Ugelheimer. A virtually identical portrait, also by Girolamo, is found in the copy presented to Ugelheimer of a 1482 Venetian edition of the *Expositio problematum Aristotelis* by Petrus de Abano, preserved in the Royal Library at The Hague. And a very similar portrait, this time by the Maestro delle Sette Virtù, again with Ugelheimer's arms, is found in a presentation copy of the 1481 Venetian edition of Innocent IV, *Decretales*, now in the State Library at Gotha.

The trompe-l'oeil characteristics are, if anything, intensified in the second volume. Girolamo made one page of text resemble a pierced banner suspended from a balcony, upon which philosophers—ranging from Thomas Aquinas on one end to an ape on the other—discuss the opening premiss of Aristotle's *Metaphysics* that "all men desire by nature to know."

PML 21194–21195 (ChL ᶠᶠ907)
REFERENCES: Renouard p. 284; Goff A-962; Marciana/Sansoviniana p. 121 (citing erroneous accession no.); *The Painted Page* no. 101.

STEFANO NICOLINI DA SABBIO. *Corona preciosa.*
Venice: Gian Antonio Nicolini da Sabbio and
Brothers for Andrea Torresani of Asola, 27 August
1527.

For virtually a score of years, 1507–27, Andrea Torresani appears to have published no books on his own. Late in his life, he had at least two books printed for him. There may have been others, of an ephemeral nature, that are not recorded. This book owes its authorship and production to members of the extensive printing dynasty that would do much work for Andrea's sons a decade hence (see also p. 94).

CAMAC 732
REFERENCE: Renouard p. 293.

[Roman Catholic Church. Slavonic rite. Prayerbook (Croatian)]. [*Alphabetum et preces Illyricae*]. Venice: Andrea Torresani of Asola, 1527.

37. Andrea Torresani's tower device, from a 1527 Slavonic prayerbook (27 × 26 mm; PML 1147).

The variety of his publications over his half century in Venetian publishing suggests that Andrea Torresani had a speculative nature. None of his books was more exotic than this, which he issued the year before his death. It is a liturgical work, variously described as containing four or six leaves, printed in Glagolitic characters in the so-called Croatian variant of Church Slavonic. It was intended for use in Slavonic-rite churches in the nearby Venetian trading areas of Dalmatia and Croatia, across the Adriatic. This copy was purchased by John Evelyn when he was in Venice in 1645, and it is one of approximately three known to survive; it may lack two central leaves.

The pamphlet contains a variety of standard prayers, with selections from the Psalms. It opens with an extensive alphabet, suggesting that it was intended to serve as a primer as well as a prayerbook. The only non-Glagolitic text appears in the colophon, which is complemented by the printer's device. The device, which Torresani began to employ at least from the 1490s, was also his shop sign at the turn of the century. A few letters survive from the first years of the sixteenth century, addressed to him and to Aldus, directed to the bookstall at the Sign of the Tower at San' Innocenzo. Torresani adapted the tower (i.e., *torre*) to the guise of a rebus device; this book contains one of the guises he employed (fig. 37).

PML 1147

REFERENCES: Renouard pp. 293–94; J. D. Prince, "A Rare Old Slavonic Religious Manual," *Proceedings of the American Philosophical Society* 55 No. 5 (1916) 357–62 (this copy); Fletcher p. 65.

[Johannot Martorell (completed by Martin Juan de Galba, d. 1490)]. *Tirante il Bianco* (*Tirant lo Blanch*, Italian). Trans. Lelio Manfredi. Venice: Pietro dei Nicolini da Sabbio for Federico Torresani, 1538.

Cervantes praises this chivalric romance, in *Don Quixote*, as the best of its kind. It relates the tale of a young nobleman, Tirant lo Blanch, who traveled to many countries, finally becoming ruler of Constantinople. Written in Spanish (or rather, Catalan) in the mid-fifteenth century, it was first printed in Valencia in 1490. This is the first Italian translation.

The title is printed in the form of a chalice or cup within a woodcut border of shaded tendrils. One of Federico's versions of the Torresani rebus device of a tower (or *torre*) is incorporated into the lower border.

PML 1640

CAMAC 258

REFERENCES: "Bibliografia del 'Tirant lo Blanch'," *Bibliofilía: recull d'estudis. . . de llengua y literatura catalanes* (Barcelona), 1 (1911–14), cols. 455–61 at 458, with facsimile illustrations; Schreiber cat. 13 [1985] no. 94.

JOANNES ZACHARIAS ACTUARIUS. *Opera.* Paris:
Guillaume Morel for Bernard Turrisan, In Aldina
Bibliotheca, 1556.

This collection of medical topics, by a thirteenth-century author, may have been intended for the local university market. It includes a commentary by the physician Cornelius Henricus Mathisius, of Bruges, who dedicates it to Louis of Flanders, chamberlain of Emperor Charles V.

Bernard Turrisan worked on the rue Saint-Jacques (mentioned in this title-page imprint) as a publisher rather than printer. This book was printed for him by Guillaume Morel, French royal printer in Greek at this time. The Aldine device is entirely woodcut, including Aldus's name (see fig. 24).

PML 1139

CAMAC 739 (variant, not in Renouard)

REFERENCES: Renouard p. 296; cf. F. Schreiber, *The Estiennes* no. 139.

PAULUS MANUTIUS. *Antiquitatum Romanarum liber de legibus.* Paris: Bernard Turrisan, In Aldina
Bibliotheca, 1557.

The sole installment of his studies on Roman antiquities that Paulus himself published—leaving the balance for his son to issue—was his treatise on Roman law. He printed two folio editions in Venice in 1557, and they were followed by this octavo Parisian edition. Paulus took pains to correct his first edition, and the corrected texts printed in this edition suggest that it was sanctioned by Paulus.

The edition follows French, rather than Venetian, typographic style and contains the royal privilege, issued at Villers-Cotterêt on 4 April 1556 *avant Pasques*. Specifying "before Easter" is intentional and signifies an Old Style date. The French new year began with Easter, which fell on 18 April in

1557, so the privilege was in fact signed on Passion Sunday of that year. The 1557 date on the title page suggests that the book was not issued until after the 18th.

PML 79324 (Bequest of Curt F. Bühler)

CAMAC 742

REFERENCES: Renouard p. 297; Curt F. Bühler, "Pen Corrections in the First Edition of Paolo Manuzio's 'Antiquitatum Romanarum liber de legibus'," *Italia medioevale e umanisticha* 5 (1962), 165–70 at 170.

BOOKBINDINGS

Bindings serve a dual purpose by safeguarding the contents and making the physical artifact enticing. The various Aldines displayed as bindings throughout the exhibition are, typically, bound in colored tanned leathers, often decorated in gilt and occasionally in polychrome. They tend to be understatedly elegant and reflect the appearance that many books from the Aldine Press enjoyed in their first decades.

They also tend to be Italian and French in origin, which is appropriate. Bookbinding traditions developed mutually between Italy and France during much of the sixteenth century, as did their closely related cuisines. The operations of the Aldine Press, in its long Manutius-Torresani phases, were strongest in Italy and France, and this is reflected in these bindings.

For further information on various aspects of contemporary bindings on Aldines, see Gabriele Mazzucco, "Legature rinascimentale di edizioni di Aldo Manuzio," in Marciana/Sansoviniana, pp. 135–79, with numerous tables and illustrations.

Milanese plaquette-decorated binding for Jean Grolier on: ARISTOTLE. *Opera* (Greek). Vol. II. Venice: Aldus Manutius, February 1497.

> Brown goatskin over pasteboards, gold-tooled. On each cover is a painted stamp based on plaquettes by the medallist IO.F.F. Front cover: Marcus Curtius riding into the chasm in the Roman forum; back cover: Horatius Cocles defending the Sublician Bridge against Lars Porsena. Traces of four pairs of green silk ties. Edges painted to a floral pattern in red and green.

Jean Grolier is the single best-known patron of luxury bookbindings, and his name continues to be synonymous with the love of books. This copy comes from a group of books bound for him during his first period in Milan, as treasurer and receiver general of the French in Lombardy, between the time he succeeded his father, who died in 1509, and his first coercive removal with French forces in 1513. Their artistic unity suggests that the books were bound within a short period of time. Grolier annotated some of the texts between the dates from 18 January to 19 September 1510 and the autumn of 1513, when the French were expelled from Milan. So this binding may date from the period ca. 1510–13; it seems likely that it was also bound in Milan.

PML 19117 (ChL f997A)

REFERENCES: Renouard p. 10; AME no. 8; Goff A-959; Wolfenbüttel no. 47; Miner no. 215 and cf. no. 216 illustrated on pl. XLIII; Nixon no. 2; Austin no. 28.1; Needham, *Twelve Centuries* no. 41.

Grolier's arms in: QUINTUS SMYRNAEUS CALABER.
Paralipomena Homeri (Posthomerica, Greek). Venice:
Aldus Manutius, [ca. 1505].

The opening page of text carries border decorations and an illumi-
nated initial (pl. 3). In the lower margin are Jean Grolier's armorial
charges, executed in pen, ink, and colored wash, in medallion format.
The "obverse" bears the Grolier arms on a cartouche within a border
inscribed: M IEHAN GROLIER CONSELLER DU ROY TRESORIER G AN LA D
DE M, "Jean Grolier, Royal Counselor, Treasurer General in the Duchy
of Milan"; the "reverse" carries Grolier's device of a mailed fist on
mounds with his motto, AEQUE DIFFICULTER, borne on a scroll.

Grolier's arms and motto, which seem to date between 1509 and 1513—the
period of his first residence in Milan—place this work among his earliest
acquisitions. Eight such volumes comprising a distinct series are known to
survive, two of them in the PML; all are Aldine octavos, printed between
1502 and 1505. Of these eight octavos, only two retain their original bind-
ings, and they come from the shop that produced Grolier's plaquette bindings
(see previous entry).

This copy was rebound in calf by Francis Bedford in England during
the nineteenth century. One wonders, of course, what the present binding
replaced. A surprising number of Groliers—both from his private library and
from the Parisian commercial venture—were rebound in the eighteenth and
nineteenth centuries. It is hard to imagine that all those original sixteenth-
century bindings had been damaged beyond recall; one would suspect that
changing tastes (not to mention ignorance of historicity) were at work.

PML 1195
REFERENCES: Renouard p. 261; Austin no. 453 and cf. no. 232.1 illustrated;
Needham, *Twelve Centuries* no. 41, illustrated on p. 141.

Jean Grolier's copy of: POLYBIUS. *Historiae*. Trans.
Nicolaus Perottus. Venice: House of Aldus and of
Andrea of Asola, His Father-in-Law, February 1521.

Brown calf over pasteboards, paneled in gilt and blind within lace-
work border; remains of two pairs of fabric ties; rebacked;
vellum/paper endleaves; limited illumination.

Jean Grolier owned multiple copies of the various volumes of Polybius and
allied works. He signed his name in this copy below the colophon, a practice
he employed following his return from Italy in 1521 in his books bound in
France; by the mid-1530s, he began to have his now-famous ownership entry

tooled in gilt on the upper covers. This volume of Polybius was bound for him in Paris, probably in the second half of the 1520s, by the so-called Eustace Binder, whose sobriquet derives from a binding he made that bore the name Charles Heustace.

CAMAC 172a

REFERENCES: Renouard p. 90; Austin no. 274 (293j).

Parisian binding for Grolier on: JACOPO SANNAZARO. *Arcadia* and *Sonetti e Canzoni*. Venice: Heirs of Aldus and of Andrea of Asola, July 1534.

> Dark-brown goatskin over pasteboards, tooled in gilt with the titles and Grolier's ex libris on the upper cover and his motto on the lower cover, the lettering on the spine a much later addition; all edges gilt; vellum/paper endleaves.

This binding is attributed to the Entrelac Binder, active in Paris from 1540 to 1543. He is now believed to have been Jean Picard, who worked in Paris during this time before decamping in the early autumn of 1547 to avoid his creditors. This same Jean Picard was the local representative, for a period of time beginning in 1540, of the Torresani export business in Paris that dealt Ex Bibliotheca Aldina. Grolier succeeded Picard in overseeing the Parisian operations of the Press until the arrival, ca. 1554, of Aldus's nephew Bernard Turrisan.

This copy was bound perhaps as a commercial venture, produced in the first instance as an example of what customers of the Parisian subsidiary could order rather than as a book for Grolier's personal library. The copy contains examples of gilt-and-painted initials as well as the Aldine dolphin-and-anchor devices and is housed in a superbly understated goatskin binding.

PML 20460

REFERENCES: Renouard p. 112; Nixon no. 31; Austin no. 475; Needham, *Twelve Centuries* no. 42 n. 8; Hobson, *Humanists* pp. 267–71.

Parisian binding for Grolier on: VALERIUS MAXIMUS. *Facta et dicta memorabilia*. Venice: Heirs of Aldus and of Andrea of Asola, March 1534.

> Brown calf over pasteboards, tooled in gilt with the title and Grolier's ownership on the upper cover, his motto on the lower cover, both within a hexagonal (Star of David) compartment; plain spine; all edges gilt; vellum/paper endleaves.

This binding is the work of the Entrelac Binder, now identified as Jean Picard.

Grolier introduced Italian style into the Parisian world of books, especially in the clothing of his books. His French bindings typically have an elegant austerity: very fine but plain brown tanned leather, often goatskin (then extremely rare in Paris), restrainedly tooled in gold, with a minimum of lettering.

PML 75174 (Gift of Mrs. Francis Kettaneh, in memory of her husband)
REFERENCES: Renouard p. 110; Austin no. 520; Needham, *Twelve Centuries* no. 42; *In August Company* p. 180, illustrated; Hobson, *Humanists* pp. 267–71.

Greek binding on: JOANNES GRAMMATICUS. *In Posteriora resolutoria Aristotelis commentaria* (Greek). Venice: Aldus Manutius, March 1504.

> Venetian blind-tooled binding of olive goatskin over boards, with smooth spine and raised endcaps, the bands laced directly into the grooved edges of the boards, fastened by two pairs of laced leather thongs, securing onto pins in the fore-edge of the upper cover. The binding complements the book's contents.

The Greek émigrés who settled in Venice after the fall of Constantinople in 1453 brought a variety of skills with them. The scholars provided the talent pool that had induced Aldus to come to Venice at the beginning of the 1490s. Many of the craftsworkers took up their trades anew, practiced their skills, and passed along their talents to the next generation. If the present example is not the work of a Greek émigré bookbinder, it is a first-class sample of what a Venetian binder could achieve while working from a Greek prototype or under the tutelage of a Greek binder. This style inspired the best Parisian binders of mid-century, enjoying a considerable vogue, but by then it would embrace a disparate medley of elements. These later "à la grecque" or "alla greca" bindings would thus be Greek-style rather than truly Greek as is this volume.

PML 1484
REFERENCES: Renouard p. 45; De Marinis no. 2712 (III 40); cf. Hobson, *Humanists* p. 62.

Greek-style binding on: Artemidorus Daldianus. *De somniorum interpretatione* (and other works, Greek). Venice: House of Aldus and of Andrea of Asola, His Father-in-Law, August 1518.

> Brown goatskin over wooden boards, bound "alla greca" with textblock flush with boards, raised head- and footcaps, remains of double-thong clasps, fastening from back to front on pins; blind-tooled in an elaborate floral pattern.

Appropriate to the book's contents, this Greek-style binding is assigned to a Roman shop that functioned from at least 1518 to the time of the Sack of Rome, in 1527, and executed a number of presentation bindings for Pope Clement VII.

CAMAC 148
REFERENCES: Renouard p. 82; cf. Hobson, *Humanists* p. 89 pl. 76.

Greek-style binding for Henri II on:
Theophrastus. *De historia plantarum* (Greek) [=Aristotle. *Opera* (Greek). Vol. IV, Part I]. Venice: Aldus Manutius, 1 June 1497.

> Parisian olive-brown goatskin over wooden boards, tooled in gold and silver, with traces of white paint; four braided-leather clasps; edges gilt and goffered to a floral pattern incorporating the emblems of Henri II.

The Greek mode of binding came into use in France at the end of the 1530s and appears fully fledged in this example, the work of the Royal Binder of Henri II, variously attributed to Claude de Picques and Gommar Estienne. It is a Greek-style binding by a French craftsman rather than by a Greek émigré.

PML 34896 (ChL ꜰ998)
REFERENCES: Renouard p. 11; AME no. 9; Goff A-959; Wolfenbüttel no. 47; *Marks in Books* no. 2; Nixon no. 19; Needham, *Twelve Centuries* no. 59; Hobson, *Humanists* pp. 172–213 at 189ff., 269–70.

Greek-style French binding on: Plato. *Opera omnia* (Greek). Ed. Marcus Musurus. Venice: House of Aldus and of Andrea of Asola, His Father-in-Law, September 1513.

> French-brown goatskin, tooled in gilt, a diaper-patterned central panel within double borders, the title and author in Greek at the top, in the corners a complex monogram; traces of four pairs of fabric

ties; gilt and goffered edges; resewn and rebacked. The monogram, which seems to include at least the letters A B C E G H L M N R T, would decipher as both the owner's name and a motto (fig. 38).

This copy of Plato and five other books in Greek printed in Italy come from the same collection. They were printed between 1498 and 1519, and each binding includes the undeciphered, complex monogram of an unidentified Frenchman. He is believed to have brought them home from Italy, unbound, in the 1520s and covered them in the Western manner, perhaps at Tours or Blois, at about this time. They were all bound in the same shop, where they were produced in a Greek-inspired style rather than in the true Greek manner. (No authentic Greek-technique bindings were produced in France until the end of the 1530s.)

38. A Greek-style French provincial binding, ca. 1520s, on a copy of the 1513 Plato (PML 1528).

PML 1528

REFERENCES: Renouard p. 62; AME no. 78; Wolfenbüttel no. 56; De Marinis no. 2724 (III 40); A. R. A. Hobson, "Some Sixteenth-century Buyers of Books in Rome and Elsewhere," *Humanistica Lovaniensia* 34A (1985), 65–75 at 73–74 and pl. V; Hobson, *Humanists* p. 182.

Florentine (?) entablature binding, ca. 1520, on:
PUBLIUS PAPINIUS STATIUS. *Sylvae. Thebaid. Achilleid* [i.e., *Opera*]. Venice: House of Aldus and of Andrea of Asola, His Father-in-Law, January 1519.

> Red goatskin over pasteboard, gilt edges, with traces of four pairs of fabric ties; recased in the nineteenth century, perhaps with some restored gilding. The titles are tooled vertically on upper and lower covers within oblong trapezoidal tablets of a type known as a *tabula ansata* (see back cover).

An ansate or "handled" tablet is so called because its sidepieces depict handles. This kind of entablature is found on Roman and, by derivation, Renaissance buildings to enclose epigraphs as well as on ancient sarcophagi as a framing device. A group of eight similar octavo bindings is recorded, four of

them enclosing five Aldines dated 1501–19 and attributable to an anonymous Florentine shop; this binding and one other belonged to Carlo di Tommaso Strozzi. These bindings were formerly thought to be Roman, and recent (and, as yet, unpublished) scholarship is reproposing this earlier attribution.

This binding must have been quite brilliant when new. The leather essentially retains its color, and the blind-ruling and gilding are still fairly fresh. Much of the rest of the pattern, however, was originally tooled in silver, which has long since oxidized (a common fate), along with a lesser-quality gold. The title "inscriptions" were among the silver components and would have shone forth. The original garb of the binding thus comprised the primary palette of red, black, gold, and silver.

PML 1610

REFERENCES: Renouard p. 88; Hobson, *Humanists* p. 162, n. 52 (on De Marinis and Roman attribution), and pl. 128. I am grateful to T. Kimball Brooker for his counsel.

Venetian binding, ca. 1527–31, on: STEFANO
NICOLINI DA SABBIO. *Corona preciosa* (Greek and
Latin). Venice: Gian Antonio Nicolini da Sabbio
and Brothers for Andrea Torresani, 27 August 1527.

Brown calf over pasteboards, blind-tooled; rebacked and the original spine laid down. This binding is assigned to the artisan called the Master of Andrea Gritti, after work carried out for that Venetian aristocrat and doge.

This is a late work commissioned by Aldus's senior partner and father-in-law near the end of his life. It is intended to permit anyone to learn Greek, Latin, and Italian without the help of a teacher. The author was a member of an extended Venetian family of printers who, especially during the 1520s and 1530s, provided many books for other printers and publishers, including a few titles nominally printed at the Aldine Press (see also p. 84).

CAMAC 732

REFERENCE: Renouard p. 293.

Alessandro Farnese's copy of: ALDUS MANUTIUS.
Institutionum grammaticarum libri quattuor. Venice:
House of Aldus and of Andrea of Asola, His
Father-in-Law, July 1523.

Italian (Roman?) binding, perhaps from the first half of the 1530s, of black goatskin over boards, containing, within a blind-tooled roll bor-

39–40. The young Alessandro Farnese learns Latin, using this copy of the 1523 edition of Aldus's Latin grammar (PML 1443): *left*, front cover, showing the deleted H in the phonetically misspelled title; *right*, back cover, with Alessandro's ownership entry.

der, a gilt arabesque built up from small tools, as a surround for gilt lettering; rebacked, the binding probably recased and the edges gilded in the nineteenth century. On the front cover, the title: GRAM | MATI | C<H>A | ALDI (the phonetic intrusion that produced the misspelling has been "corrected" by deleting the gilding in the H, but of course the impression remains); on the back, the ownership entry of Alessandro cardinal Farnese: ALEX: | FARNE | SII (figs. 39 and 40).

Alessandro Farnese (1520–89, card. 1534), nephew and namesake of Pope Paul III, was a man of learning and a great patron of scholars and artists, including Pietro Bembo, from the Aldine circle. The Aldine connection with the Farnese family was of long duration, if not great depth, and proved decisive on several important occasions. Paulus Manutius was particularly indebted to the Farnese family, whose various members and agents occasionally helped to ensure his future and success. An old friend of Paulus's, Bernardino Maffei (1514–53, card. 1549), had been in charge of the young Alessandro Farnese's education. Farnese was a student in Bologna, aged 13, when he was created cardinal; perhaps Aldus's grammar was one of his schoolbooks.

PML 1443

REFERENCES: Renouard p. 98; Needham, *Twelve Centuries* no. 44 n. 5; De Marinis no. 1347 (II 23) assigns the binding to Bologna; Lowry, *Facing the Responsibility* p. 28; see in general Clare Robertson, *"Il gran cardinale": Alessandro Farnese, Patron of the Arts* (New Haven: Yale University Press, 1992).

Wrap-around or wallet English binding on:
PRUDENTIUS, PROSPER, JOANNES DAMASCENUS, etc.
[*Opera*]. [Lyon: ?Balthasar de Gabiano, ca. 1502–03
(after January 1501)].

> Dark-brown calf, stamped central panel with acorns, roll-tool border
> with griffin and grape clusters; linen ties renewed. Though much
> restored, this is a rare example, probably from the 1530s, combining
> unusual features. The wallet-style binding is occasionally found in this
> era, typically on large volumes and especially on business volumes
> such as ledgers. But the presence of the integral protective flap is
> quite uncommon on a small volume of this subject, and it may indi-
> cate that the original owner envisioned taking his book out in various
> climatic conditions. The acorn panel together with the griffin motif
> in the border point to England, probably in the employ of an émigré
> bookbinder from the Low Countries.

Prudentius and the other authors had appeared in the first part of Aldus's
multivolume edition in quarto of the *Poetae Christiani veteres*, which finished
printing in January 1501 (1502 N.S.?). This is one of the earliest of the so-
called Lyon counterfeits or piracies. The first printer of the piracies to be
identified was Balthasar de Gabiano (d. 1518), the local representative of a
family publishing and bookselling business originating in Venice. Recent
scholarship, however, has called this attribution into doubt, suggesting that
Barthélemy Trot, a German émigré, was responsible. Trot, who made a career
of publishing Aldine counterfeits and piracies, whether of texts or format,
has heretofore been known only for his activities from some ten years later.

PML 1569
REFERENCES: Renouard p. 306; Shaw no. 10; Foot, *Henry Davis Gift* II no. 28.

Bolognese binding for Damian Pflug on: HOMERUS.
Ilias and *Odyssea* (Greek). Two vols. Venice: House
of Aldus and of Andrea of Asola, His Father-in-
Law, 1524.

> Light-brown goatskin over pasteboard, gold-tooled; remains of two
> pairs of red silk ties on fore-edge; edges gilt. Elaborate, mostly angular
> interlaces, each volume with the title in Greek on the front cover,
> along with Pflug's name, the city, and completion date of binding on
> the rear.

Damian Pflug was a German, from Saxony, who had studied at Paris and had
books bound there. He moved to Bologna by late 1542 and seems to have

had his local bindings styled after the latest Parisian taste for interlaced tooling. This pair of bindings was finished on 18 January 1545. It is the work of the so-called Ebeleben Master, about whom more appears in the next entry.

PML 55173–55174

REFERENCES: Renouard p. 98; Nixon no. 13; Needham, *Twelve Centuries* no. 52; cf. Foot, *Henry Davis Gift* I no. 23 (pp. 299–307).

Bolognese binding by the Ebeleben Master on:
CATULLUS, TIBULLUS, and PROPERTIUS. *Opera.*
Venice: House of Aldus and of Andrea of Asola,
His Father-in-Law, March 1515.

> Dark-brown calf over pasteboard, exuberantly gilt, with a central arabesque built up of small tools, within a flower, tendril, arabesque, and fleuron border; edges gilt and goffered; extremely restrained tooling on spine, ruled in gilt and blind. The back cover is entirely tooled; the front cover bears, within a central horizontal section framed by the arabesque, the title in three lines: CATVL[LVS]. | TIBVLLVS | PROPE[RTIVS].

Nicolaus Ebeleben (also Nikolaus von Ebeleben) was the cousin of Damian Pflug and, judging from his more important positions at the University of Bologna, probably Pflug's elder. They spent their French and Italian *Wanderjahre* together, and their bindings were commissioned from the same bookbinders, of which there seem to have been three, not easily distinguishable. One may have been a German named Georgius (i.e., Georg); the most accomplished work in execution of design and quality of gilding, like the present binding, is assigned to a craftsman with the sobriquet of the Ebeleben Master.

PML 15431

REFERENCES: Renouard p. 70; De Marinis no. 1325 (II 21); Nixon no. 13 at p. 52; cf. Needham, *Twelve Centuries* no. 52; cf. Breslauer cat. 110 [1992] no. 33 and illus., rptd. cat. 111 [1994] no. 167 and illus. p. 127.

Apollo and Pegasus binding, ca. 1546, on: PAULUS
OROSIUS. *Historie* (Italian). Trans. Giovanni
Guerini. [Toscolano]: Paganino and Alessandro
Paganini, [1527–33].

> Red goatskin tooled in gilt and blind, with central horizontal medallion in blind, gilt, and the colors green and black. The medallion shows Apollo driving the horses of the sun toward the steep cliff of Mount Parnassus, on whose summit Pegasus stands poised for flight,

the depiction within an ellipsoidal border carrying a motto in Greek. By Maestro Luigi, Rome, mid-1540s.

At Rome in the years 1545–47, the humanist-poet Claudio Tolomei assembled a complete "gentleman's library" for Giovanni Battista Grimaldi (ca. 1524–ca. 1612), scion of a Genoese patrician family. Some 144 of these books, which were bound in three shops, are known to survive. This example comes from the shop of Maestro Luigi (Luigi de Gava or de Gradi), a bookbinder to several popes and other important patrons. Tolomei chose the medallion and the Greek motto ("Straight and not crooked"), which refers to the ascent to Parnassus through the practice of *virtù*, as suitable for a wealthy young man with a cultivated interest in literature. (For another of these bindings, see fig. 41.)

The series of works produced by Paganini in octavo at Toscolano during these half dozen years was planned and executed as a conscious tribute to Aldus and his portable library.

PML 50667

REFERENCES: Nuovo no. 83; PML, *Report to the Fellows* 10 (1960), 23–24; Nixon no. 11; Hobson, *Apollo and Pegasus* no. 84; Needham, *Twelve Centuries* no. 49 n. 2; *In August Company* p. 181 and illus. p. 180.

41. A copy of the 1527 Priscian in an Apollo and Pegasus binding for Giovanni Battista Grimaldi, by Niccolò Franzese (i.e., the émigré Frenchman Nicolas Fery), at Rome, ca. 1546 (PML 2009).

Mahieu polychrome binding on: PAULUS
MANUTIUS. *In Ciceronis epistolas ad Atticum
commentarius*. Venice: Sons of Aldus (Paulus
Manutius), 1547.

> French (probably Parisian) interlace binding, 1550s, of brown calf over
> boards, with hatched tools and highlights in red paint; smooth rounded
> spine gilt à répétition. On the upper cover, the title: IN EPIST[OLAS].
> C[ICERONIS]. | AD ATTICV[M] | PAVLI MANV | TY COMMEN | TARIVS.; on the
> lower, an intricate monogram interpreted as comprising the letters A E
> G H I M N O P R S T V. At least one of the hatched tools was assigned at
> one point to the atelier of Claude de Picques. The copy was subse-
> quently owned by the great French bibliophile Jacques August de
> Thou, who signed it twice; a later owner was the Aldine bibliographer
> Antoine-Augustin Renouard, who had RENOUARD stamped in gilt italic
> capitals in the bottom border of the front cover (pls. 11–12).

The monogram contains sufficient letters to comprise the name and first
motto of Thomas Mahieu. Mahieu, alias Maioli, was an Italian native who
was private secretary (1549–60) to Catherine de Médicis and a friend of Jean
Grolier's, with whom he appears to have shared bibliophilic interests. Still
alive in 1584, he eventually succeeded Grolier as treasurer of France. Mahieu
employed several cuttings of this monogram and used two embittered mot-
tos: INGRATIS SERVIRE NEPHAS ("It is a plague to work for the ungrateful") and
INIMICI MEI MEA MIHI NON ME MIHI ("My enemies can take my goods from
me but not me from myself"). The Mahieu monogram has been misassigned
periodically; another monogram, generally similar to this one, was employed
once or twice in France by one Hieronimus Fioraventius. He was an Italian
native named Girolamo Fioraventi or Fieraventi, but his monogram remains a
riddle, and virtually nothing is known about him.

PML 1279

REFERENCES: Renouard p. 140; PML, *Toovey* illus. facing p. 16; Nixon no. 20;
cf. Needham, *Twelve Centuries* nos. 57–58; Jeanne Veyrin-Forrer, "Notes sur
Thomas Mahieu," in Hobson Festschift pp. 321–49; for Fioraventius, cf.
Hobson and Culot no. 44.

Parisian polychrome strapwork binding, ca. 1550s,
on: NICCOLÒ MACHIAVELLI. *Il Prencipe* (and other
works). Venice: Sons of Aldus (Paolo Manutio), 1540.

> Brown calf over boards, gilt and black-painted interlace binding; plain
> gilt edges. There is a similarity between the tools and those in the

suite of the Cupid's Bow Binder, active in Paris in the 1550s. The Cupid's Bow Binder produced bookbindings for such notable bibliophiles as Jean Grolier in France and Paul IV and Alfonso d'Este in Italy (pl. 10).

Machiavelli's writings were exported to Paris and bound in an elegant, well-proportioned example of the better Parisian bindings during the period in which Parisian binders led the field.

PML 1435
REFERENCES: Renouard p. 119; cf. Hobson and Culot no. 43.

Parisian binding, ca. 1555, on: MARCUS TULLIUS CICERO. *Le pistole. . . ad Attico* (*Ad Atticum*, trans. Matteo Senarega). Venice: Sons of Aldus (Paolo Manutio), 1555.

Brown calf over pasteboards, blind, gilt, and polychrome-painted interlace binding, with stippled and trefoil semés; gilt and goffered edges. The arms remain unidentified. This binding is assigned to the Royal Binder of Henri II, active in Paris in the 1550s. He was formerly identified with Claude de Picques, but the current contender for this period is Gommar Estienne.

This Italian version of Cicero's letters to Atticus was another component of Paulus's enormous output of the works of his favorite author. This copy probably was exported to the Torresani subsidiary in Paris and bound there during a high point in the history of French bookbinding.

CAMAC 415
REFERENCE: Renouard p. 164.

Parisian binding, ca. 1560s, on: VALERIUS MAXIMUS. *Dictorum et factorum memorabilium libri*. Venice: Aldus Manutius, October 1502 and 1 April 1503.

Brown calf over pasteboards, elaborate gilt and polychrome-painted centerpiece binding, with cornucopia cornerpieces, in strongly hatched tools, and a trefoil semé; flat spine. This style of binding was in vogue at Paris during the sixth, seventh, and eighth decades of the sixteenth century, most dominantly in the '60s.

This is the second issue of Aldus's edition of Valerius Maximus. It has been

enhanced with additional material sent to Aldus by Cuspinianus (Johann Spiesshaymer) from Vienna during the intervening winter.

CAMAC 51a

REFERENCES: Renouard p. 36; AME no. 42; Fletcher pp. 109–11.

Envelope binding, ca. 1600?, on: "SUIDAS." [*The Suda Lexicon*]. Ed. Aldus. Venice: House of Aldus and of Andrea of Asola, His Father-in-Law, February 1514.

> Limp vellum with double overlapping and interlocking flaps on top, fore, and bottom edges, secured with four (renewed) black linen ties, forming a virtual bookbox. The binding seems to date from the end of the sixteenth century, or more likely the beginning of the seventeenth, and to have originated in the region of the lower Rhine; bindings of this general type enjoyed a minor vogue in the Low Countries at about the end of the fifteenth century. A particularly rare feature of this example is how thoroughly it encases and encloses the textblock. This binding, in all its obvious utilitarian plainness, has nobly performed its intended purpose of safeguarding a substantial reference work.

This remarkably well-preserved binding appears to have been intended for personal rather than institutional use. It carries no titling, which suggests that it belonged to a scholar whose library was select, and its structure shows that it was meant to be handled painstakingly rather than consulted quickly. An early owner was Theodorus Phrearaeus (alive 1590) of Falkenberg near Lüneburg, who was licentiate in theology and worked at Cologne as canon and pastor of the Church of the Holy Apostles. He was also professor ordinarius of Greek at the University of Cologne, and this appears to have been one of the tools of his profession. It is a superb example of a book from a working scholar's library: *simplex munditiis*, in Horace's phrase.

PML 1617

REFERENCES: Renouard p. 70; AME no. 81; cf. Folger no. 9:4.

BOOKS ON BLUE PAPER

The colophon dates in several books notwithstanding, this phenomenon began probably in late summer or early autumn of 1514, when Aldus acquired a supply of blue paper suitable for printing and issued the first book printed on this medium. It seems to have been inspired by Turkish fashion, which is not surprising given Venetian trade routes and the resultant Eastern influences on Venetian life. Blue paper attracted the interest of the artists first, and thus came into Dürer's repertory, perhaps during his first Venetian period. Beginning with Aldus, it was used for the exceptional copy of a work, one that could be offered for presentation or at a premium to collectors. In a sense, it provided a less expensive alternative to vellum.

"Proper" blue paper is not simply the customary smooth, white stock tinted blue but rather a combination of much coarser stock, some of it made from blue fibers, and an admixture of dyes. The terminology for the shades is drawn from the Italian: *azzurro* (light), *turchino* (medium), and *blu* (dark). A predominantly Italian phenomenon for centuries in the West (its appearance elsewhere apparently derivative), the practice eventually took limited hold in France and Britain. The phenomenon has continued into the present generation.

The PML holds seven sixteenth-century books on blue paper, three of them Aldines. There are no fewer than twenty-one sixteenth-century books on blue paper, one of which is an Aldine, at UCLA.

The interested reader may wish to consult these recent works: Irene Brückle, "The Historical Manufacture of Blue-coloured Paper," *Paper Conservator* 17 (1993), 20–31; idem, "Blue-colored Paper in Drawings," *Drawing* 15 No. 4 (November–December 1993), 73–77; Nancy Bialler, *Chiaroscuro Woodcuts: Hendrick Goltzius (1558–1617) and His Time* (Amsterdam: Rijksmuseum, 1992), especially chapter 1.

[ROMAN AGRICULTURAL WRITERS]. *De re rustica*. Ed. Jucundus Veronensis. Venice: House of Aldus and of Andrea of Asola, His Father-in-Law, May 1514.

This was the first book printed by Aldus on blue paper (pl. 5). Though dated May 1514, the regular (white-paper) edition may not have been issued until about mid-summer, and the blue-paper copy may have appeared even later. The shade of the stock is *turchino*, and it is from the original batch that Aldus acquired to produce a small number of books during 1514. According to their respective colophon dates, the *De re rustica* was followed by the Quintilian of August, Sannazaro's *Arcadia* of September, and the Virgil of October (see the next entry).

The edition was prepared by the polymath Fra Giovanni Giocondo of Verona, Aldus's longtime friend and occasional assistant. For his labors, he received the payment of ten ducats (a substantial amount of money) and ten copies. He had one of these copies specially bound for presentation to Pope Leo X, but there is no indication that the presentation copy was other than a standard one on white paper, and no copies on vellum are known. Four or five copies of this book, including the present one, are recorded on blue paper; one copy may have been recorded twice over the years, and one consists partially of white-paper signatures (the Raimondini copy).

PML 79276 (Bequest of Curt F. Bühler)
REFERENCES: Renouard p. 66 (2 copies on *carta az[z]urra*); Christie's [Fortescue] sale, 24 March 1971, lot 45 (Raimondini); AME no. 83; Fletcher p. 91.

PUBLIUS VERGILIUS MARO. [*Opera*]. Ed. Andreas Naugerius. Venice: House of Aldus and of Andrea of Asola, His Father-in-Law, October 1514.

This stock is from the same batch as that used for the *De re rustica*. It may be, however, that the four 1514 blue-paper Aldines were all produced during the autumn. There are two distinct issues of this edition of Virgil and more than one state of this earlier issue. This blue-paper copy has been reset in part and contains type settings that conform to no known white-paper version (pl. 4). The edition was prepared, to some degree, by Aldus's longtime colleague and friend Andrea Navagero, who would become official historian of his native Venice. Aldus's preface relates that manuscripts in the library of Pietro Bembo's father, Bernardo, provided the inspiration for the portable-library format.

CAMAC 110
REFERENCES: Renouard p. 68 (white paper and vellum); AME no. 89; Fletcher pp. 78–79.

[ROMAN AGRICULTURAL WRITERS]. *De re rustica*. Ed. Jucundus Veronensis. Venice: Heirs of Aldus and of Andrea of Asola, December 1533.

The fairly faint shade of the paper is probably *azzurro,* although it is possible that the book was washed or has faded. Since the paper in this copy is of a smoother stock than one would expect, the possibility that it has been tinted also should be considered.

This is a reprint of the 1514 edition. It is striking that it is also the first book from the second "generation" of books recorded as having been printed on blue paper at the Press.

PML 1582

REFERENCE: Renouard p. 109 (several blue-paper copies).

PAULUS MANUTIUS. *Epistolarum libri*
xi . . . Prefationes. Venice: In Aedibus Manutianis
[?Aldus the Younger and/or Domenico Basa], 1573.

Here the shade is *turchino* (pl. 6). There are two separately paginated parts to this book; the latter comprises Paulus's prefaces to various works. The type was composed in octavo format but imposed and printed as a small quarto with very large margins; this copy on large blue paper appears to be essentially unrecorded.

The book is in a contemporary German binding of pigskin over wooden boards, complete with bronze catches and clasps. It is tooled in (oxidized) gilt with the initials G[erhard] R[antzow] and the date 1577, along with the oxidized-gilt 1572 armorial panel-stamps of Rantzow's father, Paul, on the front cover and his mother, Beate, on the back (probably the extensive German-Danish Rantzau family in Schleswig-Holstein). The book remained in the family for a number of years, passing by inheritance in 1589 to Gerhard's brother Heinrich (Henricus Ranzovius), then in his sixty-fourth year. It was owned in the nineteenth century by Comte Ernest de Ganay, who signed it *à Lusigny, Cote d'or* in 1839, and it was listed in the Libri sale catalogues at mid-century.

PML 1447

REFERENCE: Renouard p. 216 (white paper); *Catalogue of the Choicer Portion of the Magnificent Library, formed by M. Guglielmo Libri*, sale Sotheby's 1–15 August 1859, lot 1540.

BIBLIOGRAPHY

Ahmanson-Murphy Aldine Collection. *A Catalogue of the Ahmanson-Murphy Aldine Collection at UCLA.* Gen. eds. Paul G. Naiditch and Sue A. Kaplan. Los Angeles: UCLA, 1989–94. Five fascicles in six volumes. Cited as CAMAC.

AME. *Aldo Manuzio Editore.* Ed. Carlo Dionisotti. Two vols. Milan: Il Polifilo, 1975.

Austin, Gabriel. *The Library of Jean Grolier.* New York: The Grolier Club, 1971.

Babcock, Robert G., and Mark L. Sosower. *Learning from the Greeks: An Exhibition Commemorating the Five-hundredth Anniversary of the Founding of the Aldine Press.* New Haven: Beinecke Rare Book and Manuscript Library, 1994. Catalogue of an exhibition held at the Beinecke Library, spring 1994, and at The Grolier Club, winter 1994–95.

Barberi, Francesco. *Paolo Manuzio e la Stamperia del Populo Romano (1561–1570) con documenti inediti.* Rome: Ministero della Educazione Nazionale, Direzione Generale delle Biblioteche, 1942.

Barker, Nicolas. *Aldus Manutius and the Development of Greek Script and Type in the Fifteenth Century.* 2nd edition. New York: Fordham University Press, 1992.

———. *Aldus Manutius: Mercantile Empire of the Intellect.* UCLA University Research Library Occasional Paper 3. Los Angeles: UCLA, 1989.

Blumenthal, Joseph. *Art of the Printed Book, 1455–1955: Masterpieces of Typography through Five Centuries from the Collections of The Pierpont Morgan Library.* New York: PML; Boston: Godine, 1973.

BMC Bible. British Museum. *General Catalogue of Printed Books. Bible.* Three vols. London: British Museum, 1936–37.

Bühler, Curt F. *Early Books and Manuscripts.* New York: The Grolier Club and PML, 1973.

Clough, Cecil H. "Italian Renaissance Portraiture and Printed Portrait-books." In Rhodes Festschrift pp. 183–223.

Darlow and Moule. T. H. Darlow and H. F. Moule. *Historical Catalogue of the Printed Editions of Holy Scripture.* Two vols. in four. London: British and Foreign Bible Society, 1903–11.

Davies, Martin C. *Aldus Manutius.* London: British Library (in press).

De Marinis, Tamaro. *La legatura artistica in Italia nei secoli XV & XVI.* Three vols. Florence: Alinari, 1960.

Fletcher, H. G. *New Aldine Studies.* San Francisco: B. M. Rosenthal, 1988.

Folger. Frederick A. Bearman, Nati H. Krivatsy, and J. Franklin Mowery. *Fine and Historic Bookbindings from the Folger Shakespeare Library.* Washington: Folger Shakespeare Library, 1992.

Foot, Mirjam M. *The Henry Davis Gift: A Collection of Bookbindings.* Two vols. London: British Library, 1978 and 1983.

Goff, Frederick R. *Incunabula in American Libraries.* Third Census, annotated. Millwood: Kraus, 1973.

Hobson, Anthony R. A. *Apollo and Pegasus.* Amsterdam: Van Heusden, 1975.

———. *Humanists and Bookbinders.* Cambridge: Cambridge University Press, 1989.

Hobson Festschrift. *Bookbindings and Other Bibliophily: Essays in Honour of Anthony Hobson.* Ed. Dennis E. Rhodes. Verona: Edizioni Valdonega [1994].

Hobson and Culot. A. R. A. Hobson and Paul Culot. *Italian and French 16th-century Bookbindings | La Reliure en Italie et en France au XVIe siècle.* [Brussels]: Bibliotheca Wittockiana, 1991.

In August Company: The Collections of The Pierpont Morgan Library. New York: PML, 1992. The general guide to the Library's collections, with some material on our Aldines and pertinent bindings.

Laurenziana. *Aldo Manuzio tipographo, 1494–1515*. Comp. Luciana Bigliazzi, Angela Dillon Bussi, Giancarlo Savino, and Piero Scapecchi. Florence: Octavo, 1994. Catalogue of an exhibition at the Biblioteca Medicea Laurenziana, Florence, summer 1994.

Lowry, Martin. *Facing the Responsibility of Paulus Manutius*. UCLA University Research Library Occasional Paper 8. Los Angeles: UCLA (in press).

———. *The World of Aldus Manutius*. Oxford: Blackwell; Ithaca: Cornell University Press, 1979.

Marciana/Sansoviniana. *Aldo Manuzio e l'ambiente veneziano 1494–1515*. Comp. Suzy Marcon and Marino Zorzi. Venice: Cardo Editore, 1994. Catalogue of an exhibition at the Libreria Sansoviniana, Venice, summer 1994.

Marks in Books, Illustrated and Explained. Ed. Roger E. Stoddard. Cambridge: Houghton Library, Harvard University, 1985.

Miner, Dorothy. *The History of Bookbinding 525–1950 A.D.* Baltimore: Walters Art Gallery, 1957. Catalogue of an exhibition at the Baltimore Museum of Art, November 1957–January 1958.

Morison, Stanley. *The Typographic Book, 1450–1935: A Study of Fine Typography through Five Centuries*. London: Benn; Chicago: University of Chicago Press, 1963.

Mortimer, *Italian*. Harvard College Library, Department of Printing and Graphic Arts. *Catalogue of Books and Manuscripts Part II: Italian 16th-century Books*. Comp. Ruth Mortimer. Two vols. Cambridge: Harvard University Press, 1974.

Needham, Paul. *Twelve Centuries of Bookbindings: 400–1600*. New York and London: Oxford University Press and PML, 1979.

Nixon, Howard M. *Sixteenth-century Gold-tooled Bookbindings in The Pierpont Morgan Library*. New York: PML, 1971.

Nuovo, Angela. *Alessandro Paganino (1509–1538)*. Medioevo e umanesimo 77. Padua: Antinori, 1990.

The Painted Page: Italian Renaissance Book Illumination 1450–1550. Ed. Jonathan J. G. Alexander. London: Royal Academy; New York: PML, 1994.

Pettas, William A. *The Giunti of Florence: Merchant Publishers of the Sixteenth Century*. San Francisco: Rosenthal, 1980.

PML, *Toovey*. *Catalogue of a Collection of Books Formed by James Toovey Principally from the Library of the Earl of Gosford[,] the Property of J. Pierpont Morgan*. New York: privately printed [for J. Pierpont Morgan], 1901.

Printing and the Mind of Man. Ed. John Carter and Percy H. Muir. 2nd rev. ed. Munich: Pressler, 1983.

Renouard, Antoine-Augustin. *Annales de l'imprimerie des Alde*. 3rd edition. Paris, 1834. Latest repr. New Castle: Oak Knoll, 1991.

Renouard, Philippe. *Bibliographie des impressions et des œuvres de Josse Badius Ascensius*. Three vols. Paris, 1908. Repr. New York: Franklin, [1963].

Rhodes Festschrift. *The Italian Book 1465–1800*. Studies presented to Dennis E. Rhodes on his 70th birthday, ed. Denis V. Reidy. London: British Library, 1993.

Shaw, David J. "The Lyons Counterfeit of Aldus's Italic Type: A New Chronology." In Rhodes Festschrift pp. 117–33.

Sorbelli, Albano. *Storia della stampa in Bologna*. Bologna: Zanichelli, [1929].

Steinberg, S. H. *Five Hundred Years of Printing*. London: Faber & Faber, 1959. Reprinted as a paperback.

Villa I Tatti. *Aldus Manutius and Renaissance Culture*. Proceedings of the conference in honor of Franklin Murphy held at Venice and Florence, June 1994. Ed. David S. Zeidberg. Florence: Villa I Tatti (in press).

Wolfenbüttel. Johanna Harlfinger, Joseph A. M. Sonderkamp, and Martin Sicherl. *Griechische Handschriften und Aldinen*. Wolfenbüttel: Herzog August Bibliothek, 1978. Catalogue of an exhibition at the HAB Wolfenbüttel, spring 1978.

A CENSUS OF ALDINES AND RELATED BOOKS IN THE PIERPONT MORGAN LIBRARY

compiled by H. George Fletcher

1494/5–1500

Lascaris. *Erotemata.* 28 February 1494/5–
8 March 1495
PML 1407; ChL 988 (?Sykes)

Aristotle. *Organon.* 1 November 1495
PML 1126; ChL ᶠ989

Gaza. *Introductivae grammatices.*
25 December 1495
PML 436; ChL ᶠ990

Theocritus. *Eclogae.* Hesiod. *Opera et dies.*
February 1495/6
PML 1635; ChL ᶠ991

Bembus. *De Aetna.* February 1495/6
PML 431; ChL 992 (?Heber)

Thesaurus cornucopiae. August 1496
PML 1636; ChL ᶠ993

Aristotle. *De animalibus.*
[29] January 1497
PML 1128; ChL ᶠ995

Urbanus. *Institutiones Graecae grammatices.*
January 1497/8
PML 1643; ChL 996 (Louis XIV)

Aristotle. *Physica.* February 1497
PML 1127; ChL ᶠ997
PML 19117 (Grolier)

Theophrastus. *De historia plantarum*
(Aristotle IV.1–2). 1 June 1497
PML 1130 & 1129; ChL ᶠ998
PML 34896 (Henri II; vol. IV.1 only)

Leonicenus. *De morbo Gallico.* June 1497
PML 1414 (fig. 42); ChL 999

Maiolus. *Epiphyllides.* July 1497
PML 1438.1; ChL 1000

Iamblichus. *De mysteriis.* September 1497
PML 1483; ChL ᶠ1001

Horae B.M.V. (Greek). 5 December 1497
PML 18876.2; ChL 1002
(lacks woodcut leaf)
PML 21863.2

Crastonus. *Dictionarium Graecum.*
December 1497
PML 1334; ChL ᶠ1003 (?Renouard)

Maiolus. *De gradibus medicinarum.* 1497
PML 1438.2; ChL 1004

Aristotle. *Ethica ad Nicomachum.*
June 1498
PML 1131; ChL ᶠ1008

Aristophanes. *Comoediae.* 15 July 1498
PML 1123; ChL ᶠ1009 (Halifax–Heber)

Politianus. *Opera.* July 1498
PML 1555; ChL ᶠ1010
(MacCarthy–Drury; illum.)

Epistolae diversorum philosophorum.
March–April 1499
PML 434; ChL 1012
PML 435 (Du Puy)

Firmicus Maternus.
Scriptores astronomici veteres.
June & [17] October 1499
PML 1480; ChL ᶠ1013
PML 79110 (Manilius & Aratus only)

Dioscorides. *De materia medica.* July 1499
PML 738; ChL ᶠ1014 (?Renouard)

Perottus. *Cornucopia.* July 1499
PML 337; ChL ᶠ1015 (?Renouard)

Amasaeus. *Vaticinium.* 20 September 1499
PML 1146; ChL 1016

[Colonna]. *Hypnerotomachia Poliphili.*
December 1499
PML 373; ChL ꜰ1017
PML 1550
F 8 (on deposit)

Caterina da Siena. *Epistole.*
15 September 1500
PML 438; ChL ꜰ1018

Lucretius. *De rerum natura.*
December 1500
PML 1430; ChL 1019
(?Meerman–Renouard)

Undated incunabula
Theodorus Prodromus.
Galeomyomachia. [ca. 1495]
PML 1340; ChL 986

Musaeus. *De Herone et Leandro* (Greek &
Latin). [b. November 1495 & 1497/98]
PML 264; ChL 987 (Renouard)

Benedictus. *Diaria de bello Carolino.*
[not b. 27 August 1496]
PML 365; ChL 994
PML 442

Athenaeus. *Deipnosophistae* (Prolegomena;
Greek). [ca. 1496–1499 (1496–1497?)]
MA 1346 (230); ChL ꜰ1017A
(Beatus Rhenanus, 1513; Schweighäuser;
trial leaf)

Brevissima introductio ad litteras Graecas.
[ca. December 1497]
PML 18876.1; ChL 1005
PML 21863.1

Ps.-Cicero. *Synonyma.* [1497] (dubious)
PML 25594; ChL 1006

Psalterium Graecum. [1497]
PML 1570; ChL 1007

Leonicenus. *De tiro seu vipera.* [1498]
PML 1413; ChL 1011 (Heber)

1501
Prudentius. *Poetae Christiani veteres.* I.
January
PML 1545

Aldus. *Rudimenta grammatices.*
February & June
PML 1439

Pico della Mirandola. *De imaginatione.*
April
PML 1525 (?Renouard)

Vergilius. April
PML 1664

Horatius. May
PML 1373
PML 18064 (Firmin Didot)
PML 79020.1

Petrarca. July
PML 5069 (Renouard)
PML 17585 (Johnstone/Hopetoun; on
vellum; illum., with miniatures by
[?Benedetto Bordon])

Juvenalis & Persius. August
PML 1397 (uncut)
PML 1398 (de Bene; "1501" but [1515])

Martialis. December
PML 1463

Valla. *De expetendis et fugiendis rebus.* I–II.
December
PML 1653–1654 (Meerman–Sorbonne;
illum.)

Donatus. [*Oratio*] *ad Christianissimum
Gallorum regem.* December
PML 1269 (on vellum)

Nonnus. [undated; issued ca. 1504]
PML 1547.2
PML 19660.5

1502
Stephanus. *De urbibus.* January
PML 1612

Catullus, Tibullus, Prope<r>tius. January
PML 1207 (Renouard)
PML 1208 (variant)
PML 21877

Lucanus. April
PML 1426 (Heber)

Nicolai Leoniceni uincentini in librum de epidemia, quã itali morbum gallicum uocant, ad illuſtrem uirum Ioánem Frãciſcum mirandulenſem, Concordiæ comitem, præfatio.

 Abitã nuper Ferrariæ de morbo, qué gallicum uo-
h cant, diſputatóem, atque à me poſtmodum mãdatã
litteris, cui magis quã tibi Ioánes Franciſce mirãdulé-
ſis dedicauerim, qui cum ſupioribus diebus Ferrariæ
adeſſes, atque ante diem ad eandem diſputationem conſtitu-
tum, tibi ex cauſis urgentibus eſſet diſcedendum, non parum
dolere mihi uiſus es, ꝗ eidem diſputationi nó poſſes intereſſe,
neꝗ diſſimulanter tuliſti gratiſſimam rem me tibi facturum, ſi
quæ non potuiſſes præſens accipere, haberes abſens ex meis lit
teris, uel potius uolumine ad id dedicato legendi facultatem.
Et quoniam non te latebat magnæ cótentionis diſputationes
a medicis atque philoſophis pertractatas non ueritatis inuen
tione, ſed iurgiis, atque clamoribus plerunque terminari, illud
inſuper a me expectarè uidebaris, ut nó ſolum quæ nam inter
diſputantes opinio tandem eſſet pro uera recepta tibi ſigni-
ficarem , ſed mei quoque iudicii calculum inter ambigen-
tes ſententias manifeſtarem. Quid plura: ego qui tibi propter
tua eximia in me beneficia omnia debeo, pollicitus ſum factu-
rum me, quod optabas, arduum quidé opus, ac penè temera
rium, niſi ipſum excuſaret obſequium. Ecce igitur iam tibi fidé
promiſſam exoluo quanto tardius, quã tu forte cupiebas, tan
to maiore cum fœnore. nó ſolum enim eam, quæ præcipue de
fédebatur Ferrariæ opinioné, ſed quaſcunque alibi plurimum
uigere intellexi, conatus ſum pro mei ingenii imbecillitate có
futare, meãꝗ poſtremo loco, exemplis. rationibus. ac nobiliſſi-
moꝛ medicorum auctoritatibus confirmare. Multa præterea
Auicénæ dicta, quæ ad propoſitam contemplationem perti-
nebãt, duximus in controuerſiam. Quare qui hæc lecturi ſunt
quæſo boni cóſulant, neque me propterea impudentem, aut

 a ii

42. One product of Aldus's short-lived medical series: Leonicenus on syphilis, 1497 (PML 1414). The first European epidemic of syphilis is also marking its quincentenary.

Cicero. *Epistolae ad familiares*. April
PML 1282

Pollux. *Vocabularium*. April
PML 1557

Thucydides. May
PML 1638 (Sykes)
PML 1639 (scholia only)

Sedulius. *Poetae Christiani veteres*. II.
January 1501 & June
PML 1546

Dante. August
PML 1254 (?Renouard)
PML 1255 (thick paper)

Statius. August
PML 15430 (Lauweryn)

Sophocles. *Tragoediae*. August
PML 1604

Herodotus. September
PML 1481

Valerius Maximus. October
PML 1648 (variant: mixed state)

Ovidius. I. *Metamorphoses*.
October–November
PML 1508
PML 79193

Ovidius. II. *Heroides*. December
PML 1509
B 9 (Grolier; illum.)

1503
Ovidius. III. *Fasti*. January–February
PML 1510

Euripides. *Tragoediae*. I–II. February
PML 1327–1328 (vol. II uncut)
PML 1329–1330.1 (vol. II bd with Rome:
[Blado], 1545 *Electra*)
PAAB 5.1–2

Origenes. *Homiliae*. February
PML 1506 (Butler)

Valerius Maximus.
October 1502 & a. 1 April
PML 1649 (illum.)

Ammonius Hermiae. *Commentaria*. June
PML 1115

Lucianus. *Dialogi*. June
PML 1490

Bessarion. *In calumniatores Platonis*. July
PML 1133
PML 1134 (Renouard; thick paper)

Ulpianus. *Commentarioli*. October
PML 1642

Xenophon. *Hellenica*. October
PML 1670 (Beatus Rhenanus, 1513;
?Renouard)
PML 1352 (Gemistus portion only, with
new title-page leaf; see next entry)

Gemistus Pletho. October
PML 1352 (original portion of Xenophon;
cancel title-page leaf [ca. 1535?])

Anthologia Graeca. November
PML 1151 (with epigrams by ?Sanudo)

Lascaris. *De octo partibus orationis*.
[undated; 1501–03]
PML 1409

1504
Joannes Grammaticus. *Commentaria*.
March
PML 1484

Philostratus.
March 1501, February 1502, & May
PML 1523

Gregorius Nazianzenus.
Poetae Christiani veteres. III. June
PML 1547.1

Homerus. I–II. a. 31 October
PML 1365–1366 (vol. II title page from
1524 ed.)

Demosthenes. November
PML 1332
PML 1333 ("1504" but [1520–27])

1505
Bembo. *Gli Asolani*. March
PML 1178 (Doge Marco Foscarini)

Augurellus. April
PML 1174 (Renouard)
PML 1175
PML 125351 (Ramey)

Horae B.M.V. (Greek). July
PML 1070

Pontanus. *Urania.* August
PML 28270 (Powis)

Aesopus. October
PML 1114 (?Meerman–Renouard)

Quintus Smyrnaeus Calaber. [undated]
PML 1195 (Grolier)
PML 1196 (de Thou–Renouard)

1507
Euripides. *Hecuba & Iphigenia in Aulis*
trans. Erasmus. December
PML 1326

1508
Aldus. *Institutiones grammaticae.*
October 1507 & April
PML 1440

Erasmus. *Adagia.* September
PML 23205
(Pirckheimer–Arundel–Norfolk–Royal
Society)

Plinius. *Epistolae.* November
PML 1532
PML 79187

Rhetores Graeci. I. November
PML 1577

1509
Horatius. March
PML 1375
PML 1376 (Renouard)
PML 78962 (Glazier)
JPW 3222 (illum.)

Plutarchus. *Moralia.* March
PML 1541–1542 (?Renouard; bd as 2 vols)

Sallustius. April
PML 28273 (Clive)

Rhetores Graeci. II. May
PML 1578

1512
Lascaris. *De octo partibus orationis.* October
PML 1408

Cicero. *Epistolae ad familiares.*
PML 1283

1513
Pindar. January
PML 1526

Aristotle. *De animalibus.* February
PML 1124 (Granvelle)

Oratores Graeci. April, a. 6 May, a. 4
May
PML 1505

Cicero. *Epistolae ad Atticum.* June
PML 1276

Plato. September
PML 1528
GNR 5308

Alexander Aphrodisiensis. September
PML 1121 (?Renouard; uncut)

Caesar. April, November, & December
PML 1192

Pontanus.
PML 1560

Strozzi.
PML 1614

1514
Suda Lexicon. February
PML 1617

Cicero. *Rhetorica.* March
PML 3112

Libri de re rustica. May
PML 1581
PML 79276 (Bühler; blue paper)

Athenaeus. August
PML 1125 (illum.)

Quintilian. August
PML 1572 (notes by ?Melanchthon)

Hesychius. *Dictionarium Graecum*. August
PML 1482

Petrarca. August
PML 5071 (?Renouard)

Sannazarius. *Arcadia*. September
PML 1591
PML 127153 (variant)

Valerius Maximus. October
PML 1651

Vergilius. October
PML 16173

Aldus. *Institutiones grammaticae*. December
PML 28263

1515
Lucretius. January
PML 1432

Catullus, Tibullus, Propertius. March
PML 1209 (?Renouard)
PML 15431 (Ebeleben)

Lactantius & Tertullianus. April
PML 1404

Bembo. *Gli Asolani*. May
PML 1179

Ovidius. II. *Heroides*. May
PML 1512

Lucanus. July
PML 23015

Dante. August
PML 1256 (Heber)
PML 79184

Erasmus. *Moriae encomium*. August
PML 1274

Aulus Gellius. September
PML 1344 (Grafton)
PML 1345

Aldus. *Grammaticae institutiones Graecae*.
a. 13 November
PML 1441

Juvenalis & Persius.
[misdated "August 1501"]
PML 1398 (de Bene)

1516
Ovidius. III. *Fasti*. January
PML 1513

Ovidius. I. *Metamorphoses*. February
PML 1511
PML 79038

Rhodiginus (Ricchieri). February
PML 1579

Gregorius Nazianzenus. *Orationes*. April
PML 1359

Lucianus. May
PML 1429

Pausanius. July
PML 1507
PML 16168

Egnatius. *De Caesaribus*. (Historiae
Augustae Scriptores.) July
PML 1271 (Grafton–Heber)

Suetonius. (Historiae Augustae
Scriptores.) August
PML 1215

Bessarion. September
PML 1134

Iamblichus. November
PML 27472 (Sellière)

Strabo. November
PML 28276

1517
Cicero. *De officiis*. June
PML 17576 (Paris de Maisieux–
Williams–Beckford–Hoe;
on vellum; illum.)

Homerus. I–II. June
PML 1367–1368

Seneca. *Tragoediae*. October
PML 1597

Ausonius. November
PML 1176 ("Nulli plus fortuna")
PML 79186

Musaeus. November
PML 1480 (Renouard)
PML 79240

Martialis. December
PML 28265 (Grafton–Powis)

Oppianus. December
PML 1500
PML 79173

Priapeia.
PML 1267 (Renouard; uncut)

Terentius.
PML 1627 (Hoym; illum.)

1518
Aeschylus. *Tragoediae*. February
PML 1141 (Sykes)

Biblia Graeca. February
PML 895

Pontanus. *Amores*. February
PML 1563 (?Grolier; illum.)
PML 1564 (Heber–Butler; very large paper)

Dioscorides. June
PML 47508 (defective date in colophon)

Plinius. *Epistolae*. June
PML 1533
PML 79194

Pontanus. *Opera omnia soluta oratione*. I.
June
PML 1561
PML 79198

Artemidorus. August
PML 1171

Erasmus. *Querela pacis*. September
PML 1275

Pomponius Mela. October
PML 1558
PML 1559 (large paper)
PML 16216

1519
Cicero. *Orationes*. I. January
PML 79201

Statius. January
PML 1608
PML 1609 (Granvelle)
PML 1610 (Strozzi)
PML 79195

Cicero. *De officiis*. February
PML 1291

Livius. *Decas tertia*. February
PML 1419 (Granvelle)

Pontanus. *Opera omnia soluta oratione*. II.
April
PML 79199

Cicero. *Orationes*. II. May
PML 79202

Cicero. *Orationes*. III. August
PML 79203

Historiae Augustae Scriptores. August
PML 1364 (Marinus)

Plutarchus. *Vitae*. August
PML 1543 (Renouard)
PML 21870 (Hoe; uncut)

Pontanus. *Opera omnia soluta oratione*. III.
September
PML 1562
PML 79200

Caesar. January 1518/9 & November
PML 1193 (illum.)
PML 78929 (Glazier)

Horatius. November
PML 1377

1520
Curtius Rufus. July
PML 3150
JPW 1776 (?Grolier; illum.)

Livius. *Decas quarta*. November
PML 1421.1 (Granvelle–Besançon
Capuchins)

Alexander Aphrodisiensis. *In Priora
analytica Aristotelis commentaria*.
PML 28252

1521
Anthologia Graeca. January
PML 1152 (?Heber)

Sallustius. January
PML 1587 ("Nulli plus fortuna";
Renouard)
PML 1588 (Butler; thick paper)
PML 79045

Cicero. *Epistolae ad Atticum*. January
PML 15427 (Grolier–de Thou; large paper)

Livius. *Decades*. f° February
PML 1487 (Lauweryn)

Livius. *Epitome*. March
PML 1420 (Granvelle–Besançon
Capuchins)
PML 1422 (Grolier; illum.)

Apollonius Rhodius. April
PML 1154

Apuleius. May
PML 1156
PML 79182 (Doge Marco Foscarini)

Didymus. *Interpretationes*. May
PML 1372.1

Porphyrius. May
PML 1372.2

Suetonius. (Historiae Augustae
Scriptores.) May
PML 1617
PML 28262 (Powis)

Horae B.M.V. (Greek). June
PML 1071

Terentius. June
PML 1629 (Arundel–Lumley–British
Museum)

Petrarca. July
PML 5072

Cicero. *Rhetorica*. October
PML 3113 (Pömer–Kloss)

Longolius. [undated]
PML 1424 (large, thick paper)

1522
Justinus. January (1521/2?)
PML 1395 (?Grolier)

Quintilianus. January (1521/2?)
PML 1573

Cicero. *Epistolae ad familiares*. June
PML 1284

Plautus. *Comoediae*. July
PML 1530

Budé. *De asse*. September
PML 1189

Lucianus. October
PML 1491

Alcyonius. *De exsilio*. November
PML 1143 (uncut)
PML 1144 (with notes by Paulus
Manutius)

Boccaccio. *Decameron*. November
PML 1184 (?Renouard)

Asconius Pedianus. December
PML 1245

Seneca. *Naturales quaestiones*.
August & February (1522/3?)
PML 1596

1523
Claudianus. March
PML 1322

Nicander. November 1522 & April
PML 1481

Georgius Trapezuntius. April
PML 1353

Cicero. *De philosophia*. I. May
PML 1306 (Lauweryn; bdg restored)

Valerius Flaccus. *Argonautica*. May
PML 1646
PML 1647

Aldus. *Institutiones grammaticae*. July
PML 1443 (Alessandro Farnese)

Silius Italicus. July
PML 1601

Cicero. *De philosophia*. II. August
PML 1307 (Lauweryn)

1524
Homerus. I–II. April
PML 1369–1370
PML 55173–55174 (Pflug)

Herodianus. September
PML 1363 (Granvelle)

Dictionarium Graecum. December
PML 1335 (Grolier)

1525
Galenus. I–V. April & August
PML 1346–1350

Xenophon. April
PML 1671

1526
Hippocrates. May
PML 28259

Simplicius. October
PML 1602
PML 28275

Brevissima introductio ad litteras Graecas.
PML 28260 (?Renouard)

1527
Priscianus. May
PML 2009 (Grimaldi)

Simplicius. June
PML 1602 (thick paper)

Sannazarius. *De partu Virginis*. August
PML 28374 (Renouard)

Horatius. September
PML 1378

Joannes Grammaticus. September
PML 1486 (Renouard; large paper)

Alphabetum et preces Illyricae. (Torresani)
PML 1147 (John Evelyn, 1645; Butler)

1528
Celsus. *De medicina*. March
PML 1219 (Tosi; large paper)

Macrobius. April
PML 1437

Castiglione. *Il cortegiano*. April
PML 1216

Didymus. *Interpretatio*. June
PML 1371

Paulus Aegineta. August
PML 28251

1529
[Steuchus]. *Recognitio Veteris Testamenti*.
PML 1613

1533
Castiglione. *Il Cortegiano*. May
PML 15498 (Grolier; large paper)
PML 28071 (very large paper)

Livius. *Decas quinta*. May
PML 1421.2 (Granvelle–Besançon
Capuchins)

Cicero. *Epistolae ad familiares*. October
PML 1285

Libri de re rustica. December
PML 1582 (blue paper)

Ptolomaeus & Ovidius. III. *Fasti*.
December
PML 1515

Capella. *L'anthropologia.* January (1533/4?)
PML 1197 (?Sykes)
PML 28071

Ovidius. II. *Amores.* January (1533/4?)
PML 1514

Sannazarius. *De partu Virginis.*
PML 1593

1534
Grat<t>ius, Nemesianus, Ovidius.
(*Poetae tres egregii.*) February
PML 1358 (Colonna)

Priapeia. March
PML 1665.2 (Granvelle; bd with 1545
Virgil)

Valerius Maximus. March
PML 75174 (Grolier; illum.)

Themistius. May
PML 1634.1 (de Thou–Renouard)

Isocrates. July
PML 75868

Sannazarius. *Arcadia.* July
PML 1592
PML 19014 (Poor; on vellum)
PML 20460 (Grolier; illum.)

Aetius. September
PML 1120 (Herwagen)

Tacitus. November
PML 1618

Joannes Grammaticus. December
PML 1485

Ovidius. I. *Metamorphoses.*
PML 1516 (September 1533 colophon)
PML 1517 (uncut; September 1533
colophon)

1535
Lactantius & Tertullianus. March
PML 1405–1406 (Torresani to Legrain;
Renouard; bd as 2 vols)

Plinius. *Naturalis historia.* II
PML 1537 (uncut)
PML 127137 (1540 title page)

1536
Eustratius. July
PML 1336

Aristotle. *Poetica.*
PML 1169 (large paper)
PML 1170

Gregorius Nazianzenus. *Orationes.*
PML 1360 (?Renouard)

Plinius. *Naturalis historia.* I
PML 1536 (uncut)
PML 127136

Plinius. *Naturalis historia.* III
PML 1538 (uncut; 1535 title page)

Valla. *Elegantiae.*
PML 1655 (Renouard)

1538
Plinius. *Naturalis historia.* Index.
[?Nicolini da Sabbio for Torresani]
PML 1539
PML 127139

Hadrianus Finus.
(Nicolini da Sabbio for Torresani) January
PML 1361 (de Thou)

[Martorell]. *Tirante il Bianco.*
(Nicolini da Sabbio for Torresani)
PML 1640 (Grafton–Hibbert)

1539
Ramberti. *Cose de Turchi.*
PML 1390.2 (bd with 1541 Giovio &
Gambini)
PML 53863

Aretino. *Lettere.* (Padovano for Torresani)
PML 1159 (Butler)

Chrysoloras. (Zanetti for Torresani)
February
PML 1223

1540

Cicero. *Epistolae ad familiares.* July
PML 1237

Cicero. *Epistolae ad Atticum.* August
PML 1236

Cicero. *Orationes.* I. October
PML 1240

Machiavelli. *Arte della guerra.*
PML 28261 (Powis)

Machiavelli. *Discorsi.*
PML 1433

Machiavelli. *Historie.*
PML 1434

Machiavelli. *Il Prencipe.*
PML 1435

Plinius. *Naturalis historia.* III
PML 127138

Aretino. *L'humanità di C<h>risto.*
[Zanetti (?for Torresani)]
PML 1158

Egnatius. *Panegyricus.* (Nicolini da Sabbio
for Torresani) December
PML 1272

1541

Cicero. *Orationes.* II. February
PML 1241

Cicero. *Orationes.* III. March
PML 1242

Cicero. *De officiis.* May
PML 1239.1

Terentius. *Comoediae.* May
PML 1631

Cicero. *De philosophia.* I–II. August
PML 1308–1309

Fortunio. *Regole grammaticali.*
PML 1339 (uncut; notes by [Vettori])

Giovio & Gambini. *Commentarii.*
PML 1390.1 (bd with 1539 Ramberti)

Leone (Abarbanel). *Dialogi.*
PML 1412 (Bigot–Libri)

Politianus. *Stanze.*
PML 1556

1542

[Grimani]. *Commentarii.* March
PML 28258 (Powis)

Ferrarius. *Emendationes in Philippicas
Ciceronis.* March
PML 1246

Villagagnon. *Caroli V Expeditio in Africam.*
(Nicolini da Sabbio for Torresani) August
PML 1663

1543

Sanutus. *Oppugnatio.* July
PML 1594

Alunno. *Richezze.*
PML 1150 (Duc d'Orléans)

Viagi fatti da Vinetia alla Tana.
PML 28278 (Huth)

1544

Sforza. July
PML 1598

Terentius. *Andria & Eunuchus* (Italian).
July
PML 28277 (Boutourlin; very large paper)

Cicero. *Epistolae ad Atticum.* November
PML 1278

Speroni. *Dialoghi.*
PML 1605
PML 19606

Vergilius. *Aeneid* I–VI (Italian). (Padovano
for Torresani)
PML 1667

1545

Ariosto. *Orlando furioso.*
PML 1161

Colonna. *Hypnerotomachia Poliphili.*
PML 1551
PML 1552

Flaminius. *In librum Psalmorum brevis explanatio.*
PML 28257 (Sykes)

Patritii. *Discorsi.*
PML 28267

Riccius. *De imitatione.*
PML 28272

Terentius. *Comoediae.*
PML 1632 (Thorold; very large paper)

Vergilius.
PML 1665.1 (Granvelle; bd with 1534 Priapeia)

Viagi fatti da Vinetia alla Tana.
PML 1659

1546
Alciato. *Emblemata.* June
PML 1142 (Renouard)

Philippus. *Ecphrasis.* August
PML 1385 (uncut)

Cicero. *Rhetorica.* September
PML 1243

Cicero. *Rhetorica. De oratore. De claris oratoribus.*
PML 3114. 1–3 (?Libri; very large paper)

Ammonius Hermiae.
In voces Porphyrii commentarius. In praedicamenta Aristotelis commentarius. In Aristotelis de interpretatione commentarius.
PML 28253.1–3

Capicius. *De principiis rerum.*
PML 1198 (illum.)

Cicero. *Orationes.* I
PML 1293 (Renouard)

Cicero. *Orationes.* II. May
PML 1294 (Renouard)

Cicero. *Orationes.* III. August
PML 1295 (Renouard)

Cicero. *De philosophia.* I–II
PML 1310–1311 (Renouard)

Cicero. *Defensiones.*
PML 1239.2

Cicero. *De oratore.*
PML 1244

Cicero. *Epistolae ad familiares.*
PML 1286 (very large paper)

Folengius. *Commentaria.*
PML 1338 (Boutourlin; uncut)

Lacinius. *Pretiosa margarita.*
PML 1403 (Dawson Turner)

Liburnio. *Occorrenze humane.*
PML 1417
PML 79277

Macchiavelli. *Il Principe.*
PML 1436

Petrarca.
PML 5073 (Renouard)

1547
Georgius. *Epitome principum Venetarum.*
PML 1354 (Doge Francesco Donà ded. copy; on vellum; illum.)

Castiglione. *Il cortegiano.*
PML 1203 (?Renouard)

Dolce. *Didone.*
PML 28254 (Powis)

Medici antiqui.
PML 1492

Paulus Manutius. *In Ciceronis epistolas ad Atticum commentarius.*
PML 1279 (Mahieu–de Thou)

Bordone. *Isolario.* (for Torresani)
PML 1135

1548
Cicero. *Epistolae ad familiares.*
PML 1287

Cicero. *De officiis*.
PML 15489 (notes by ?Tasso)

Lettere volgari. II.
PML 1416.2

Liburnius. *Epithalamium*.
PML 1418 (uncut)

Caterina da Siena. *Epistole*. (Nicolini da Sabbio for Torresani)
PML 1205

1549
Franciscus Priscianensis. September
PML 28271 (Renouard; uncut)

Demosthenes.
PML 1258 (Renouard; uncut)
PML 79285

Dolce. *Fabritia*.
PML 28256

Dolce. *Giocasta*. a. 5 & 6 March
PML 28255

Plato, Thucydides, Demosthenes.
Funebres orationes.
PML 28269

Aeschines & Demosthenes. *Orationes*.
(Torresani)
PML 1140

Magnum etymologicum Graecae linguae.
(Torresani)
PML 1489 (Monte Cassino)

1550
Marinus. *Carmina*.
PML 28264

Lettere volgari. I
PML 1416.1 (1549 title page)

Bustamante Paz. *Methodus*.
PML 28268

Speroni. *Dialoghi*.
PML 1605

Tarchagnota. *L'Adone*.
PML 1619

1551
Anthologia Graeca.
PML 1153 (1550 title page)

Aretino. *Il Genesi, l'humanità di C<h>risto, e i salmi*.
PML 1157 (Butler)

Aristotle. *Opera omnia*. I
PML 1163

Aristotle. *Opera omnia*. II
PML 1164

Bembo. *Historiae Venetae*.
PML 1132

Faustus. *Orationes*.
PML 1337

Generali statuti ordinis Sancti Francisci.
PML 1351.1 (Renouard)

Apostolica Privilegia. a. 17 September
PML 1351.2 (Renouard)

Ordinationi delli Frati.
PML 1351.3 (Renouard)

Parisetus. *Theopoeiae*.
PML 28266.1 (1550 title page)

Dio Chrysostom. *Orationes*. (Torresani)
[undated]
PML 1262

1552
Aretino. *La vita di Maria vergine*.
PML 1160 (Butler)

Aristotle. *Opera omnia*. IV
PML 1166

Aristotle. *Opera omnia*. V
PML 1167

Aristotle. *Opera omnia*. VI
PML 1168

Speroni. *Dialoghi*.
PML 1606

1553

Aristotle. *Opera omnia*. III
PML 1165

Parisetus. *Epistolarum posteriorum libri*.
PML 28266.3

1554

Cataneo. *Architettura*.
PML 1218

Joannes Damascenus. *Adversus sanctarum
imaginum oppugnatores*.
PML 1389

Demosthenes. *Orationes*. I
PML 1259 (Thorold)

Demosthenes. *Orationes*. II
PML 1260 (Thorold)

Demosthenes. *Orationes*. III
PML 1261 (Philemon Holland–William
Ireland–Thorold)

Luisinus. *In librum Horatii De arte poetica
commentarius*.
PML 1382
PML 15725

Lauredanus. *Oratio*.
PML 1410 (large paper)

Lorenzo de' Medici. *Poesie volgari*.
PML 1467

Oribasius. *Collectorum medicinalium libri*.
[undated]
PML 1501 (uncut)

Oribasius. *Synopseos libri*.
PML 1503 (uncut)

Parisetus. *Pausithea*.
PML 28266.2

Vico. *Caesarum imagines*.
PML 1661.1

Joannes Chrysostomus. *Della providenza di
Dio*. (Torresani, a. 24 June)
PML 1226

1555

Cicero. *Epistolae ad Atticum* (Italian).
PML 1280 (large paper)

Horatius.
PML 1379

Longinus.
PML 1423

Moschus.
PML 1473

Ragazonius.
PML 1249

Sigonius. *Pro eloquentia*.
PML 1599 (uncut)

Sigonius. *Fasti consulares*.
PML 64794

Oribasius. *Collectorum medicinalium libri*.
(Paris: Turrisan)
PML 1502

1556

Athenagoras. *De resurrectione mortuorum*
(Italian).
PML 1172 (uncut)
PML 79279

Cicero. *Le Filippiche*.
PML 1305 (Doge Marco Foscarini)

Paulus Manutius. *In orationem Ciceronis pro
Sextio commentarius*.
PML 1248

Paulus Manutius. *Lettere volgari*.
PML 1448

Sigonius. *Fasti consulares*.
PML 64795

Actuarius. (Paris: Morel for Turrisan)
PML 1139

1557

Paulus Manutius. *Commentarius in epistolas
Ciceronis ad Brutum*.
PML 1247

Paulus Manutius. *Antiquitatum Romanarum liber de legibus*.
PML 1444 (uncut)
PML 79260 (Bühler; first issue)

Paulus Manutius. *Antiquitatum Romanarum liber de legibus*.
(Paris: Turrisan, a. 4 April 1556/7)
PML 79324 (Bühler)

Sallustius.
PML 1590

Castellani. *Stanze*. (Bologna: Antonio, a. 25 January)
PML 1201
PML 1202 (facs. Milan: Tosi, 1841)

Massolo. *Sonetti morali*. (Bologna: Antonio)
PML 1465

Statuti e provisioni. (Bologna: Antonio)
PML 1611 (Costabili)

See also under Accademia Veneziana.

1558
Archimedes. *Opera & Commentarii*.
PML 1122. 1–2

Georgius. *Epitaphia*.
PML 1355 (Butler)

Lauredanus. *In Ciceronis orationes De lege agraria commentarius*.
PML 1315
PML 125035 (Ramey)

Vico. *Augustarum imagines*.
a. 30 September
PML 1660

See also under Accademia Veneziana.

1559
Cicero. *Epistolae ad Atticum*.
PML 1281 (Luca Mannucci; 1558 title page)

Cicero. *Orationes*. I–III
PML 1301–1303

Georgius. *Periocha*.
PML 1356.1 (Butler)

Natta. *De Deo*.
PML 1495

Plinius. *Naturalis historia*.
PML 1540 (de Thou)

Delphinus.
PML 27471

See also under Accademia Veneziana.

1560
Cicero. *Epistolae ad familiares*.
PML 1288 (uncut)

Dionysius Halicarnassensis.
PML 1263 (Renouard)

Odoni. *Discorso*.
PML 1498

Vico. *Imperatorum Romanorum numismata*.
PML 1661.2 (bd with 1554 *Caesarum imagines*)

See also under Accademia Veneziana.

1561
Camillus. *De ordine*.
PML 1194.2 (de Thou–Renouard–Butler)

Aldus Manutius Jr. *Orthographiae ratio*.
PML 1455

See also under Accademia Veneziana.

1562
Pole. *De concilio*. (Rome)
PML 1548

Pole. *Reformatio Angliae*. (Rome)
PML 1549

Pole. *De concilio & Reformatio Angliae*. (Venice: Zilet<t>i [?for Paulus Manutius])
PML 79299

1563
Cyprianus. (Rome)
PML 1250

1564
Amicus. *Epistola.*
PML 1148

Index librorum prohibitorum. (Rome)
PML 1387

Index librorum prohibitorum.
PML 1388

Natta.
PML 1494 (?ded. copy to Pius IV; illum.)

Valerius Palermus. *Pastorale carmen.*
PML 1518

Council of Trent. *Canones et decreta.* f°
(Rome)
PML 1214 (attested copy)
PML 1215 (rev. ed.)

Council of Trent. *Canones et decreta.* 8°
PML 1324

1565
Aldus Manutius Jr. *Eleganze.*
PML 125355 (Ramey)

Bizzarus. *Opuscula.* a. 1 June
PML 1180
PML 3212 (variant)

Taurellus. *Exquisitior patronymia.*
PML 1625

Thomasius. *Disputationes.* (Rome)
PML 1637 (Este; large paper)

1566
Cicero. *Opera.* I–IV in 2. (Paris:
Prevosteau for Turrisan) February
PML 1233–1234 (1565 & 1566 title pages)

Catullus. a. 1 March
PML 1212.1 (uncut)
PML 79226

Horatius. I–II
PML 1380–1381 (Devonshire)

Constitutiones et decreta condita in provinciali
synodo Mediolanensi.
PML 1320

Curtius Papiensis. *De prandii ac cenae*
modo. (Rome)
PML 1252 (uncut)

Livius. *Historiarum libri xxxv.*
PML 1488

Victorius. *De sacramento confessionis.*
(Rome)
PML 1662 (uncut)

Callistus. *Historia ecclesiastica.* I–II. (Paris:
Menier for Turrisan, 30 May)
PML 1496–1497

Catharinus Politus. *Commentaria.* (Paris:
Turrisan)
PML 1554

1567
Tibullus. a. 1 June
PML 1212.2 (uncut; bd with 1566
Catullus)

1569
Caro. *Rime.*
PML 79252.1

Gregorius Nazianzenus. *Due orationi.*
PML 79252.2

1570
Breviarium Romanum. (Rome)
PML 1138

Brutus. *Epistolae.* a. 1 September
PML 1188

Nunnesius (Nuñez). *Epitheta Ciceronis.*
PML 1290

Dudley. *Ad populum Londinensem concio.*
(Rome)
PML 1270

1571
Maximilian II. [*Diploma insignium*]. a. 28
April
PML 27693 (on vellum)
PML 1466 (facs. [Milan: Tosi, ca. 1840s],
on vellum)

Streinnius (Strein von Schwarzenau). *De
gentibus et familiis Romanorum.*
PML 20476

1572
Caro. *Rime.*
PML 1199

Paulus Manutius. *In epistolas Ciceronis ad
Brutum, ad Quintum fratrem commentarius.*
PML 1289 (uncut)

Paulus Manutius. *In Ciceronis orationem pro
Archia commentarius.* (Rome: de Angelis)
PML 1304

1573
Paulus Manutius. *Epistolarum libri xi.*
PML 1447 (Rantzau–de Ganay–Libri; large
blue paper)

1574
Missale Romanum.
PML 1470

1575
Catechismus.
PML 1325 (Clement XI)

Aldus Manutius Jr. *Discorso intorno all'
eccellenza.*
PML 1453

Aldus Manutius Jr. *Epitome orthographiae.*
PML 1456

Bizzarus. *Opuscula.*
PML 1180 (uncut & unopened)

1576
Clarantes. *Ad Alexandrum Farnesium
epitome.* 31 March
PML 1319

Aldus Manutius Jr. *De quaesitis per
epistolam.*
PML 1459

Muretus. *Orationes.*
PML 1475

Rocca. *Osservationi.*
PML 79307

1577
Calepinus. *Dictionarium.*
PML 1213

1578
Contarenus.
PML 1235

1579
Ciofani. *In Ovidii Fastorum libros scholia.*
PML 1316

1580
Caravita. *Pragmaticae sanctiones.*
PML 1566

Ciofani. *In Ovidii Halieuticon scholia.*
PML 1317

Crichton. *Carmina.* (Venice: Typographia
Guerraea)
PML 1300

Vergilius.
PML 1666

1581
Aldus Manutius Jr. *Relatione.*
PML 1251

Ciofani. *In Ovidii elegias observationes.*
PML 1318

Censorinus.
PML 1220 (uncut)
PML 1221 (thick paper)

Mocenicus. *Universales institutiones.*
PML 1493

Tasso. *Rime*. I
PML 1620

1582
Cicero. *Opera*. I
PML 1227 (Loménie de Brienne–Drury)

1583
Cicero. *Opera*. II
PML 1228.1 (Loménie de Brienne–Drury)

Cicero. *Opera*. III
PML 1228.2 (Loménie de Brienne–Drury)

Cicero. *Opera*. IV
PML 1229.1 (Loménie de Brienne–Drury)

Cicero. *Opera*. V
PML 1229.2 (Loménie de Brienne–Drury)

Cicero. *Opera*. VI
PML 1230 (Loménie de Brienne–Drury)

Cicero. *Opera*. VII
PML 1231.1 (Loménie de Brienne–Drury)

Cicero. *Opera*. VIII
PML 1231.2 (Loménie de Brienne–Drury)

Cicero. *Opera*. IX
PML 1232.1 (Loménie de Brienne–Drury)

Cicero. *Opera*. X
PML 1232.2 (Loménie de Brienne–Drury)

Tasso. *Il Forno*. a. 1 January or 1 March
PML 1622
PML 1624 (thick paper)

1584
Tasso. *Aminta*.
PML 1621.1–2 (2 issues; second without title page)

Tasso. *Il Padre di famiglia*. a. 1 May
PML 1623

Audebertus.
PML 1173 (uncut)

1585
Brancatio. *Nuova disciplina militare*.
PML 1136

Paulus Manutius. *Antiquitatum Romanarum liber de comitiis*. (Bologna: Aldus Jr.)
PML 1445

Turco. *Agnella*.
PML 1641

1586
Aldus Manutius Jr. *Vita di Cosimo de' Medici*. a. 25 March. (Bologna: [?Benacci for] Aldus Jr.)
PML 1460

Horatius. *De laudibus vitae rusticae*. (Bologna: [?Benacci])
PML 1384

1587
Constitutiones cleri Venetiarum.
PML 1321 (uncut)

1588
Aldus Manutius Jr. *Lepidi comici veteris Philodoxios tabula*. (Lucca)
PML 1415

1589
Ananias. *De natura daemonum*.
PML 1149 (uncut)

Aldus Manutius Jr. *Inscriptio Gordiana*.
PML 1454

Morandus. *De Bononiae laudibus oratio*. (Rome: Coattinus)
PML 1472

Vairus (Du Vair). *De fascino*.
PML 1644 (uncut)

1590
Biblia Vulgata Latina.
(Rome: Typographia Apostolica Vaticana [Aldus Jr.])
PML 823 (Pius VI–Renouard; very large paper)

Velserus (Welser). *Inscriptiones antiquae
Augustae Vindelicorum.*
PML 1657 (uncut)

Aldus Manutius Jr. *Attioni di Castruccio
Castracane.* (Rome: heirs of Gigliotti)
PML 1451
PML 1452 (Conde de Lemos)

1591
Aldus Manutius Jr. *Orthographiae ratio.*
PML 1458 (uncut)

Contarini. *Della Republica Venetiana.*
PML 1323 (uncut)

1592
Biblia Vulgata Latina. a. 9 November.
(Rome: Typographia Apostolica Vaticana
[Aldus Jr.])
PML 824 (very large paper)

Bodin. *Demonomania.*
PML 1186 (uncut)

Aldus Manutius Jr. *De Clemente VIII
collapsam pietatis disciplinam restituente.*
(Rome: Aldus Jr.)
PML 1450

1593
Biblia Vulgata Latina.
(Rome: Typographia Apostolica Vaticana
[Aldus Jr.])
PML 825 (Butler)

1594
Velserus (Welser). *Rerum Augustanarum
Vindelicarum libri octo.*
PML 1658

1596
Brandolini. *De virtutibus.* (Rome:
Domenico Basa, a. 1 April)
PML 1187

Gian Pietro & Paolo Manucio (Onori).
Transsilvaniae descriptio. (Rome: Accolti)
PML 1461
PML 1462

1597
[Del Monte (Julius III)]. *De Christi
passione oratio.* (Rome: Zanetti)
PML 1603 (uncut)

UNDATED OR MISDATED
16TH-CENTURY ALDINES

Nonnus. [1501; issued ca. 1504]
PML 1547.2
PML 19660.5

Lascaris. *De octo partibus orationis.*
[1501–03]
PML 1409

Quintus Smyrnaeus Calaber. [1505]
PML 1194 (Grolier)
PML 1195 (de Thou)

Juvenalis & Persius. "August 1501" [1515]
PML 1398 (de Bene)

Dioscorides. 1518
PML 47508 (defective date in colophon:
M.D.X.)

Demosthenes. "1504" [1520–27]
PML 1333

Gemistus Pletho. 1503 [cancel title-page
leaf, ca. 1535?]
PML 1352 (portion of October 1503
Xenophon)

Longolius. [1521]
PML 1424 (large, thick paper)

Dio Chrysostom. *Orationes.* (Torresani)
[ca. 1551?]
PML 1262

Oribasius. *Collectorum medicinalium libri.*
[ca. 1554]
PML 1501 (uncut)

ACCADEMIA VENEZIANA

1557
Lettera al Camillo Vezzato. [a. September]
PML 40659 (Powis)

1558
Paulus Manutius. *Epistolae et praefationes.*
PML 1446 (S. Giorgio Maggiore–
S. Michele di Murano)

Pole. *Oratione in materia di pace.*
PML 1264.2

Haedus (Cavretto). *De miseria humana.*
PML 1362 (Renouard; uncut)
PML 79265

Raviglio Rosso. *Historia . . . Regno
d'Inghilterra.*
PML 1576 (uncut)
PML 3252

Girardi. *Discorso intorno alle cose della
guerra.*
PML 1264.1

Elettione et obligo dei quattro nodari.
PML 40669 (Powis)

Cyllenius. *De legato pontificio.*
PML 1411 (de Thou)

Sansovino. *Ordine de cavalieri del Tosone.*
PML 1264.4

Corraro. *Progne.*
PML 1568

Polizze di Paolo Manutio. [a. 30 October]
PML 40660 (Powis)

Badoer. *Testamento.* 30 December
PML 1177

1559
*Conti di Domenico e Cornelio de Nicolini
stampatori.*
PML 40661 (Powis)

Conto di Mistro Nicolo [*Bevilaqua*]
stampator.
PML 40662 (Powis)

*Institutioni dell' imperio contenute nella bolla
doro.* (1558/9)
PML 1264.3

Procura del Giovanni Badoardo.
[a. 9 January]
PML 40663 (Powis)

Summa librorum.
PML 1544.2 (de Thou)

Delphinus. *De fluxu et refluxu aquae maris
disputatio.*
PML 27471 (Thorold)

Sadoleto. *Duo poemata heroica.*
PML 1583

1560
Affittatione della volta.
PML 40668 (Powis)

Instrumento.
PML 40667 (Powis)

*Procura Ioannis Baduarii in Iustinianum
Baduarium.* [a. 30 March]
PML 40666 (Powis)

1561
Accordo . . . co 'l Tasso.
PML 40665 (Powis)

[*Lettere agli Signori Academici Venetiani*].
[a. 7 January 1560/1]
PML 40664.1–8 (Powis)
 Lettera del Cardinal di Napoli
 (Ranuccio Farnese; 8 June 1559)
 PML 40664.1
 Lettera del Cardinal di Trento
 (Christoforo Madruzzo; 15 June 1559)
 PML 40664.2
 Lettera del Cardinal Alessandrino
 (Christoforo del Monte; 13 August
 [1559])
 PML 40664.3
 Lettera del Cardinal di Mantova
 (Ercole Gonzaga; 10 February
 1559/60?)
 PML 40664.4
 Lettera del Cardinal di Ferrara
 (Ippolito d'Este; 19 February
 1559/60?)
 PML 40664.5
 Concessione (28 November 1560)
 PML 40664.6
 Lettera del Mons. Rever. di Feltre
 (Filippo Maria Campeggio; 6
 November 1560)
 PML 40664.7
 Lettera del Duca di Savoia (Emanuele
 Filiberto di Savoia; 7 January 1560/1?)
 PML 40664.8

INCUNABULA BY ANDREA TORRESANI D'ASOLA

Aristotle. *Opera* (Latin). (1483; with Bartolommeo de' Blavi)
PML 21194–21195; ChL ^{ff}907
(Ugelheimer–Yates Thompson; on vellum; illum. with miniatures by [Girolamo da Cremona, Antonio Maria da Villafora, et al.])

Sabellicus. *Rerum Venetarum decades.* (21 May 1487)
PML 385; ChL ^{ff}908

Bartolus de Saxoferrato. *Super II parte Infortiati.* (5 December 1487)
PML 20667.2; ChL ^{ff}909

Breviarium Cartusianum. (5 May 1491)
PML 1018; ChL 910

Breviarium Fratrum Praedicatorum. (1 March 1494)
PML 474; ChL ^f911

Breviarium Cisterciense. (16 December 1494)
PML 18222; ChL 912

PSEUDO-ALDINES & QUASI-ALDINES

Lyon
Horatius. [Lyon, 1502]
PML 1374

Martialis. [Lyon, 1502]
PML 1464

Dante. [Lyon, ca. 1502–03]
PML 1257 (Renouard)

Valerius Maximus. [Lyon, 1502/3?]
PML 1652

Lucanus. [Lyon, 1502]
PML 1427

Prudentius. [Lyon, 1502–03]
PML 1569

Juvenalis & Persius. [Lyon: ?Gabiano, 1502]
PML 1402 (?Renouard)

Petrarca. [Lyon, ca. 1502]
PML 5070

Sal<l>ustius. [Lyon], a. 2 June 1504
PML 1586

Sal<l>ustius [inverted ⊤]. [Lyon]: Gabiano, 5 November 1504
PML 1585

Philostratus. [Lyon, 1504–05]
PML 1524

Cicero. *Opera.* [Lyon, ca. 1506]
PML 79301

Caesar. [Lyon: Gabiano], 20 June 1508
PML 1190

Valerius Maximus. [Lyon: Gabiano, 31 July 1508 (Aldus's preface redated October 1508)]
PML 1650

Suetonius. Lyon: [Gabiano], 3 October 1508
PML 29236 (date altered in contemporary ink to 1513: *v* to *x*)

Petrarca. [Lyon: ?Gabiano, ca. 1508]
PML 1571 (Renouard)

Lucanus. [Lyon, 1510]
PML 1428

Plinius. *Historia naturalis.* I–II. [Lyon: Gabiano], 31 August 1510
PML 1534–1535

Justinus. *Historia ex Trogo Pompeio.* [Lyon: Trot], 24 July 1510
PML 1393
PML 1394

Xenophon. [Lyon]: for Trot, 2 September 1511
PML 1672

Caesar. [Lyon: Trot], 4 November 1512
PML 1191

Aulus Gellius. [Lyon]: for Trot, 1512
PML 1342

Dioscorides. Lyon: Villiers for Trot, 1512
PML 79206

Plautus. [Lyon: ?Myt], 4 April 1513
PML 1529

Pontanus. *Urania*. [Lyon, ca. 1513?]
PML 1565

Juvenalis & Persius. [Lyon]: [?Myt] for
Trot, 30 June 1515
PML 1400

Catullus, Tibullus, Propertius; Gallus.
Lyon: [?Myt] for Trot, 22 September 1518
PML 1210 (Kloss; lacks colophon leaf)

Sallustius. [Lyon: ?Huyon or Trot], 1523
PML 1589

Terentius. [Lyon: ?Huyon or Trot], 1523
PML 1630

Vegetius. [Lyon: ?Huyon or Trot], 1523
PML 1656

Vitruvius. [Lyon: ?Huyon or Trot], 1523
PML 1669

Elsewhere
Sallustius. Florence: Giunta,
27 January 1503
PML 1584 (Borgia; illum.)

Valerius Flaccus. Florence: [Giunta],
20 November 1503
PML 1645

Terentius. Florence: Giunta,
8 August 1505
PML 1626 (Meerman–Hibbert; on vellum)

Quintus Curtius. Florence: Giunta,
December 1507
PML 1253

Pico della Mirandola. *De providentia Dei*.
Novi di Modena: Dolcibello,
5 November 1508
PML 2003 (Grolier)
PML 77613

Horae B.M.V. Paris: Le Rouge, [ca. 1510]
SP 17 (on vellum, illum.)

[Castellesi]. *Venatio*.
[Rome: Silber, ca. 1510]
PML 77774

Justinus & Florus. Florence: Giunta,
30 January 1510
PML 1392

[Castellesi]. *Venatio*. Strassburg: Schürer,
1512
PML 78485

Apuleius. Florence: Giunta,
February 1512
PML 1155

Lucretius. Florence: for Giunta,
March 1512
PML 1431 (Heber–Drury; uncut &
unopened)

Aulus Gellius. Florence: Giunta,
January 1513
PML 1343 (Grolier; illum.)

Juvenalis & Persius. Florence: Giunta,
October 1513
PML 1399

Silius Italicus. Florence: Giunta,
March 1515
PML 1600

Dante. [?Venice: ?de Gregoriis, a.
August 1515]
PML 1268

Chrysoloras. *Erotemata*. Florence: Giunta,
22 September 1516
PML 1222

Aldus. *Institutiones grammaticae*. [Paris]:
Badius Ascensius, 1 May 1517
PML 1442

Prodromus. *Galeomyomachia*. Ortona:
Soncino, 1518
PML 1341

Horae B.M.V. (Greek). Hagenau:
Anshelm, 1518
PML 127519

Benevieni. Florence: Giunta, March 1519
PML 1181

Juvenalis & Persius. Florence: Giunta,
May 1519
PML 1401

Horatius. Florence: Giunta, 1519
PML 15724

Alexander Aphrodisiensis. Florence:
Giunta, December 1521
PML 1145 (uncut)

Vitruvius. Florence: Giunta,
27 October 1522
PML 1668

Justinus. *Trogi Pompei historiae*.
[?Venice: ?Padovano, a. January 1522]
PML 1396

Castiglione. *Il cortegiano*. Florence:
Giunta, April 1531
PML 1181

Orosius. *Historiae*. Toscolano: Paganini,
[1527–33]
PML 50667 (Grimaldi)

Aldus. *Alphabetum Hebraicum*. 8°
[?Venice: by or for Sessa, ca. 1533]
PML 58721

Catullus. [Venice]: Zanetti,
[a. 18 December 1534]
PML 1211

[Apostolios]. *Scholia in septem Euripidis tragoedias*. Florence: Giunta,
24 December 1534
PML 1331

Georgius. *De Paulo III opuscula*. [?Venice:
Nicolini da Sabbio for Paulus Manutius],
1 & 5 July 1538
PML 1356.3
PML 19459 (Ottavio Farnese; on vellum;
illum.)

Georgius. *Selectae IIII epistolae*. [?Venice:
Nicolini da Sabbio], 1, 4, 5 July 1538
PML 1356.2 (Butler)

Aristophanes. *Comoediae*. Florence:
Giunta, 1540
PML 1162

Euripides. *Electra*. Rome: [Blado],
a. 14 March 1545
PML 1330.2 (bd with 1503 Aldine
Euripides)

Giraldi. *Orbecche*. [?Venice: Nicolini da
Sabbio], 1547
PML 1357

Paschalius. "Venice: Sons of Aldus, 1548"
[?Lyon or Venice: ?S. or J. Gryphius;
Geneva, ca. 1620?]
PML 1519

[Colonna]. *Hypnerotomachie*. Paris:
Masselin, 22 December 1553 for Kerver,
1554
GNR S-367

Officium B.M.V. Rome: [Fabrizio
Galletti] In Aedibus Populi Romani, 1571
PML 18244 (Pius V ded. copy; on vellum;
illum. MS title page; velvet bdg with
silver hardware and Pius V's arms in silver
& silver gilt)

REFERENCE WORKS

Renouard. *Annales de l'imprimerie des
Alde*. (Paris, 1825; 2nd ed.)
PML 125609–125611 (Renouard; on
vellum)

Renouard. *Annales de l'imprimerie des
Alde*. (Paris, 1834; 3rd ed.)
PML 1674 (Gosford–Toovey; large paper;
annotated)
PML 110140 (Bologna, 1953 facs.; Bühler;
annotated)

Toovey. *A Catalogue of an Extensive and
Extraordinary Assemblage of the Productions
of the Aldine Press*. (London: Toovey, 1880)
PML 40626 (Toovey; interleaved)

PUBLISHED BY THE PIERPONT MORGAN LIBRARY

Julianne Griffin, *Publisher*

Patricia Emerson, *Editorial Coordinator*

Noah Chasin, *Publications Administrator*

Deborah Winard, *Publications Associate*

PROJECT STAFF

H. George Fletcher, *Astor Curator of Printed Books and Bindings*

David S. Zeidberg, *Head, Department of Special Collections, UCLA Research Library*

David A. Loggie, *Chief Photographer*

Marilyn Palmeri, *Administrator, Photographic Services, Rights, and Reproductions*

Edward J. Sowinski, *Assistant, Photography Department*

Elena Kemelman, *Assistant, Photographic Services*

Patricia Reyes, *Mellon Conservator*

Mary Cropley, *Assistant Conservator*

Timothy Herstein, *Assistant, Conservation Department*

Robert Oswald, *Maintenance*

Freelance editorial: Kathryn Talalay

Design and typesetting: Bessas & Ackerman

Printed and bound by Thomson-Shore, Inc.